Seeing Through

Photographs

Michael Hiley

Gordon Fraser

London

First published in 1983 by
The Gordon Fraser Gallery Ltd, London and Bedford
Copyright © Michael Hiley 1983

BRITISH LIBRARY CATALOGUING IN PUBLICATION DATA

Hiley, Michael
 SEEING THROUGH PHOTOGRAPHS
 1. Photography-History
 I. Title
 770'.9'034 TR15
 ISBN 0-86092-055-0
 ISBN 0-86092-069-0 Pbk

Photograph on title page:
Rival Artists
Albert Azulay
1903

Set in Monotype Plantin and printed at
The Roundwood Press, Kineton, Warwick
Designed by Peter Guy

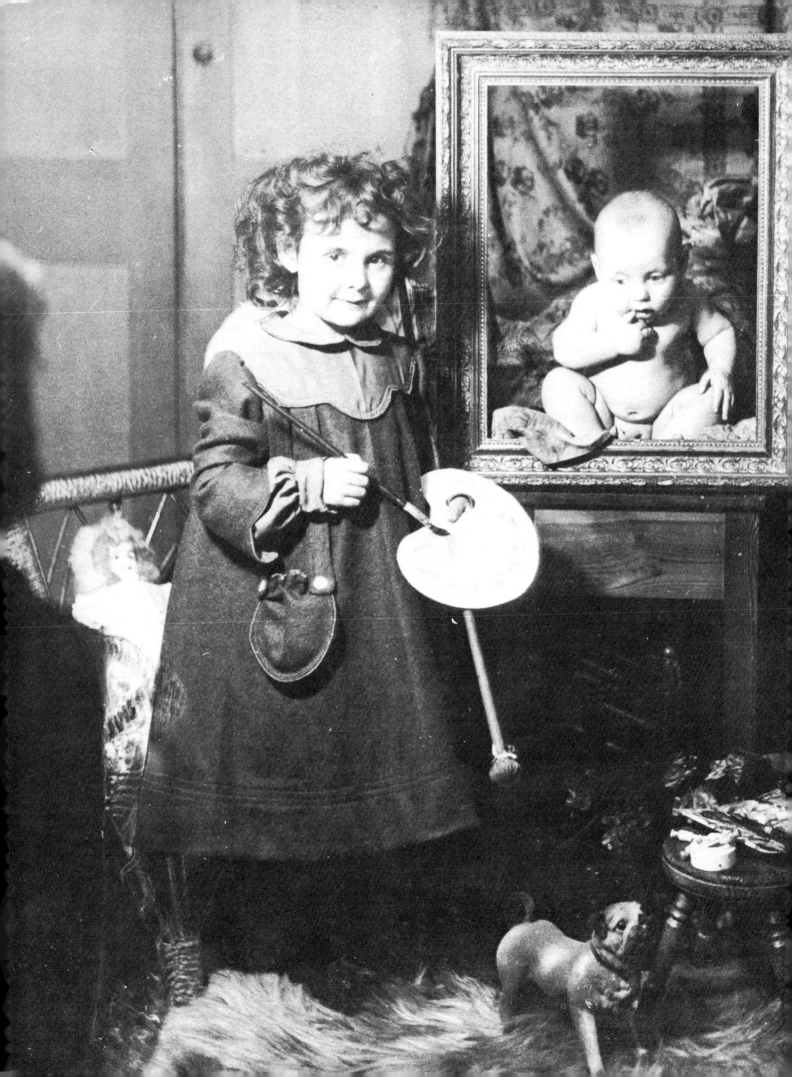

Contents

All the reproductions in this book – except those few otherwise indicated – are from photographs originally registered at Stationers' Hall to obtain protection under the Copyright Act of 1862. They are now in the care of the Public Record Office, and the references, which are listed at the end of the book, are to the class of papers identified as COPY 1. This consists of 'entry forms' which carry a description of the photograph to be entered into the register, along with other details, often accompanied by a print of the photograph. The descriptions had to be straightforward for legal reasons and were sometimes corrected or clarified by the clerk receiving the documents.

I would like to thank the Keeper of Public Records and his staff for the help they have given and the kindness they have shown me during the years I have worked on the copyright records at Chancery Lane and Ashridge.

Since prints were kept for reference and not for exhibition, their condition was not of great importance, though some were of a surprisingly high quality. Some, however, were folded, creased, or even holed. Inevitably, a few reproductions in the book show evidence of the imperfect state of the originals.

d. each.

f Art) Act.)

THE REGISTERING OFFICER APPOINTED BY THE STATIONERS' CO

I, George Bernard Sha don W.C. ,

do hereby certify, That I am entitled to the Copyright a Memorandum of

such Copyright [or, the Assignment of such Copyright] yright in Paintings,

Drawings, and Photographs, kept at Stationers' Hall, acc n.)

Description of Work.			ent	Name and Place of Abode of Proprietor of Copyright.	Name and Place of Abode of Author of Work.
Photograph Portrait of George Bernard Shaw, dramatic author. a face, talking too right hand up to face				George Bernard Shaw 10 Adelphi Terrace London W.C.	George Bernard Shaw 10 Adelphi Terrace London W.C

Dated this fourth day of

(Signed) George Bernard Shaw.

N.B.—In filling up the first column the description should commence thus: " Painting," " Drawing," or " Photograph," as the case may be. All names in the third, fourth, and fifth columns to be written in full.

In all cases where a Painting, Drawing, or Negative of a Photograph is transferred for the first time by the owner to any other person, the Copyright will cease to exist, unless *at or before the time of such transfer* an agreement in writing be signed by the transferee reserving the Copyright to the owner, or by the owner transferring the Copyright to the transferee, as may be the intention of the parties ; and the date of such agreement and the names of the parties thereto must be inserted above, or registration will be no protection.

The second and third columns are only to be used when there is a written agreement or assignment.

Pictures are the books of the unlearned
THOMAS FULLER, 1662

ILLUSTRATED BOOKS AND NEWSPAPERS

Discourse was deemed Man's noblest attribute,
And written words the glory of his hand;
Then followed Printing with enlarged command
For thought – dominion vast and absolute
For spreading truth, and making love expand.
Now prose and verse, sunk into disrepute
Must lacquey a dumb Art that best can suit
The taste of this once-intellectual Land.
A backward movement surely have we here,
From manhood – back to childhood; for the age –
Back towards caverned life's first rude career.
Avaunt this vile abuse of pictured page!
Must eyes be all-in-all, the tongue and ear
Nothing? Heaven keep us from a lower stage!

WILLIAM WORDSWORTH, 1846

For everything for which art, so-called, has hitherto been the means but not the end, photography is the allotted agent – for all that requires mere manual correctness, and mere manual slavery, without any employment of the artistic feeling, she is the proper and therefore the perfect medium. She is made for the present age, in which the desire for art resides in a small minority, but the craving, or rather necessity for cheap, prompt, and correct facts in the public at large. Photography is the purveyor of such knowledge to the world . . . of facts which are neither the province of art nor of description, but of that new form of communication between man and man – neither letter, message, nor picture – which now happily fills up the space between them.

ELIZABETH, LADY EASTLAKE, 1857

Poetry and progress are two ambitious creatures who hate each other instinctively. And when they meet on the same road one of the two must give way to the other. If photography is allowed to stand in for art in some of its functions it will soon supplant or corrupt it completely thanks to the natural support it will find in the stupidity of the multitude. It must return to its real task, which is to be the servant of the sciences and of the arts, but the very humble servant, like printing and shorthand which have neither created nor supplanted literature.

CHARLES BAUDELAIRE, 1859

Pictures, even extremely poor ones, have invariably some measure of attraction. The savage knows no other way to perpetuate the history of his race; the most highly civilized has selected this method as being the most quickly and generally comprehensible. Owing, therefore, to the universal interest in pictures and the almost universal desire to produce them, the placing in the hands of the general public a means of making pictures with but little labor and requiring less knowledge has of necessity been followed by the production of millions of photographs. It is due to this fatal facility that photography as a picture-making medium has fallen into disrepute in so many quarters.

ALFRED STIEGLITZ, 1899

If you cannot see at a glance that the old game is up, that the camera has hopelessly beaten the pencil and paintbrush as an instrument of artistic representation, then you will never make a true critic : you are only, like most critics, a picture fancier.

GEORGE BERNARD SHAW, 1901

Photographs have the kind of authority over imagination today, which the printed word had yesterday, and the spoken word before that.

WALTER LIPPMANN, 1922

It has been rightly said that people unable to master the camera will soon be considered the equivalent of illiterate.

FRANZ ROH, 1929

Individualists of 1930 shudder at the thought that everybody will soon photograph.

The same shudder people might have felt about 1630 at the thought that soon everybody would learn to write, and thereby hold fast their experience, instead of this being reserved for those exclusively who have things of importance to say. With great calmness history passes over such resentment.

FRANZ ROH, 1930

Earlier much futile thought had been devoted to the question of whether photography is an art. The primary question – whether the very invention of photography had not transformed the entire nature of art – was not raised.

WALTER BENJAMIN, 1936

Printing upset the balance of oral and written speech: photography upset the balance of ear and eye.

MARSHALL MCLUHAN, 1970

Seeing Through Photographs

The View from the Darkroom

The least worthwhile question to ask about photography is whether or not it is an art. What has happened is that it has taken over most of the functions of what are called the *fine arts*. Photographs now provide us with the most accurate mirror in which we can see our present society reflected. Photography now offers the most reliable visual index to our culture.

Within living memory cultural forms have been reshaped beyond recognition – if you refer only to the old plans. To conservative members of the cultural establishment it must seem that the monkeys have taken over the zoo. 'Commercialism' is usually identified as the monster which has brought the catastrophe upon us, and extraordinary theories have been worked up to explain away the prominence of popular culture – theories which try to demonstrate that popular culture was subverted, commercialised and fatally compromised at some vague date after the age of morris dancing and *hey nonny no*. Disco dancing and rock music are not worth consideration as anything but the mindless entertainment of the masses because of the inverse square law of official culture: the more widespread the appreciation and enjoyment of any activity, the further away it must be from Art.

Like the countryman in the joke giving directions to a passing motorist who thought carefully and then advised 'Well, sir, if I were you I wouldn't start from here . . .', let me say that the best place to look for modern art is not in the art galleries. You won't find the creative genius of the twentieth century in those cultural warehouses. Modern culture is all around you – on television, on billboards, on record sleeves, in garages, in newsagents, in fast-food take-aways, and in all the *wrong* places. The art pundits and arbiters of taste wander through the modern world like tourists lost in London with only maps of nineteenth-century Paris to guide them. How can the image-blitz of illustrated advertisements in the stations of the London Underground have anything to do with the art they know and love? How can they relate their precious gems of culture, these quintessences of the human spirit, to a ten-foot high reproduction of a colour photograph of a glamorous model advertising tights? The simple answer is that they cannot without the whole of the Temple of Culture coming tumbling down.

Photography has exploded visual culture not by destroying the old edifices, but by carrying representation into every corner of modern life. No system of art criticism based upon minority, élite interests can cope with this proliferation of images. To those clutching grimly at the old truths, this appears to be a world fragmented and gone crazy. It must seem that the safest thing to do is to close the door of the Temple of Art against chaos and dream of an end to the new Dark Ages. But the darkness is inside the Temple and the sunlight outside.

A new start has to be made to cope with the flood tide of visual messages which threatens to engulf our understanding. The old rules won't work any longer. Using the tools of the old trade on these modern products simply makes you look like Charlie Chaplin in *The Pawnshop*, where he attacks an alarm clock with a tin-opener.

All the attempts made over the years to evaluate photography in terms of painting were doomed to failure. And to try to set up photography as an official sub-branch of the visual arts was simply to make it the Aunt Sally for anyone who wanted to let fly at it. What we should be looking for is understanding and not status. We need to understand what makes photography tick, and we don't want to use Charlie Chaplin's clock-mangler.

So forget about Wordsworth's bleating, Baudelaire's griping about 'the stupidity of the multitude' and Stieglitz's misguided *hauteur* – you can read what they have to say in the introductory quotations. Theirs is the resentment of the élite under threat. Like aristocrats in a revolution they cannot believe that their days are numbered, their way of life crumbling.

What we have to do is to try to come to terms with the complexities of a culture which asks both *Whither Poetry?* and *Who put the ram / In the ram-a-lam a-ding-dong?* We have to understand the processes which made a painting by the obscure artist Francis Barraud as well known as Leonardo da Vinci's *Mona Lisa*. Barraud painted his dog Nipper listening quizzically to the voice coming from the horn of a Victor Talking Machine and called the finished work *His Master's Voice*, and Nipper was immortalised as the mascot of HMV Records.

Nipper led the way forward to a future in which we can now see that word-based communication is becoming of secondary importance to image-based communication.

Is it true that one picture is worth a thousand words? Are pictures 'the books of the unlearned'? Most pictures we see are photographs, and it is by looking at photographs that we can get a better understanding of the problems involved in this fundamental change in the means by which we are now presented with information and ideas.

You can gain a lot from the opportunity of seeing photographs for the first time. First reactions may have to be modified later but the fact that the images

Success or Failure
Walter Muchamore
1906

[12]

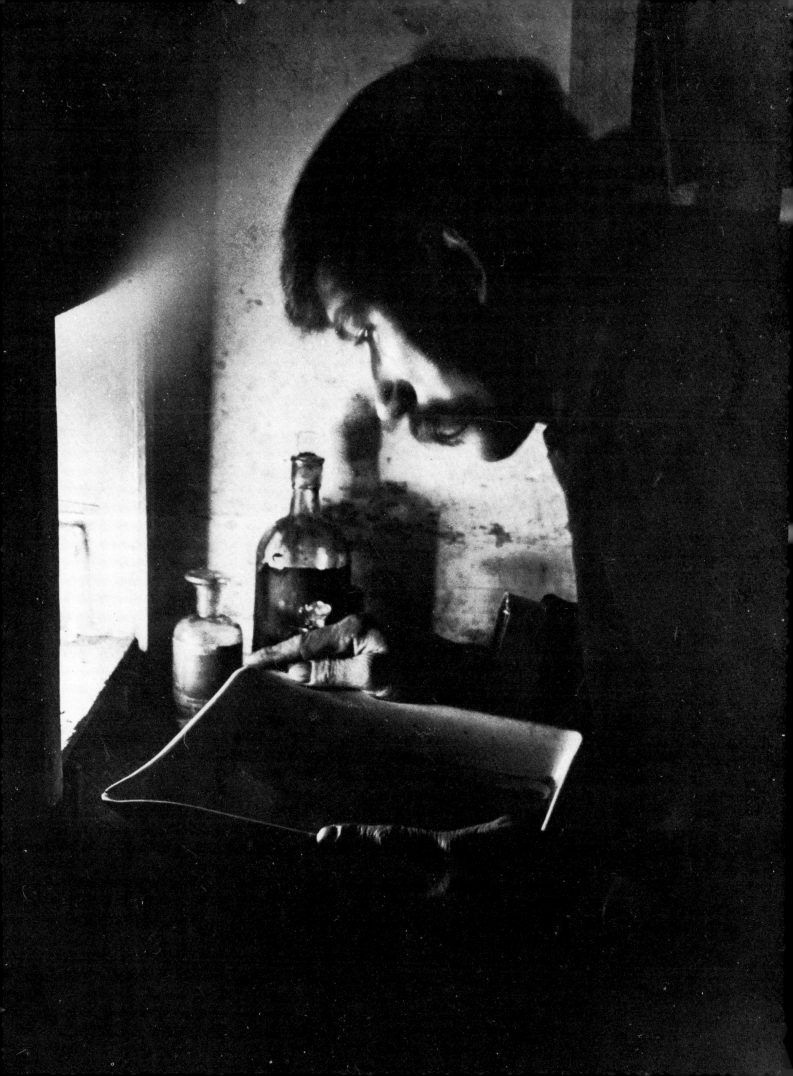

come to you fresh and unseen spurs you to look carefully at what is in front of you and to try to understand why the photographs are presented as they are. Almost invariably in photography there is interest both in the subject matter and in the way it is handled. By the time that certain photographs have been converted into 'masterpieces' by repeated reproduction in books promoting 'the art of photography', the eye tends to register their presence rather than evaluate their significance or examine the means by which they function and convey meaning.

Very few people will have seen any of the photographs in this book before – for many this is the first time they have been reproduced in any form this century. They cover a very wide range of what were becoming specialist areas of photography – news photography, glamour photography, advertising photography and so on. I have no wish to thrust all these photographs forward as 'masterpieces' of 'the art of photography'. Many of these photographs were taken for practical commercial reasons, and although I have made a careful selection of photographs to emphasize the vitality of this new medium and to foster an understanding of the incalculable number of purposes photographs have been used for, I don't even make the claim that these are all 'good' photographs. As Mae West said,

Goodness has nothing to do with it.

A Freak of Nature —
a lamb with two heads,
two tails, six legs and
eight feet
George Snidall
1910

The photographs in this book were all registered as copyright under the terms of The Fine Arts Copyright Act of 1862. Under modern laws the copyright of a book or a painting or a photograph is granted automatically. In the fifty years that The Fine Arts Copyright Act was in force, from 1862 until 1912, British photographs were only granted the protection of copyright law if they were entered in the registers at Stationers' Hall in London. That's why under many Victorian and Edwardian photographs you see the words *Copyright* or *Registered* or *Entered at Stationers' Hall*. You had to pay a small sum of money to register the photograph and you had to go to the trouble of dealing with the business of registration. This means that all these photographs were considered by their creators to be worthy of copyright and, for one reason or another, interesting and valuable. They have survived thanks to the legal demands of an Act long since forgotten, and they provide a fascinating cross-section of work which bears little relationship to the hierarchies of photography which have been established in recent years. It should be remembered, though, that this is my personal selection from over a quarter of a million photographs.

The Act gave copyright protection to paintings, drawings and photographs and there was considerable debate as to whether photographs should be included. There was also much criticism from opponents of photography, and it was later said that under the Act 'a mechanical abortion got the same protection as a work of high art that may have taken years to consummate'.[1] The Solicitor-General had steered the bill through the House of Commons in 1862 against objections that 'Photography [was] not a fine art, but a mechanical process'. He argued that 'although, strictly and technically speaking, a photograph [was] not in one sense to be treated as a work of fine art, yet very considerable expense [was] frequently incurred in obtaining good photographs.' He reminded Members of Parliament that photographers had travelled abroad in order to obtain a valuable series of photographs and had 'thus entailed upon themselves a large expenditure of time, labour, and money'. Such enterprise and endeavour deserved due protection under the law. Because the successor to the Great Exhibition of 1851 – the International Exhibition of 1862 – was about to be staged in London he stressed that it was important that the Act should be passed, 'otherwise foreign artists, who had a copyright in their own country in those works which we were most anxious to see in the Great Exhibition, must either withhold their contributions or expose themselves to the danger of having their rights invaded.'[2]

1862 was a year in which there were several opportunities to see how difficult people found it to classify photography. The Fine Arts Copyright Act became law, and in this photography rubbed shoulders with paintings and drawings. On the other hand at the International Exhibition in that same year photography was excluded from the fine art section and impassioned pleas were made to save photography from 'the comparative degradation of being mixed up with the last improvement in ploughs or cartwheels, or ships' tackle.'[3]

Photographers were touchy about their status and the public found it very difficult to know whether to think of them as tradesmen or as artists. The photographer Valentine Blanchard recalled that he had photographed just about every duke and duchess in the kingdom but that towards the end of his career 'he was asked to dine with the butler, and at times he was not even asked to dine at all, so greatly had photography fallen, even in his day.'[4] This confusion surfaced time and time again. Another photographer said that they were often received at the houses of the rich and famous 'very much the same as a plumber'. He added that: 'The people whose houses we visit do not know whether to shake our hand or to send us down to the kitchen for a glass of beer.'[5]

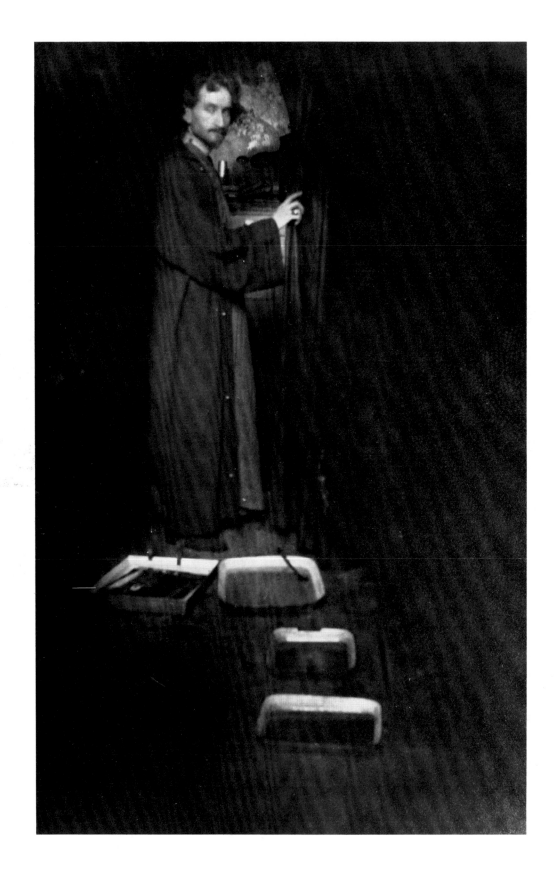

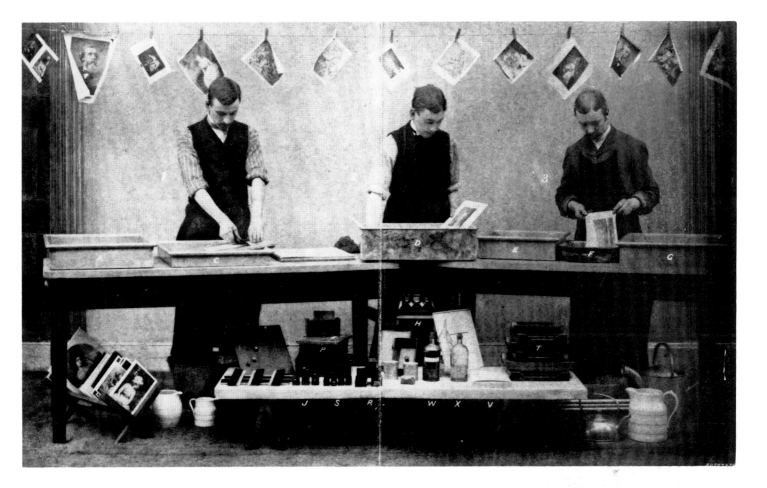

The photographs on these two pages show two very different aspects of photography. In the first the Boston aesthete and photographer Frederick Holland Day appears in his darkroom like the Merlin of photography, an alchemist with his magic potions, pausing for a moment in the midst of mighty and momentous labours. Let us use this image to characterise the ambitions of the photographers who wished to exploit the potential of photography as a medium of self-expression. The second shows darkroom workers employed by the Autotype Company who are developing, fixing and mounting prints. This presents us with a more representative image of the everyday work of commercial photographers whose ambition was not to produce art but to make money. Most photographs taken during the Victorian and Edwardian periods were taken by commercial photographers and most of them are not worth a second glance. But don't be deceived by the propaganda churned out over the years by 'art photographers'. Some commercial work reached a very high standard.

Oscar Gustaf Rejlander, one of the most lively, original and enthusiastic of Victorian photographers, who spent all his life searching for success and never found it, was once moved to comment with some bitterness 'when a man works not for money, he wants honour; and if he gets neither, why go on?'[6] Photography had few honours to offer, but if you were lucky and industrious you could make money. At the top end of the market when the Copyright Act came into force some photographers could charge anything from 100 to 250 guineas for giant photographic enlargements on canvas seven feet by four. These 'photographic portraits' were then overpainted.[7] At the popular end of the market a *carte-de-visite* portrait of the Queen with the baby Princess Royal on her back sold 300,000 copies.[8]

Autotype Printing in the 1890s

Fred Holland Day (in his London darkroom)
Alvin Langdon Coburn
1900

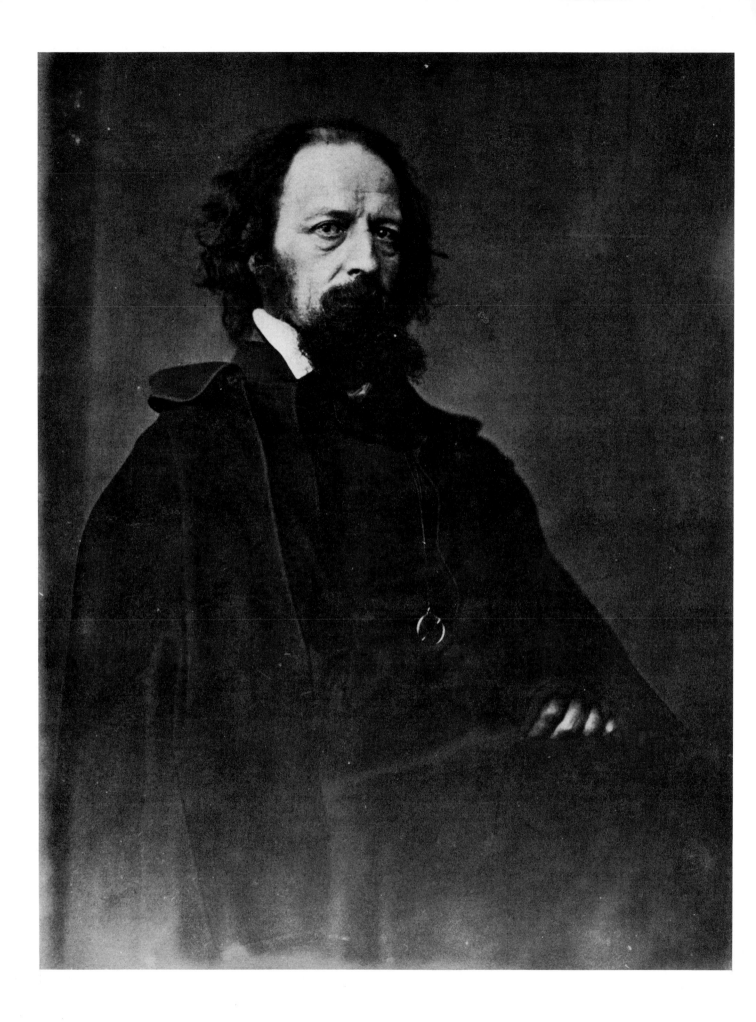

It was against the enormous volume of mediocre commercial photography that Julia Margaret Cameron liked to set her work. She was delighted when Alfred Tennyson said that he liked one of her photographs of him, a piece of heroic portraiture which he brought down to earth by calling the 'Dirty Monk'. In her fragment of reminiscences of her photographic activities which she called *Annals of My Glass House* Mrs Cameron recorded with pride that Tennyson had said 'that he likes it better than any photograph that has been taken of him *except* one by Mayall; that "except" speaks for itself. The comparison seems too comical.'[9] This portrait by Mayall, taken the year before Mrs Cameron's, is probably the portrait preferred by Tennyson. In her enthusiasm she does her best to discredit Mayall's work as that of a commercial hack, although I for one think that his is the more forceful portrait.

In the light of Mrs Cameron's ambition to achieve great things in photography it is interesting that an acquaintance recalled that: 'She had a notion that she was going to revolutionise photography, and make money.'[10] So although she insisted on the difference between her photographs and commercial work she was careful to copyright her photographs in order to derive whatever financial benefit she could from them. She made arrangements for The Autotype Company to make carbon prints from her pictures. So the photographic technicians seen at work on the Autotype production line would have made prints of Mrs Cameron's work, and would have made them much more skilfully than she was able to do herself.

When in 1912 a new Copyright Act came into force and the registration of photographs ended, the market for photographs had changed. There was by this time, for example, a huge market for picture postcards – a market which flourished when it became legal to send them through the post in the nineties. The veteran photographer William Downey recalled in 1907 that his firm had sold *two and a half million* postcards of a well-known beauty in eighteen months.[11] Most picture postcards which were not hand-drawn carried *reproductions* of photographs. For much of the nineteenth century if you bought a photograph you would have bought a photographic print whether the subject was the Queen of England or a view of Stratford-upon-Avon – an actual photograph from the original negative, or a copy negative. By 1897 another venerable photographer, H. P. Robinson, bewailed the fact that 'the photographers of today have been content to allow the grand trade to slip out of their hands into those of the printers and publishers.'[12] The half-tone process had made the mass-reproduction of photographs in newspapers and magazines both technically possible and cheap. The production of a woodblock for an illustrated magazine such as *The Illustrated London News* had been a long and laborious business. The first stage was to photograph the artist's drawing onto a solid slab of boxwood – in fact a composite slab held together by bolts. 'These bolts unscrewed, and twenty-four separate pieces of wood were the result – one containing nothing but sky, another sea, another a piece of a ship, another a sailor's head. Each piece went to a separate engraver, who worked all night upon it. One engraver had a special faculty for sky, another for the human face, another for housework, and so on. In any case, some twelve hours later the pieces were brought together, screwed up once more, and behold a wood-engraving – a double-page of the *Illustrated London News*.'[13] The cost of this labour-intensive process was estimated at £60.

By 1900 the craft of wood engraving was virtually dead because of the introduction of the half-tone process. This could provide a block ready for printing from an undeveloped photographic negative – a scoop by a newspaper photographer perhaps – in well under an hour by 1913, and the cost of producing a reproduction from a photograph by means of the half-tone process block had dropped dramatically to only £4.[14] The increase in the use of photographs for reproduction at the beginning of the century was massive. It was estimated that by 1909 newspapers and publishers were spending at least £500,000 per year on the purchase of photographs for publication.[15]

That's why the period covered by the old Copyright Act is so interesting. This was the time when crucial developments were taking place in photography which were to determine the future development of newspaper reporting, magazine publication, advertising and many other fields of mass communication.

Copyright Acts are only necessary when the possibility exists to reproduce material without permission, and when the opportunity is there to make large profits by mass-producing illegal copies. The long saga of the Copyright Acts is that of a constant battle against pirates – right from the time of the legislation of 1735 which became known as 'Hogarth's Act' because it tried to stop the pirating of Hogarth's engravings, through Victorian Acts covering lithography and photography, up to the present day when photocopying and video-recording are only two of the current threats to copyright holders. There is now pressure to change the law once again, and over the years the Copyright Acts are an accurate guide to the periodic upsurge of strident demands for justice prompted by the shock waves of successive leaps forward in the technology of mass reproduction.

It is not possible to claim that the work of any single photographer included in this book is 'typical'. Photography embraced far too many specialist activities for such a claim to mean anything. Certainly those who devoted their creative energies to 'art photography' and have since been promoted so that they are now the most famous photographers of their day are not typical of photographers in general.

Alfred Tennyson
J. J. E. Mayall
1864

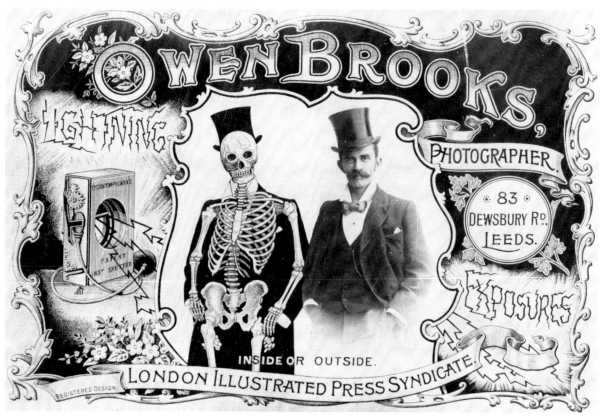

Advertisement
produced for his own
photographic business
Owen Brooks
1896

Here is a magnificent advertisement produced in
1896 by the Leeds photographer Owen Brooks, a man
from the ranks of commercial workers to set against
the P. H. Emersons and the Alfred Stieglitzes. It is a
brash and vivid celebration of the sheer energy and
enthusiasm with which some commercial photo-
graphers approached their work. There's Owen Brooks
looking rather flashily dressed in top hat and frock
coat, and to the left is the inner man revealed by the
newly-discovered process using Röntgen rays – or
what we now call X-rays. Owen Brooks was deter-
mined to appear an up-to-the-minute photographer
with the latest developments in photographic techno-
logy at his finger tips. In this inventive fake photo-
graph you can see not only his bones but also the
loose change in his pockets and his watch and key
chains. *Inside or Outside* not only refers to the fact
that we can see both Owen Brooks' outward appear-
ance and the inner man revealed thanks to a marvel
of science, it also means that he's prepared to go any-
where to take photographs either in studios or out-
doors. The *London Illustrated Press Syndicate* banner
indicates that he's in touch with the demands of the
mass media in the capital. On the left you can see a
Thornton Pickard instantaneous roller-blind shutter
which enables him to make *Lightning Exposures* –
I've no doubt he also knew how to use flash powder.

Here is a new hero of our time. A man whose job
is to be where the action is and to search out truth,
using all the technical means at his disposal to do it.
He works for money and has more concern for what
his clients and, more widely, for what the public
wants than for any ideal of art. Owen Brooks is one
of the men whose skills were to transform the way in
which the twentieth century saw itself. The modern

world sees itself through the eye of the camera and
not through the eye of the painter. At the Photographic
Convention in 1913 the President, F. J. Mortimer,
summed up the situation: 'Our fathers received other
men's impressions; they saw through other men's
eyes. We are enabled to see the real thing through the
lens of the camera.'[16] The future belonged to photo-
graphy and to enterprising men like Owen Brooks.

Many of the photographs in this book were taken
by men like him who adapted their work according
to the demands made upon them by the public or by
the publishers who employed them. If they were
lucky they made money. As a by-product of the
commercial process in which they were involved they
sometimes made what some people might get hold of
and praise as 'art'. But the art of the photographer
was strictly dependent upon the freedom which his
clients allowed him and the room for manoeuvre which
his photographic assignments offered. Photographers
had to be businessmen, and their deadlines and profit
margins ruled out for the most part any idea of photo-
graphic art which other men with more time on their
hands might enthuse over.

Gradually they realised that they held a key rôle
as professional communicators through their photo-
graphy. They didn't need to worry about the old rules
of art because photography had made those redundant.
Their task was to respond to the challenges and to
investigate the possibilities opened up by photography.
The photographs in this book provide examples of
the solutions they found to visual problems and the
discoveries they made as, little by little, the camera
taught them how to see and to record the world around
them with a freshness of vision which was unique to
photography.

One Picture is worth a Thousand Words

Photography has profoundly disturbed the balance between verbally and visually transmitted information. As early as 1857 that acute observer of the Victorian art world, Elizabeth, Lady Eastlake, had realised that photography provided 'facts which are neither the province of art nor of description, but of that new form of communication between man and man – neither letter, message, nor picture – which now happily fills up the space between them.'[1] Not only was photography providing a new medium of visual communication, it was doing so in a way that required no reference at all to the accepted conventions of art.

It was not until a few more years had passed, and photographers had begun to gain a better appreciation of the idiosyncrasies of their medium, that it was possible to see that the 'impartial evidence of facts' provided by photographs did not necessarily represent the Truth in all cases. Photographers soon realised that their problem was not to decide whether or not their cameras could or couldn't lie – they already knew some of the subtle ways in which they could. Their main problem has always been – and this might seem paradoxical to all those people who still staunchly believe that the camera is a machine which can be relied upon to show 'reality' truthfully – how to keep under control photography's fearful ability to distort, or to incriminate itself by remaining silent on vital matters.

'One picture is worth a thousand words' – a catch phrase which sprang from the age of the mass circulation picture newspaper and not from the lips of some ancient Chinese philosopher[2] – is both profoundly true and yet at the same time is no more than a hollow argument-stopper which does nothing to clarify why or in what circumstances this should be so. Photography cannot supplant words, but it almost invariably gains immensely in being supplemented by them. Like allies engaged in a battle against ignorance, they fight more effectively together than alone.

For various reasons this powerful alliance did not become effective for decades. In the same way that photography by its very existence forced a redefining of the nature and the boundaries of art, so it is gradually forcing a reappraisal and a reassessment of the whole problem of communicating with words. Basic questions are raised – what is best communicated verbally and what gains by being communicated visually. Outside the comparatively modern developments of sound film and television, the various stages towards enlightenment can be seen in the field of newspaper reporting.

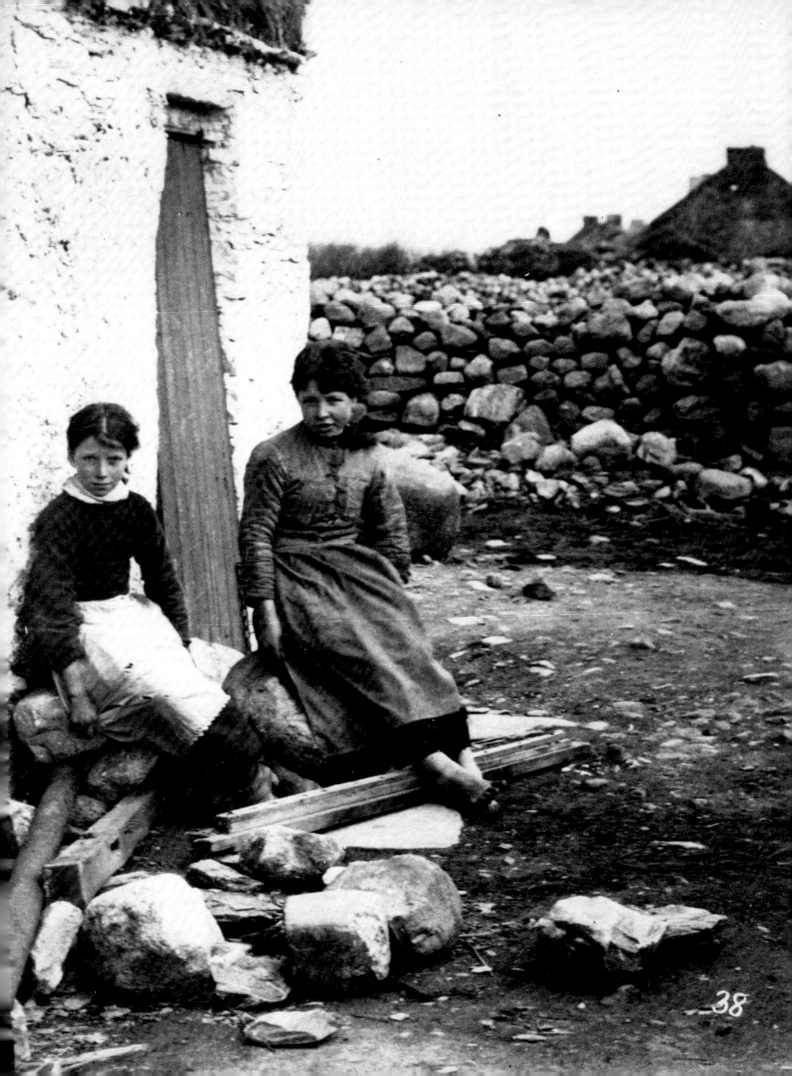

38

On the left is a photograph taken by Robert Banks in 1889. It shows two young girls, one without shoes, in creased and worn clothing which identifies them as poor. The setting is rural and clearly primitive – we can see what are probably crofters' cottages with stone walls built from huge stones. It could be in Scotland or in some remote part of the Balkans. We have little more visual information to go on. So let's invent another saying of Confucius: 'A photograph out of context is like a fish out of water.'

Well that gets us no further and we are still floundering – like those times when at family gatherings the photograph album is being used as a visual prompt book and the communal memory fails to come up with the appropriate identification tags. If we decide to call this 'Two bonny Yugoslav lassies at their cottage door' the tag doesn't fit too badly – thought it doesn't explain the stones and broken timber lying around.

The answer to this visual riddle does not bring instant enlightenment; the inscrutable does not immediately become the obvious. Even when the photograph gains a caption – Mr Banks tells us that his photograph shows *Two girls arrested at Drumnatinny, County Donegal, Ireland* – this revelation raises more questions than it answers. Who are they, why were they arrested, what had they done? The photograph presents us with uprooted visual facts, it does not explain. For an explanation we have to go back to contemporary newspaper accounts.[3]

The people of Donegal were starving in early 1889 because of a complete failure of the potato crop. Their local Member of Parliament, Mr Swift MacNeill, told of their plight in the Commons: 'The times were bad, and the Donegal peasantry had no money, and they were under the shadow of death because they could not obtain the means of living.'

In this 'most destitute' corner of Ireland the people lived for months on Indian meal. They had fallen into arrears with their rent and were evicted from their homes by 'Emergencymen' backed up by police and, where necessary, soldiers. When the M'Ginley and M'Gee families in Drumnatinny knew that the bailiffs were coming, they barricaded themselves inside their houses with large stones. Against opposition such as this the forces of law and order brought in crowbars and a battering-ram which, it was explained to a dumbfounded House of Commons, was a 'defensive' ram 'for protection'. The Emergencymen tried to break in through the end of the house. Bottles and boiling water cascaded down on them. Eventually they broke in through the roof and at the same time rushed the door, overpowering the M'Ginleys.

We then crossed the road to Anthony M'Gee's house, which was garrisoned by the tenant, his wife, and a girl, who had been in the garrison of one of the houses cleared on the previous day. John Houston headed the rush into this house, and was met with a can of boiling tar and water full in the face, which peeled off large patches of skin. The tenant and his accompanying viragos were remanded on bail till next Falcarragh Petty Sessions.[4]

They had nowhere to go, and so within a few days families broke back into the homes from which they had been forcibly evicted. Houston, the assistant bailiff, asked Charles M'Ginley what he was doing there. M'Ginley had tried to put together the semblance of a home – with a fire burning in the hearth and what sticks of furniture he could gather together – and he replied, with some dignity: 'I have come back to the walls that I built. It is better for me to die here than in the ditch.' Next day they came again, broke down his door, and arrested him along with a woman and several children. The houses were cleared and it was said in court that they would be levelled. Charles M'Ginley was given two months hard labour, and as the resident magistrates regarded the offence of Maggie M'Ginley – the young girl who had scalded the bailiff's face and neck – as being very grave, she also was sent to prison, along with Bridget M'Gee, for two months.

So these two little girls who look towards the camera are perhaps two of the 'viragos' who defended their homes. These are the victims of what was described at the time as 'a policy of extermination' and 'a kind of white terror'. They are homeless. They are near starvation. The photograph explains none of this. Like the tip of an iceberg, what you see is only part of a much larger whole which is hidden from view.

To complain of this is simply to misunderstand the nature of the problem. The problem is not that the photograph lies, but that it is mute. It has an immediacy which is enhanced by a knowledge of what these girls have experienced. In order to understand fully why a photograph looks as it does, or indeed was taken at all, you need to know the context from which it may well have been torn, and also the photographer's motive for taking it. In this case Robert Banks seems to have been travelling with a Gladstonian Liberal deputation from Manchester, and recorded several scenes at which violent action had taken place. What use he was able to make of these 'on the spot' records I don't know. It would still have been comparatively difficult to print photographs in *The Donegal Independent* in 1889, even if Sam Trimble at the printing press in Ballyshannon had taken the historic decision to break into those regular columns of type which made up his broadsheet newspaper.

One final point about this photograph. It is not particularly striking, and yet in saying that I realise how selfish and perverse it is to demand a 'good' photograph out of an appalling situation. In some of his other shots Banks kept clear of the action and could have done with the advice later offered by the modern war photographer Robert Capa: 'If your pictures aren't good, you're not close enough.' But these days we're spoilt, and would expect to see Maggie M'Ginley actually hurl the boiling tar and water in the bailiff's face. Here we have to accept these two girls as token victims of an inhuman state of affairs, and this can only be appreciated when words are used to explain the image.

Photograph taken by Robert Banks in 1889

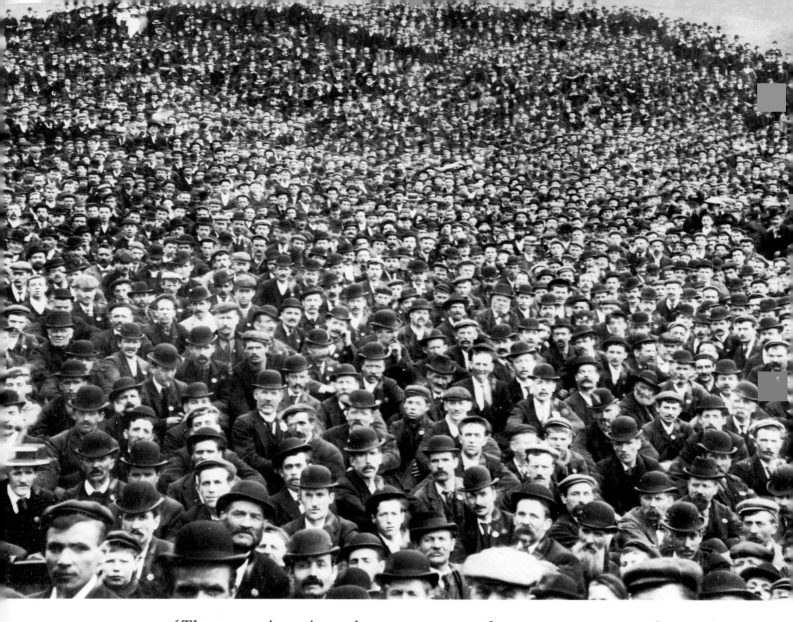

'*The camera is getting to be as necessary to the newspaper correspondent as the pen.*'
George Eastman, 1885.

The photograph above was taken in 1899 by John Powell of Penygraig, Glamorgan and is captioned *Mass meeting of colliers at Porth*. Again, it is possible to attempt to deduce meanings from the photograph without knowing the circumstances which produced the scene shown. Thousands of men – a sea of heads packed into the frame of the photograph – are looking directly towards the camera. They are working men but each is dressed in his best clothes and wears a badge on his left lapel. The men are orderly and serious, and the occasion is clearly of special significance. This photograph is not mute like that of the Drumnatinny girls, and it carries visual meanings which are conveyed forcefully – *solidarity, unity is strength*.

The occasion is a Demonstration at Porth, the first held by the South Wales Miners' Federation, which had been formed a few months previously. And it is the badge of the S.W.M.F. which identifies them as members of the union.

In the spring and summer of 1898 the Welsh miners had endured a five-month lock-out in an attempt to break the system of payment based on a Sliding-Scale Agreement linking their wages to the selling price of coal, and thus to achieve higher wage rates.

The miners were not unionised and had no strike funds. As the lock-out dragged on into a second and then a third and a fourth month, the miners and their families were going hungry. Keir Hardie ran a headline in the *Labour Leader*: STARVING WALES. *Men Fighting Gallantly and in Good Spirit, but the Wolf is Showing his Fangs.*[5] Many men went away 'on tramp' looking for work. The women had to sell household goods to the pawnbrokers to buy food.

First pictures and ornaments, then the furniture, then the bedstead and clothes. As a local M.P. told the Commons: 'A glance inside some of the houses shows how far this sort of work has gone, for there is nothing to be seen but the bare walls.' The miners' lack of organisation had given them no chance against the united front presented by the masters. In September, after five months, the miners gave in. Although they were far from unanimous in the vote which committed them to accept the employers' terms, they returned to work defeated. But they had learned their lesson in the bitter fight against the coal-owners, and the next month saw the formation of the South Wales Miners' Federation. By the time this photograph was taken, 100,000 men had joined.

On 5 July 1899 – Labour Day – 20,000 men gathered at Porth to hear their leaders speak. It seems likely that the photographer took his picture from the speakers' platform. The following week's issue of *The Pontypridd & Rhondda Valleys Weekly Post* carried an editorial article on the gathering which is extraordinary in the way in which it provides a verbal parallel to the photograph:

The Miners' Demonstration on Wednesday was very significant and imposing. It was significant because it expressed in a clear and unmistakable manner that the division in the ranks of the Colliers had been healed, and today they are a united mass. This reads strength and power to maintain the principles which they have laid down as the dominant ruling in all future actions. It was imposing because of the numbers, and reflected the result of the marvellously quick growth of the new organisation. Acknowledgement of an opponent's strength is the best deterrent to provocation of conflict. We have no hesitation in pronouncing that the late strike was precipitated by the owners in the delusive belief that the men, who were at that time wretchedly disorganised and divided, would fail in that stamina of prolonged resistance. We know now how tenaciously the men fought, and at what painful sacrifice of physical endurance. The demonstration of Wednesday also was a model of orderly display of force and power. We congratulate the miners and their leaders on the dignity and decorum of the whole of the proceedings. In point of appearance also, it was a demonstration which indicated that the Welsh collier in his majority force is a man moved by personal self-respecting consideration. It was not a procession of stragglers. Almost to a man we saw the good artizan standard of dress, the calm reflective resolute man who has grasped the depth of power in the golden maxim of unity is strength, and means by peaceful intellectual means to stand by those principles as the only means of elevating and bettering his condition in the social life of the country.[6]

Once again, no photograph was used to illustrate the scene at Porth.

If this photograph had been used, it is clear how the 'facts' of the photograph would have linked with and reinforced the comments in this editorial article. The photograph alone cannot provide us with the details necessary to give us a full understanding of why these men came together as they did. The article alone cannot convey the impressiveness and dignity of the gathering as it appeared on the day. It is one thing to be told that 20,000 people were present. It is quite another to see for yourself in John Powell's memorable photograph such a huge mass of men carpeting the very landscape right over to the horizon – each man an individual but also part of a larger whole – a great tidal wave of humanity carrying on its crest comrades united in common purpose with a collective power as sure and as mighty as a force of nature.

The future of illustrated journalism it is not easy to forecast. Will the public get tired of photographs? I think not – while they are able to convey with such intense reality many of the incidents of the hour.

This was the opinion of Clement Shorter, who was on the editorial staff of *The Illustrated London News*, in 1899.[7] Before journalists working on illustrated magazines and newspapers could come to grips with the problems of using photographs, there were technical problems to be overcome.

Newspapers consisting of text only could be printed about twenty times faster than those carrying illustrations. The *Daily Graphic*, first published in 1890, was by the turn of the century carrying in each issue eight or ten pen-and-ink drawings and three or four half-tone reproductions from photographs. But it could be printed at the rate of only 10,000 an hour. Arkas Sapt was the man who made the breakthrough which led to the meteoric rise of the *Daily Mirror*, which first appeared on the streets in 1903, having been produced on high-speed rotary presses which were able to print picture pages at the rate of 24,000 copies an hour. With the issue of 7 January 1904 it became the world's first daily newspaper to be illustrated exclusively with photographs, and within a year sales of the *Daily Mirror* were around 290,000 copies a day.[8]

The man who did most to promote and to develop photo-journalism in these early days was Hannen Swaffer, Fleet Street's first art editor, who worked for the *Mirror* from 1904 until 1913. James Jarché, one of the first press photographers, wrote that it was Swaffer who 'really started picture editing' and 'did more for press photography than any man living': 'He raised it from a humble trade and put it among the arts, making it an integral part, and not the smallest part either, of the modern newspaper.'[9] At a time when others found it difficult to see photographs as anything but illustrations with only a minor part to play or, like Northcliffe, as necessary trimmings to a modern-style newspaper, Swaffer firmly believed that a photograph with a dramatic caption was the equivalent of a descriptive article.

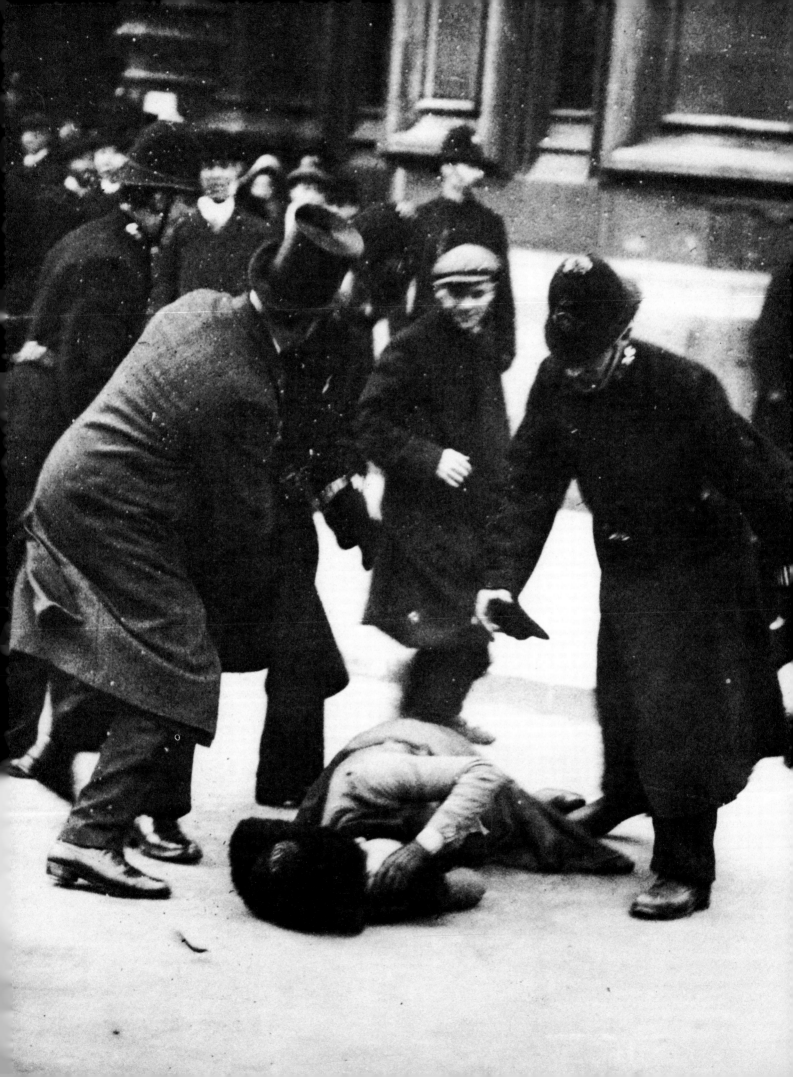

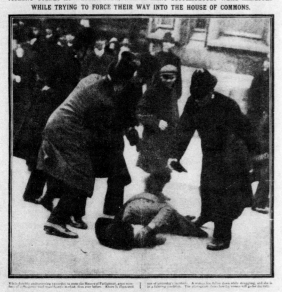

The Daily Mirror

THE MORNING JOURNAL WITH THE SECOND LARGEST NET SALE

No. 2,205. SATURDAY, NOVEMBER 19, 1910 One Halfpenny.

VIOLENT SCENES AT WESTMINSTER, WHERE MANY SUFFRAGETTES WERE ARRESTED
WHILE TRYING TO FORCE THEIR WAY INTO THE HOUSE OF COMMONS.

Here is a front-page story produced in 1910 – the heyday of Swaffer as art editor at the *Mirror*. On the left is the original photograph taken by 'Victor Consul' (this is almost certainly a mis-spelling of Consolé – Victor and Armando Consolé were both press photographers who worked with Swaffer) which was registered as copyright by London News Agency Photos Ltd. Above is how Swaffer splashed it across the front page of the *Daily Mirror*. The picture boldly dominates the page. Above it Swaffer placed the headline:

VIOLENT SCENES AT WESTMINSTER, WHERE
MANY SUFFRAGETTES WERE ARRESTED, WHILE
TRYING TO FORCE THEIR WAY INTO THE
HOUSE OF COMMONS

The caption beneath it, which completes the front page, reads:

While forcibly endeavouring yesterday to enter the Houses of Parliament, great numbers of suffragettes used more frantic methods than ever before. Above is illustrated one of yesterday's incidents. A woman has fallen down while struggling, and she is in a fainting condition. The photograph shows how far women will go for the vote.[10]

Swaffer's front-page package of information consists of one photograph and 73 words.

In order to be able to present the news in this way, Swaffer had to have a forceful, striking photograph – the photographer had to be there close-in at the right spot at the right moment. The *Mirror* photographer must have known he had an exceptional photograph, which was why care was taken to register it as copyright. Another photographer was also on the scene, and his work was used that same day as part of a double-page picture-spread in the *Daily Sketch* – rival to the *Daily Mirror*. He had been standing

slightly to the left of the other cameraman and took a picture of the same incident only a split second later. The dynamic action seen from one angle – the shot used in the *Mirror* – shows clearly a fast-moving swirl of bodies frozen at a crucial moment. The policemen, the man in the top hat, the woman lying on the ground, and the youth looking on in the background are all isolated and expressively poised, like characters in a staged drama acting out their parts. The *Sketch* photograph loses the detail and the action against the chaos of the crowd. The *Mirror* picture made the front page. The *Sketch* photograph was reproduced on a much smaller scale on the inside pages, with the unassertive, bland caption: 'An unpleasant incident – a woman lying in the mud'.

Both newspapers carried written accounts of that day's events and sequences of photographs showing scenes of arrests and suffragettes struggling in the grip of the police. Mrs Pankhurst had led a deputation of over 300 women members of the Women's Social and Political Union towards the House of Commons to protest about delays in passing legislation which would have given women the vote. They tried to push past the police who stood between them and their goal, and for several hours Parliament Square was filled with 'a turbulent mass of men and women and police'. Some of the police on duty had been drafted in from the East End of London and were not used to any velvet-glove tactics, women or not. They reacted with a firmness which the militant suffragettes had not experienced before. Women were pushed, kicked and, it was alleged, indecently assaulted. One suffragette reported seeing another assaulted by a policeman who broke the bamboo pole of her banner across the woman's shoulder: 'Some of the language used by the policemen was beyond description. One gripped me by the thigh, and I demanded that he should cease doing such a hateful action to a woman. He said, "Oh, my old dear, I can grip you wherever I like today".'[11] Women had their noses punched and their breasts twisted and bruised.

At the height of the violence, Sylvia Pankhurst arrived in a taxi with Annie Kenney:

Finding it unbearable thus to watch other women knocked about, with a violence more than common even on such occasions, we jumped out of the taxi, but soon returned to it, for policemen in uniform and plain clothes struck us in the chest, seized us by the arms and flung us to the ground. This was the common experience. I saw Ada Wright knocked down a dozen times in succession. A tall man with a silk hat fought to protect her as she lay on the ground, but a group of policemen thrust him away, seized her again, hurled her into the crowd and felled her again as she turned. Later I saw her lying against the wall of the House of Lords, with a group of anxious women kneeling round her.[12]

This was the scene recorded by the *Daily Mirror* photographer. Eventually 115 women and three men were arrested, and the day went down in suffragist history as Black Friday.

The suffragettes had been careful to court the press over the years. As early as 1906 they had won over

Taken by 'Victor Consul' (almost certainly Victor Consolé) during the demonstration which took place on 'Black Friday' — 18 November 1910

The front page of *The Daily Mirror* for Saturday 19 November 1910.

[27]

Bernard Alfieri who provided photographs for the *Mirror* and subsequently publicised their cause in the paper. Hannen Swaffer sympathised with the suffragettes; he knew their leaders and even dreamed up publicity stunts for them.[13] Perhaps at the back of his mind was the thought that this might give him the edge on his rivals in the struggle to get exclusive pictures. That might sound cynical, but the suffragettes knew the nature of the game they were playing as well, and the publicity value of the newspaper coverage of the Black Friday battles kept their cause as – quite literally – front page news.

Even before he splashed the *Mirror* picture across page one, Swaffer knew that he had a photograph which might well have a key rôle to play in the row which was bound to break out over the unprecedented violence. A few hours after the incident a representative of the *Daily Mirror* had shown a copy of the photograph to Sir Edward Henry, the Chief Commissioner of Police. The *Mirror* next morning carried both the photograph and the police chief's response:

Through his secretary, Sir Edward expressed the opinion . . . that he thought from the smiling expression of a boy seen in the background, and from the fact that there was not a dense crowd round the police, that the woman had simply sunk to the ground exhausted with struggling against the police.

The superintendent of the division presumably concerned had been asked for his explanation, which would no doubt remove all possibility of suggestion that the woman had been pushed down.

Swaffer's instincts as a newspaperman were proved reliable, and a storm broke.

The Vice-President of the Royal College of Surgeons wrote to the editor of the *Mirror* that, contrary to what he had printed in a leading article, the police had *not* 'displayed great good temper and tact' on that occasion. According to him: 'The women were treated with the greatest brutality. They were pushed about in all directions and thrown down by the police. . . . I was there myself and saw many of these things done.' Then he added, significantly: 'The photographs

that were published in your issue of November 19 prove it.'

The *Mirror* had by this time managed to identify the lady on the ground who had appeared on the front page as Miss Ada Wright. Under the heading ARRESTED WOMAN'S VIEW, she told her story:

'This was my fourth arrest,' said Miss Wright to *The Daily Mirror* yesterday at Caxton Hall. 'I have been in seven demonstrations, but I have never known the police so violent.

'There are bruises all over me. I was knocked about like a football from 1.20 p.m. to 5.40 p.m.'

After that it was just a matter of sitting back and letting irate correspondents fire off salvoes of words at one another. 'Hitherto the police have been friends of women, but on that black Friday they completely lost their heads' – from one side. 'Militant suffragettes are a disgrace to our land, but London police are a credit to the city' – from the other.

The photographs of the girls at Drumnatinny and of the Welsh miners were never thrust into the public's field of vision in this manner. No irate letters were written about the jailing of Maggie M'Ginley. The *Daily Mirror* photograph was reproduced on the front of each of the 750,000 or so copies printed that day. Any newspaper with such a large circulation wields incalculable power in shaping public attitudes. Because Hannen Swaffer seemed to have an almost instinctive understanding of how photographs could best function in a newspaper and because he held the key position of picture editor – a job which he invented – on the *Daily Mirror*, he was in a unique position to investigate and develop the powers of photojournalism. Better than anyone else of his day, he understood how photographs could be made to work in alliance with words. Looking back, he once reflected: 'I always contend that I created the art of caption-writing, and it died with me; they have no idea of it now. I would see a picture and the caption as one thing. To me they were one. Nowadays they put a picture anywhere and write something underneath.'[14]

Get Pictures!

This is a news photograph – a photograph about news being made.

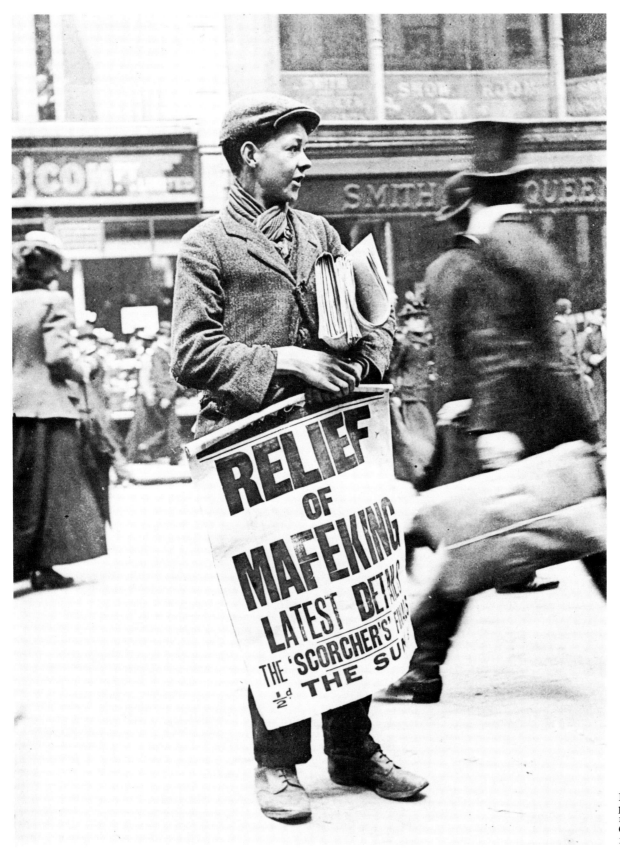

Boy selling news-
papers proclaiming the
relief of Mafeking
Carlton Roberts
1900

The newspaper boy has become the triumphant herald of good news sharply defined against the blurring swirl of city life. The news he carries made Londoners take to the streets in celebration. Ragged though his jacket is, he seems to dominate the scene heroically. The photograph has been taken close-in by Carlton Roberts, and he gives the boy stature by shooting from below: the camera is held at waist level. Everything but the newsboy is deliberately thrown out of focus; the man on the right who turns his head away is striding along so quickly that he blurs and merges with the man behind him. In front of this fast-moving frieze of city life stands the boy displaying his message to Londoners – Mafeking has been relieved. In the absence of news photographs from the front, this newsboy has himself become the symbol of the great event – the means whereby the news reached Londoners. No other photographs were available to satisfy public demand.[1]

At 11.35 a.m. on 18 May 1900 a telegram was sent from Pretoria, the capital of the Transvaal, which read MAFEKING HAS BEEN RELIEVED. FOOD HAS ENTERED THE GARRISON. ENEMY DISPERSED. REUTER. The message was received in the London office of Reuter's at 9.17 p.m. the same day and triggered off wild celebrations in the capital. To use the new word coined for the occasion, all London was Mafficking. By 11 p.m. newsboys were rushing, shouting, into the streets of the West End carrying special 'war editions' of halfpenny evening newspapers and selling them for twopence a copy. That night the engine drivers on the late trains out of London sounded their whistles as they passed through villages to spread the good news.[2]

But there were no photographs from Mafeking. The report of the *Times* correspondent inside the garrison took over a month to come through. When photographs did arrive the news story had grown cold, and in any case there was nothing to match the emotions and release of tension of the night that the news came in.

The Boer War coincided with a great expansion in the use of photographs for illustrations and in the number of illustrated journals published. The public wanted action pictures but were no longer prepared to accept derring-do cobbled together in the London studios of artists far from the front line: 'The public want the facts as near as may be, and are too deeply stirred to be put off with melodrama. The *Charge of the Lancers*, done (in St John's Wood) with a fine artistic instinct, has no chance against the much more prosaic picture by the photographer, *The Black Watch Advancing in Open Order at Magersfontein*.'[3]

If possible the public wanted to see everything at the instant it actually happened. Another commentator noted the public's appetite for 'strongly spiced meat' in press photography: 'The unhappy sailor must be half way down the shark's throat, as it were, the bodies of the victims of an explosion be shown in mid air, the colliding trains in the actual smash, the wrecked vessel in the act of striking upon the reef or breaking in two.'[4] There are examples elsewhere in this book where photographers, through a combination of skill and luck, have produced pictures which satisfy this public appetite.

In order to extend the range of their skills and make possible photographs which ordinary cameras couldn't take, press photographers began to use special equipment such as magnesium powder flash and the newly-developed telephoto lenses. Extending their luck was more difficult; that involved a sharp eye and an acute sense of timing – as well as being in the right place. As early as 1891 Major J. Fortune Nott had anticipated Cartier-Bresson's idea of the decisive moment. If such moments are captured, he said, the resulting photographs will speak for themselves: 'But if the moments are lost, or any indecision is allowed to cloud the judgement, or even in the event of too hasty action, then the opportunity is gone like a flash. It has passed and cannot be recalled.'[5]

Press photographers went to extraordinary lengths to get the pictures they wanted. To get a shot of the Kaiser arriving at Portsmouth in 1907 a cameraman crawled under the engine and advanced on his prey indian-style under the carriages before the guard caught him. Others leapt out in front of tramcars, and set off their flash with explosive and smoky results. The photograph opposite shows a photographer who has balanced himself and his huge whole-plate camera precariously above the heads of the crowd with the shutter of his dark slide drawn back ready to photograph Earl Brownlow opening the Public Library in Stamford. It was said that the motto of the freelance press photographers was 'Get pictures by legitimate means if possible, but get pictures.'[6]

The opening of Stamford Public Library by Earl Brownlow
Raoul Moore
1906

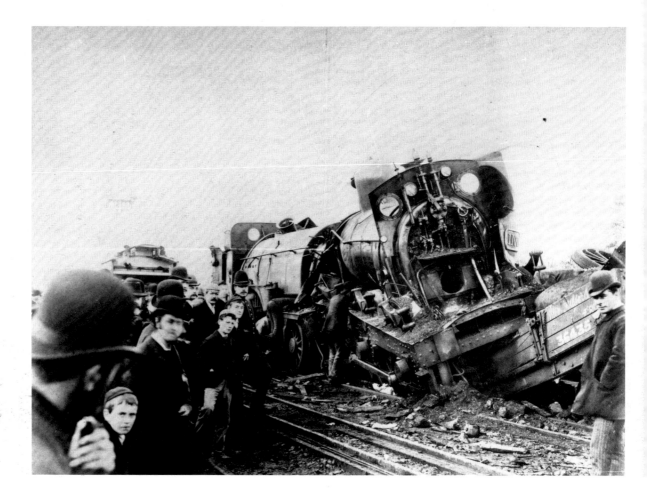

Railway Collision at
Norton Fitzwarren
Albert Petherick
1890

Before the national newspapers appointed their own staff photographers it was local photographers and amateurs up and down the country who had to be relied upon to provide pictures for the Press. In 1908 Hannen Swaffer complained that these photographers did not grasp the opportunities which presented themselves to them:

A railway disaster occurs in an important town; there are, say, four professional studios and forty or fifty amateurs in that town, but not one of the whole company can grasp the fact that there is a newspaper market for views of the disaster. The editor must race his men off in a special train for any remainders of good views.[7]

But there were some local photographers who hurried to the scene of disasters either for profit by selling their prints, or merely to record the event for posterity. This photograph was taken by Albert Petherick of Taunton of the head-on collision on the Great Western Railway's main line nearby at Norton Fitzwarren. Ten people had died in the crash which occurred at 1.30 in the morning.

A disaster on a smaller scale was recorded by Joseph Readman when two horses took fright and plunged off Beggar's Bridge near Whitby. The strangled horse hangs in its harness – an unnatural sight like a terrible omen.

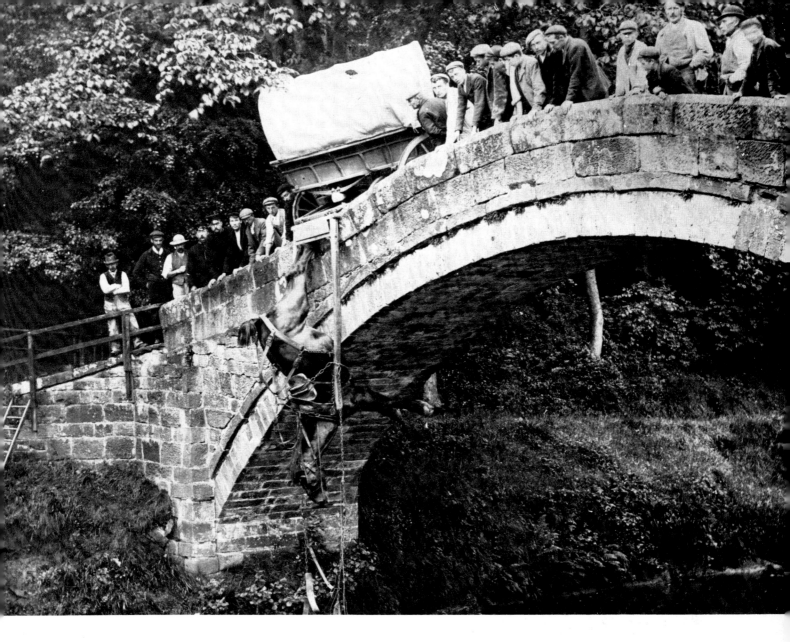

Serious Accident at Beggar's Bridge

On Saturday morning, a farmer and carrier, named Francis Bland, who resides at Glaisdale, was proceeding to Whitby Market, as usual, with a waggon and two horses, when, on crossing Beggar's Bridge about a quarter to six o'clock the first horse, which was being led by Mr Bland, suddenly took fright and rolled over the parapet into the river below, pulling the shaft horse after it. Fortunately, Police-constables Harrison and Parker happened to be on the spot at the time, and at once rendered assistance. They found Mr Bland entangled between the waggon shafts and the parapet of the bridge, and, on being immediately released, he was found to have been cut about the head and face and crushed in the body. A ladder was procured, and the shaft horse, which had also become entangled, was extricated, but, unfortunately, it had been strangled. The first horse, after being set free, was found to be little the worse for its immersion; whilst the waggon remained intact on the crown of the bridge. Mr Bland was removed to his home. It is estimated that the strangled horse was worth about £30.

Whitby Gazette, Friday 30 June 1899
This report was not accompanied by a photograph.

Accident at Beggar's Bridge
Joseph Readman
1899

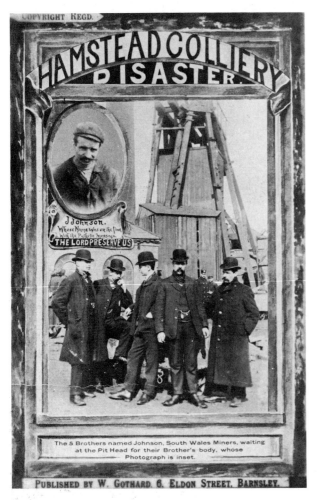

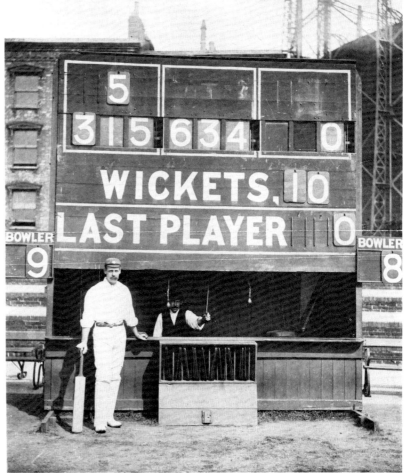

Postcard commemorating the Hamstead Colliery Disaster
Warner Gothard
1905

Hayward and his record score
Herbert Tear
1898

Warner Gothard of Barnsley specialised in topical postcards commemorating disasters of various kinds in visual form. This example shows the five Johnson brothers waiting for their brother's body to be recovered from underground at Hamstead Colliery, Great Barr, Birmingham. The image is made up of a complicated blending together of headlines, captions, photo insert and drawn-in monumental border surrounding the main 'news' photograph. Disaster postcards seem to have flourished briefly in the few years between the introduction of picture postcards into Britain and the arrival of full picture coverage of important events by local newspapers.

Other notable events photographed were of a happier nature, such as the photograph by Herbert Tear of the Surrey batsman Tom Hayward standing in front of the scoreboard at Kennington Oval, having scored 315 not out for Surrey against Lancashire in August 1898.

After the turn of the century, as more specialist photojournalists were appointed, the business of press photography became more professional, and the pace quickened. In 1904 the *Daily Mirror* set a record by printing a photograph of the finish of the Derby in the following day's edition. That same year it arranged for half-tone process blocks to be made on board an express train, enabling reproductions to be printed in the paper next day. The timetable went like this:

1.00 p.m.	Photographs taken of the Tariff Reform demonstration at Welbeck
1.45	Specially hired Beeston-Humber car arrives with the exposed plates in Chesterfield (a distance of 18 miles)
2.45	Prints completed by Mr Seaman
3.45	Pictures made from them upon zinc plates by means of the process camera
4.21	Midland Railway train leaves Chesterfield, with special *Daily Mirror* car attached in which the blocks are etched. As the train sways, acid splashes out of the tanks, but the job is eventually completed
7.50	train is met at St Pancras station, London by motor car
8.00	plates reach *Mirror* office[8]

By 1908 the *Mirror* had got things off to such a fine art that it only took an hour and a half from the arrival of an undeveloped photographic plate at the office to getting reproductions made from it rolling off the printing presses in the next day's *Mirror* at the rate of 80,000 an hour. In 1909 the indefatigable Hannen Swaffer rushed by car from Aintree to Manchester carrying a photograph of the finish of the Grand National which was sent from there by wire to the *Mirror* in London, using their new Korn Telephoto apparatus. As one professional photographer commented at the time: *Speed goes a long way in this business.*

[34]

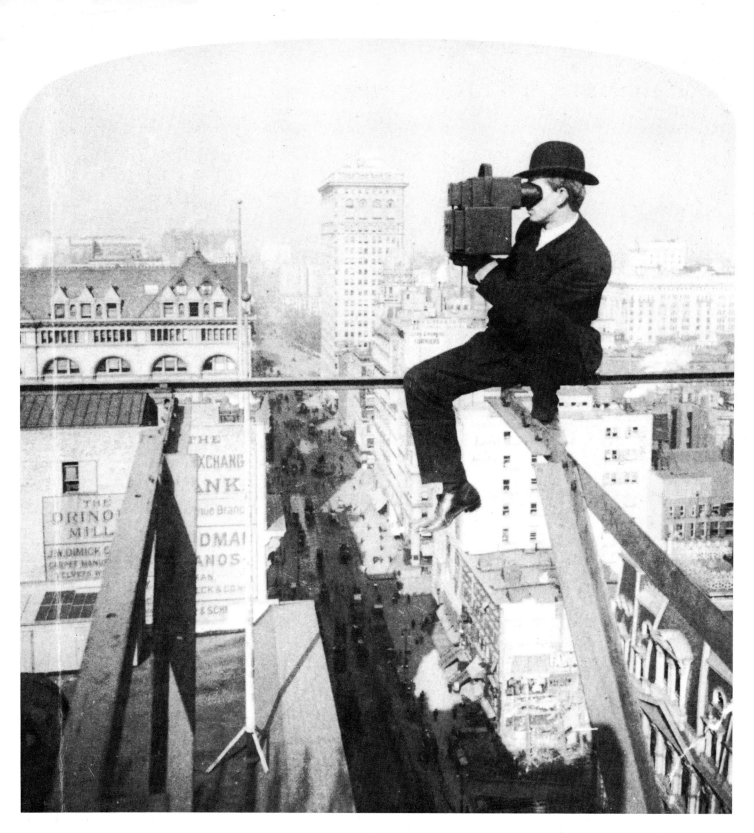

To satisfy the public's insatiable appetite for photographs a new breed of superman had to be created, each man a daredevil with nerves of steel, a Clark Kent transformed by a camera into a super-newsman who could overcome any difficulty and meet any deadline. In 1907 a journalist wrote enthusiastically about this modern hero:

He was unknown a few years ago. The public taste has brought him to the forefront, and now a little army of a hundred of them is to be found when the sun has set, in their dark rooms in Fleet Street attics. Grit is the motto of the new race of newspaper photographers. He is an indispensible factor in modern journalism. His life is a succession of shocks and thrills – a continuous battle to snap that which seems unsnappable.

There he goes, Goerz-Anschutz camera by his side, ready 'to risk all but life and honour for the sake of getting a photograph that will "tell the tale."'[9]

Photographing New York City eighteen stories above the pavement of Fifth Avenue Arthur Westrop 1908

[35]

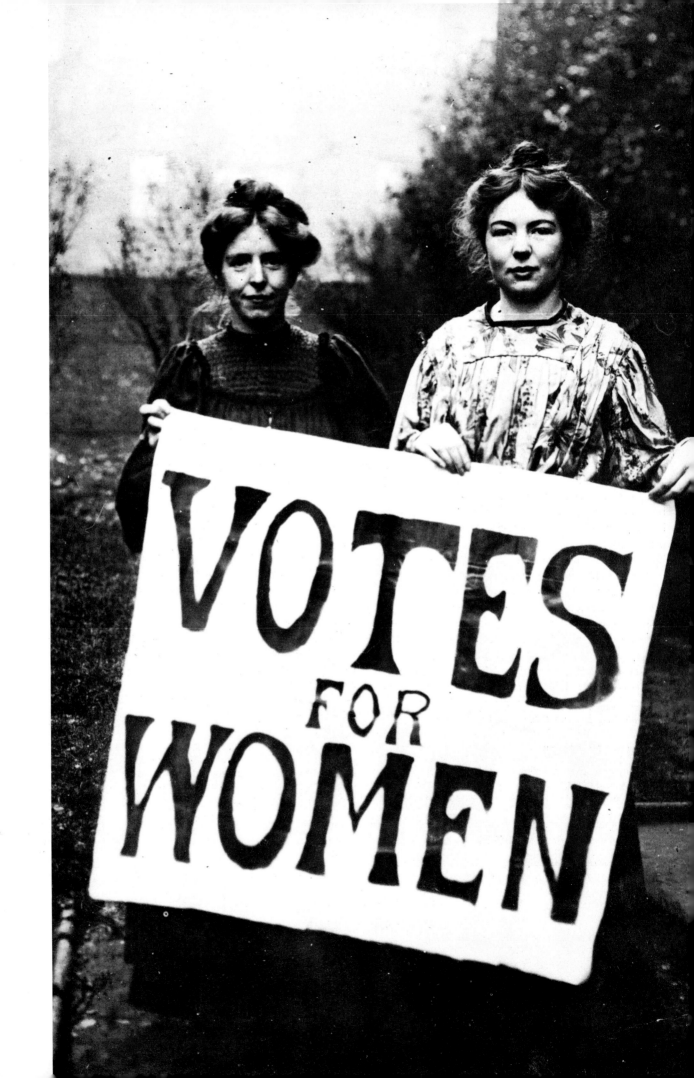

Votes for Women

Until those who had a cause to promote learned how it was possible to gain publicity through the Press, and until the Press learned to encourage the liaison between those who wish to make news and those whose job it is to make newspapers, many potential news stories were not developed as they might have been.

This photograph shows Christabel Pankhurst and the Lancashire mill-girl she had taken under her wing the previous year, Annie Kenney – the girl we have already encountered with Sylvia Pankhurst in a taxi in the midst of the violence during the Black Friday demonstration of 1910, which was to make the front page of the *Mirror*. Here she is photographed four years earlier by Christabel's uncle, Frank Clarke, probably in the garden of his house in Manchester. It looks like a family snapshot, and yet this photograph of the two girls holding their banner has much wider significance than just an incident in family history. It is a visual memento of the incident which bound these women closely together, and the manner in which it is presented – facing the camera whilst displaying the text on their banner – endows it with both symbolic and historic significance.

Annie went with Christabel to a Liberal party meeting at the Free Trade Hall in Manchester in 1905 with the aim of asking Winston Churchill the question: 'If you are elected, will you do your best to make Woman Suffrage a Government Measure?' It was virtually impossible for him to answer. To answer yes would practically commit the Cabinet to that course of action. To answer no would alienate women supporters of the Liberals. In her *Memories of a Militant* Annie described what happened:

We made a banner, and inscribed on it the new war cry, 'Votes for Women,' and we decided if we were not answered, to stand up and unfurl the banner, so that all could see that the question that had been put was one on Votes for Women. We went to the meeting, listened very attentively to the speeches, and at the end questions were asked, some Labour men putting questions about the unemployed.

They were answered. Then I rose and put mine. No reply. The chairman asked for other questions. I rose again, and was pulled down by two enthusiastic Liberals behind me.

We then unfurled the flag. That was enough. . . .

There was no answer to our question, and the strong arms of Liberal stewards dragged us from the meeting and literally flung us out of doors. This created a sensation. A great part of the audience followed. I addressed them. At least I made an effort to do so, but before I had explained what had happened I found myself in custody and being marched off between two policemen. The strange thing was that I had not the least fear. I did not feel ashamed at the crowds seeing me marched off. I had indeed started a new life.[1]

Both Annie and Christabel refused to pay their fines and were sentenced to three days' imprisonment in Strangeways Gaol. They knew that their point had gone home when they saw 'the very extremity of abuse, criticism, and condemnation hurled at us by the morning Press for such an inoffensive protest.' An antagonistic Press had no use for a photograph such as this, which in any case was taken several weeks after the event. But the Free Trade Hall meeting was historic – as was the banner and the message that it carried. This was the occasion on which Christabel made her first militant gesture, when she struck and spat at a policeman as he was arresting her, and Annie Kenney looked back on that day as the turning point in her life.

For the organisers of political meetings at this time the problem was to spot suffragettes who might 'cause trouble' before they got into the hall. Evelyn Sharp, a suffragette who like Annie and Christabel went to meetings in order to ask 'unanswerable' questions remembered:

It was very nerve-racking to travel down to some provincial town, to mingle with the crowd outside the meeting hall and speculate with them as to whether 'any of those dreadful women will get in this time,' to sail past the scrutineers at the entrance door, with or without a forged ticket, often quite easily because, like the crowd, they expected the dreadful women to look like nothing on earth – or like the *Punch* cartoons of them.[2]

Annie Kenney and
Christabel Pankhurst
Frank Clarke
1906

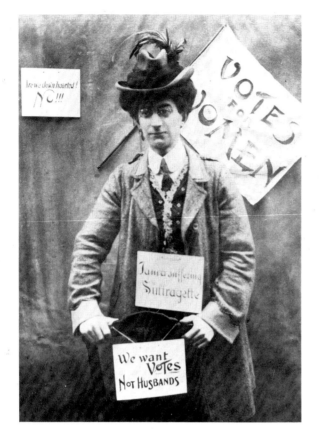

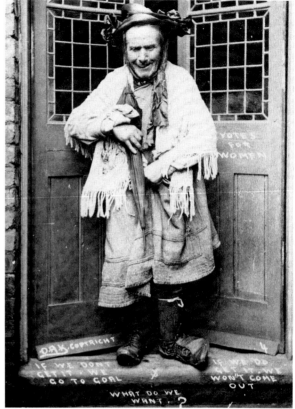

These two photographs of men dressed up as appalling parodies of women were published in 1906 and 1908, and reflected – then as now – widely-held public prejudices. Suffragettes are ugly, unattractive, cranky, unfashionable and masculine, according to these outrageous stereotypes, and the bouncers on the doors of the halls seem to have expected monstrosities such as these to arrive. It is interesting and depressing that prejudices have changed so little over three-quarters of a century. A feminist, as every reader of the popular press knows, is only a posh way of saying a women's libber; and women's libbers are – as every decent citizen who appreciates the true nature of the gentler sex knows – a lot of unfeminine, bra-burning extremists.

Christabel seems to have set out to counter these stereotypes and searched out the studios of female photographers such as Gilmour Stiell in Broadstairs and Kate Simmons in Margate. The portraits on the right by Kate Simmons show Christabel as a charismatic leader – romantic, idealistic, attractive, warmhearted. They were taken in 1910, and it is interesting to see how much the image she projects owes to the lighting and the pose, and even more to the retouching which has removed wrinkles and softened the features. Christabel wasn't averse to self-promotion by means of photography and appeared on thousands

of button badges as the heroine of the movement.

Supporters of the suffragettes soon realised that they could obtain massive publicity through getting photographic coverage by a national newspaper of an act of protest. The press photographer Bernard Grant was involved in one such incident in 1912. The *Daily Mirror* received a telephone call and he was told to go to a certain point in Piccadilly Circus and to make himself known to a man wearing a grey suit and carrying a white handkerchief in his right hand. No other details were given. Grant found his contact – an elderly man in a state of great excitement:

The moment I had joined him he insisted upon our taking cover – in a convenient saloon bar! There he became more and more excited as the minutes passed, but still he would not let me know what it was all about.

Beads of perspiration stood on his forehead, and the glass chattered against his teeth when he drank.

Naturally I was most anxious to solve the mystery, but right up to a few minutes to noon all I could get out of him was – 'It is not yet time!'

At last he led the way into the street and, with a dramatic gesture, pointed across the Circus.

'Do you see that sheet of glass?' he said in a hoarse whisper, indicating the largest window of a famous firm. 'In three minutes my beautiful daughter will smash that with a hammer!'

He was now almost out of control with excitement,

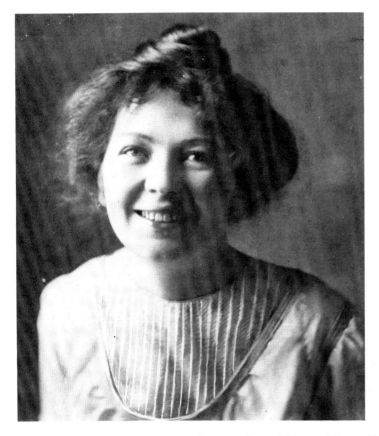
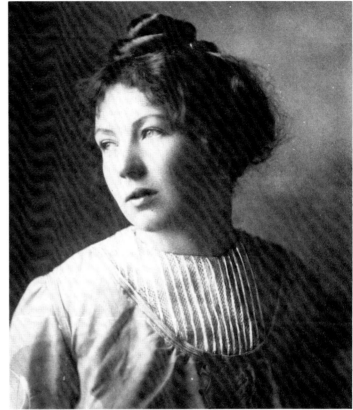

Miss Christabel Pankhurst LL.B. Kate Simmons 1910

and tried to forcibly prevent me from getting within 'shooting' distance. He seemed to think I should give the game away to the police, but in any case there was no time.

As I ran across the Circus I saw the girl walk up, take something out of a bag – a hammer decorated with the suffragette colours – and make a mighty slash at the plate-glass.

'Votes for Women!' she screamed as the hammer landed with a 'sconch!' I had expected to see the window fly into a thousand pieces, but instead there came only a spider's web of cracks.

In a moment she disappeared from view, lost in the crowd that gathered like magic. Then I saw her again struggling in the arms of a policeman twice her size. Still she continued her battle-cry in a voice gone thin and squeaky with excitement.

I got my picture, but not such a good one as I should have done if the frightened father had not withheld the information just too long.[3]

Just as it is only a short step from Christabel's political glamour shots to the careful construction of the image of a modern politician through the media, so it is easy to see how pseudo-events deliberately generated for the media to record have grown out of the sort of incident in which Bernard Grant found himself involved.

One final comment on the power of the illustrated press from a scene between mother and daughter, who is a suffragette, in Evelyn Sharp's *Rebel Women*:

'You will never persuade me, my dear, that you can cure anybody's attitude towards women by knocking off policemen's helmets –'

'We don't knock off –'

'I am convinced, Penelope, that I have seen a picture, in the *Daily Illustrated*, I think it was, of a woman knocking off a policeman's helmet. Her mouth was wide open, and she was doing it with an umbrella – a dreadful, ill-bred, unwomanly creature she looked! I remember it distinctly. The *Daily Illustrated* is a most respectable paper; it would never –'

'Darling, you know you have told me over and over again how all the respectable papers of the day called Florence Nightingale a dreadful, unwomanly creature for wanting to go out to the war to nurse grown-up men without a chaperon, instead of staying at home to nurse the baby she hadn't got,' shouted Penelope down the ear-trumpet.

'And so they did,' cried her mother, as though her veracity were being called in question. 'All sorts of wicked and untrue things were said about that noble woman, for whom I have the utmost veneration . . . Oh! it was shocking the things they said about her! But now –'

'Now,' said the wily Penelope, 'no woman in England is more honoured. That shows, doesn't it, that we should not believe everything the papers –'

'Penelope,' said her mother abruptly, 'I have dropped my ear trumpet again, so you had better ring the bell for tea.'[4]

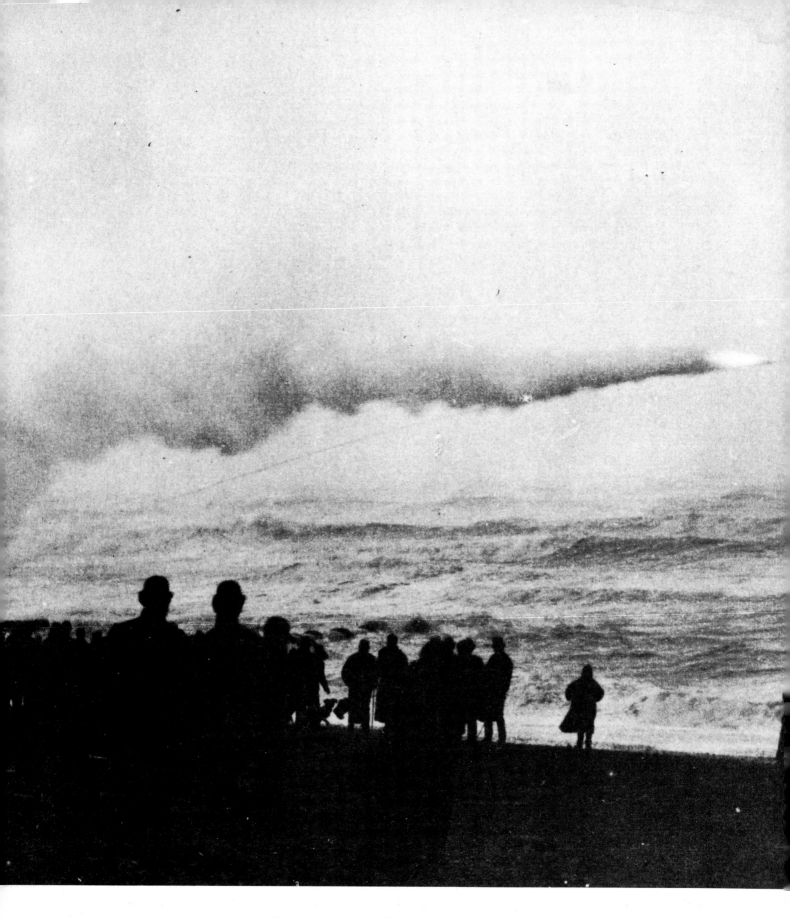

A Rocket to the Rescue

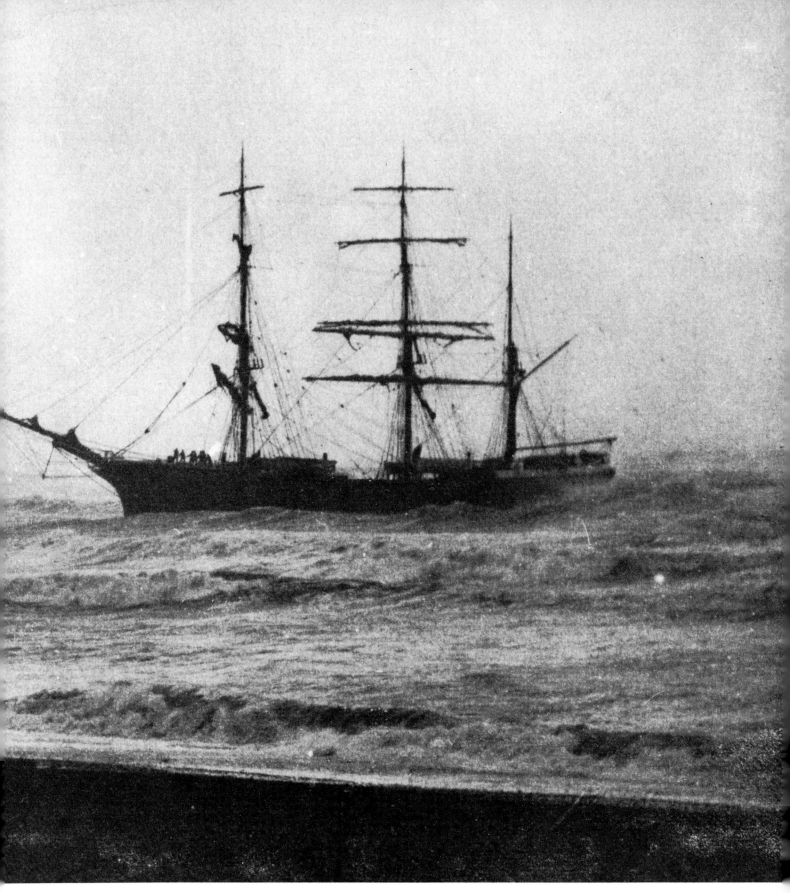

This is probably the most spectacular news photograph to have been taken in the nineteenth century, but it never appeared in a newspaper. Until public demand for the immediacy and the realism offered by photographs had given newspapers the incentive to develop the equipment to get outstanding news photographs into print fast, news reporting was almost exclusively in the form of words. There were no channels yet established through photo agencies and picture editors to rush photographs from the cameraman on the spot to the morning paper on the breakfast table. Some editors regretted the passing of the wood engraving and looked upon photographs as mundane records turning their journals into a sea of

A Rocket line being fired to the *J.C.Pfluger*, ashore at St Leonards on Sea, 11 November 1891. Later given the title *A Rocket to the Rescue*
Henry Godbold
1891

grey half-tone reproductions where once stylish engravings held pride of place. Others looked to America and saw the pace being set by the Sunday supplements offered by the *New York Times* and the *New York Tribune* which contained almost nothing but photographs – forerunners of the colour supplements produced by modern Sunday newspapers.

But in 1891 this gripping photograph, taken on the south coast in a hurricane force wind, suffered a fate which must have been similar to that of many early news photographs – undeserved oblivion. News coverage was in the 1890s still almost exclusively in the hands of local photographers, and even if they succeeded in taking an astonishing, exclusive photograph, they were usually without any outlet for their work except printing copies themselves for sale locally as mementoes.

Henry Godbold sent this photograph to the annual exhibition of the Photographic Society of Great Britain, with the title *A Rocket to the Rescue*. So the public eventually got to see it in the autumn of 1892, almost a year after the event which it showed, and the judges at the exhibition would have considered its merits as *a study of a shipwreck* rather than as hot news. One reviewer, no doubt impressed by the rocket arrested in mid-air, commented that Mr Godbold had 'accomplished a photographic *tour de force*, but little else'. No details were provided of the shipwreck, nor would the judges and reviewers have wanted any – and they didn't award Henry Godbold a medal.

So after an interval of ninety years let me redress their injustice and bring this outstanding photograph to the attention of a wider public. This is the first time it has been reproduced and for this photograph, as for the others which follow, I want to set it in context by providing the background information to the scene depicted. In these unpublished news photographs we will be able to see photographers trying to solve the various problems which presented themselves as they set about reporting events through the camera lens as they happened. Here are photographers beginning to learn by trial and error the basic techniques of photojournalism as we know it today.

On 11 November 1891 hurricane force winds swept the south coast of England. Many vessels foundered, and many people were drowned. Both the Dungeness and Sandgate lifeboats, which had put to sea on rescue missions, lost members of their crews. The ship was the barque *J. C. Pfluger* – an iron-built German vessel of just under 1,000 tons – almost at the end of the long voyage from San Francisco to its home port of Bremen. The captain had been trying to 'beat to seaward' in the teeth of the gale, but finding that impossible, ran his vessel ashore at St Leonards at about ten in the morning. She struck the sandy bottom about three hundred yards off shore and, fortunately, stayed both at right angles to the shore and to the rolling surf, and kept on an even keel.

The local coastguard immediately got their rocket apparatus ready, and a large crowd of spectators gathered. Rocket after rocket was fired off, only to fall short due to the force of the wind, which had swung round to due west, blowing along the shore with great violence. Tension mounted as it was feared that the people on board – who can be seen clearly in the photograph – would be swept away before they could be rescued. The thirteenth rocket carried its line over the vessel and the crew immediately hauled the hawser on board and made it fast in the foretop cross-tree. By about noon the breeches-buoy was rigged up and the rescue began. The first person brought ashore was a lady passenger, whose safe arrival on dry land was hailed with loud cheers. Her little sons came next, followed by two male passengers, the seamen, the first and second mates together, and finally the captain – the last to leave his ship. Conditions were so bad that it was not until four o'clock that they were all safely ashore.

Rocket-line rescues were not always so successful. Further down the coast that same day the survivors of the *Benvenue* climbed the rigging as she went down in shallow water and lashed themselves to the topsail yards. There several of the men were struck and injured by rockets in unsuccessful rescue attempts, and some, later rescued by lifeboat, received burns from the rocket lines across their faces and hands.

To stop the rocket in mid-flight as it carries the rescue line Henry Godbold has had to underexpose and be satisfied with silhouettes of the spectators and of the sailing ship. But this only serves to heighten the sense of threat and foreboding in the photograph. Fishermen and many others from Hastings had turned out to see what they could do to help the people whose lives hung in the balance, and this powerfully evocative photograph allows us to feel that we are there sharing their dramatic experience – unseen observers among the shadowy watchers on the shore.

This photograph sums up the whole rescue in one spectacular instant. If you asked children to draw the scene they would probably instinctively select these same essentials and, like the photograph, show a ship in profile with its masts and spars clearly seen, the raging surf crashing in towards the beach, people watching and waiting on the shore, the crew standing on the deck and clinging to the mast waiting for rescue, and the rocket flying through the air with fire and smoke pouring out behind, carrying the line which brings safety. These details would also probably be those most vividly remembered by the onlookers, together with the roar of the waves and the buffeting of the wind.

This is the crucial moment. Will the crew be saved? Will the line break? The rocket hangs in mid-air as it arcs out over the boiling surf towards the ship. The eye follows it from left to right, and then along the flying jib which completes the sweeping arc. The photograph not only records the most tense moment in a dramatic rescue, but through the powers unique to photography to conjure up time past, enables us to share something of this most decisive moment.

The Wreck of the Mohegan

There were other ships which came to grief with much more tragic consequences, and other wrecks which did not present themselves quite so readily to the camera as had the *J. C. Pfluger* at St Leonards. The long and often treacherous coast of Britain gave many opportunities for photographers to record the lifeless hulks of doomed steamships and the smashed timbers of clippers and barques beaten against the rocks. The most outstanding photographer of shipwrecks in the late nineteenth century was Alexander Gibson – the most remarkable member of a whole dynasty of photographers – the Gibsons of Scilly. Even he found it difficult to record the wreck of the *Mohegan*, which sank in pitch darkness off the Cornish coast. This was a most appalling disaster which left over a hundred people dead. When day broke there was nothing to be seen of the ship except the top of the funnel and the masts sticking out of the water between comparatively insignificant-looking rocks. No rockets or foam-crested breakers, no sturdy lifeboatmen braving the deep or dramatic scenes of rescue – just the dull waters of the sea on an Autumn day giving no hint of the tragedy which had been acted out the previous evening.

On 13 October 1898 the liner *Mohegan* had left Gravesend with 159 people aboard. She was outward bound for New York, carrying only saloon passengers. The list enumerates whole families travelling together in style. The following evening she was sailing westward down the Channel on a clear evening at full speed. In command was Captain Griffiths – a very experienced mariner who had crossed the Atlantic two hundred times before – and his officers were described as 'all cautious navigators, good disciplinarians, and sober men'. Transatlantic liners usually passed twelve or fifteen miles south of the Lizard, but as darkness fell that night one of the coastguard at Coverack saw a ship's lights heading straight for a ridge of rocks called the Manacles – a graveyard of countless ships. When the sea was smooth you could look deep down into the transparent water and see the weed-coated spars and rigging of ships wrecked long ago. No one ever discovered why the *Mohegan* was so far off course. The coastguard fired a rocket to warn the ship of the danger she was in, but it was too late to save her.

At about ten to seven the passengers were sitting down to dinner when they heard grating sounds followed by crashing – the *Mohegan* had struck the rocks at full speed and her bottom had been torn out. Passengers rushed up onto the deck as almost immediately the vessel began to sink and took on a list to port. The more the list increased, the more difficult it became to launch the lifeboats. The stewards got everyone they could into lifebelts. The waters rushing in through the gashed hull lifted the metal plates which formed the floor of the engine room and within five minutes reached the dynamos. The electric lighting failed and the vessel was plunged into darkness, greatly adding to the horror of the situation. As the ship sank she swayed in the surf, grinding against the rocks. Survivors were thrown into the sea as she lurched downwards only fifteen minutes after hitting the rocks. It was said that the shrieks of the despairing passengers could be heard four miles inland.

The survivors' stories were pitiful:

The vessel filled rapidly. I secured a lifebelt and jumped overboard in company with Mr Couch, the chief officer. When in the water Mr Couch made me take off my coat and boots. Soon after we got parted from each other. When leaving a little girl begged me most piteously to save her, as she 'did not want to die yet,' but I was powerless. On getting into the water I fortunately found a bit of plank floating, and to it I clung until I was picked up seven hours afterwards . . . I could not have lasted much longer.

The Porthoustock lifeboat searched close by the rocks in the pitch darkness and found a boat full of survivors:

We took them all in, women and children and men. One woman threw her arms round my neck; they were mad with joy. Then we picked up all we could, some on lifebelts and some on wreckage. The last was Miss Noble, a girl on a piece of wreckage. She had been in the sea three hours, and, mind you, a very nasty sea. All she said was, 'Just chuck me a rope,' and we hauled her on board and she just shook the water off her and sat down in the most unconcerned way. We got ashore after a devil of a pull.[1]

Fifty-three people were rescued from the sea and from the rigging of the sunken ship. One hundred and six people died, including the captain and all the deck officers who might have been able to shed light on the cause of the tragedy.

From daybreak small parties were on the lookout for bodies being washed ashore. The Coverack coastguard, Charles May, went along the beach and picked up four dead bodies, three of them in lifebelts. One girl of thirteen or fourteen had the straps entwined in her hair, which had to be cut away to disengage the belt. The parish church of St Keverne was used as the principal mortuary, and there were soon forty bodies laid out at the west end of the church, screened off by curtains, and relatives began to arrive to identify the dead.

The Times was in touch with events in Cornwall by

telegraph, and by telephone to Falmouth and to Porthoustock. It was also being telegraphed reports from a correspondent in St Keverne, a remote village, where the little post office with its primitive telegraph instruments was carrying so much traffic that it was almost impossible for newspapermen to file their reports.

Very soon after the disaster Alexander Gibson travelled from his Mount's Bay Studio at Penzance to photograph the scene. He photographed what could still be seen of the ship above water and then must have decided that this comparatively tranquil scene gave no idea of the extent of the tragedy. So instead of trying to sum up the situation in a single photograph he set about taking a sequence of fifteen photographs showing the aftermath of the wreck. In doing this he was able to set the disaster in context – rather like a modern photojournalist giving an event extensive photographic coverage – rather than seeking out a single telling shot.

These are two of the photographs from the series. The first shows the wreckage thrown up onto the shore which Gibson must have arranged to convey the enormity of the disaster which had taken place – in the foreground are placed a lifebelt carrying the name MOHEGAN, HULL, and behind it an empty lifejacket, with shattered fragments of the ship stretching into the distance.

The second shows the scene in the church at St Keverne. The sheets covering the faces of the dead have been pulled back and we can see the human wreckage. They seem asleep, with their hair matted and tangled with seaweed, as they rest their heads on straw and on their lifebelts which serve for some as pillows.

There is nothing sensational about this photograph, which is as straightforward and powerful as all Gibson's work. But some people considered it outrageous that this photograph, with the others in this series, had been exhibited and offered for sale in Penzance soon after the wreck. At the inquiry into the loss of the *Mohegan*, counsel for the shipping company criticised Alexander Gibson's photograph of the bodies in the church: 'On behalf of the owners of the ship, who had done all they could to assuage the grief of those who were lost, he had to say that they felt great indignation that this revolting photograph should be exposed to the public. He hoped that the Court would express an opinion that such a photograph ought not to be exhibited to pander to the morbid taste of those who looked on it.'[2] Finding that the presiding magistrate shared his objections, counsel stated that he intended to contact the photographer to convey the feelings of the inquiry.

But who was at fault in this affair: Alexander Gibson for photographing what he saw, or the public who wanted to see photographs like this? A few years earlier the journalist George R. Sims – probably best known today as the author of the popular ballad be-

ginning *It is Christmas Day in the Workhouse* – had complained in a half-joking manner of sketches from photographs published in the *Daily Graphic* of the victims of the wreck of the *Roumania*. 'A corpse now and then', he wrote, 'is all very well, but a cold corpse with your breakfast every morning for a week is exceedingly trying to the digestion.'[3] Modern editors are understandably cautious of either adding to the grief of mourning relatives or of offending their readers by publishing similar photographs of tragedies today. What Alexander Gibson photographed was what he actually saw around him – bodies being brought up from the beach in carts and laid out in the church, and outside a mass grave being dug where the coffins were to lie, ranged three deep. That was the reality of the situation.

Reporters could describe in words the most devastating scenes of grief:

A poor woman dressed in black was in search of her dead husband, Robb, a steward. His body had been placed in a coffin, and the lid was removed as the woman was led weeping into the church. Directly she caught sight of the dead face she fell down and kissed it saying, 'My God! and is he to be taken from me? How can I live alone?' For a long time she lovingly stroked the hands and kissed all over the face of her dead husband, and then, composing herself by a violent effort, got up and walked away. In a minute or so, however, she returned for one more inexpressibly sad and wistful gaze upon the dead, and then the coffin lid was fastened down.'[4]

That's powerful writing, describing a minor incident which encapsulates the way that people were having to deal with death in St Keverne – a mixture of the agonies of extreme distress with the practical business of getting the bodies identified, nailed down in coffins and then buried.

Words can have great power and can give great offence. But only photographers face the special charge that their work can encourage *voyeurism* – allowing people to gaze upon something which some think they should not. The accusation is that while words describe, inform and perhaps move the emotions, photographs allow people to become sightseers at a disaster, prying into what should remain decently hidden, and indulging their morbid curiosity. Contemporary comment from a photographic journal on the affair of the publishing of pictures of the *Roumania* victims had been decisive: 'the sooner public opinion rises to stamp out this debasement of our art to the level of the doings of Burke and Hare, the better it will be for photography, and for public and private decency.'[5]

The photograph is too powerful and too direct a medium for comfort, which is why this kind of subject is still dangerous territory for photographers and for editors. To be told that dozens of people died is one thing. To see them lying there in rows is quite another.

Wreckage from the
Mohegan on the coast
Alexander Gibson
1898

Corpses in St Keverne
Church
Alexander Gibson
1898

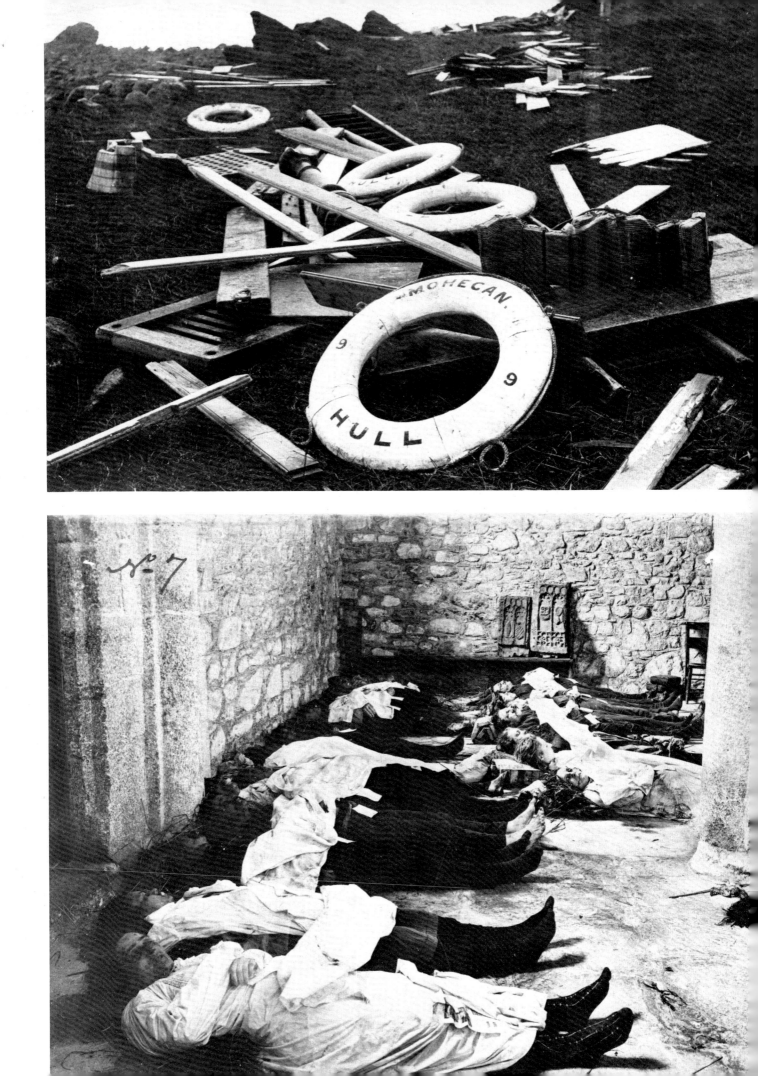

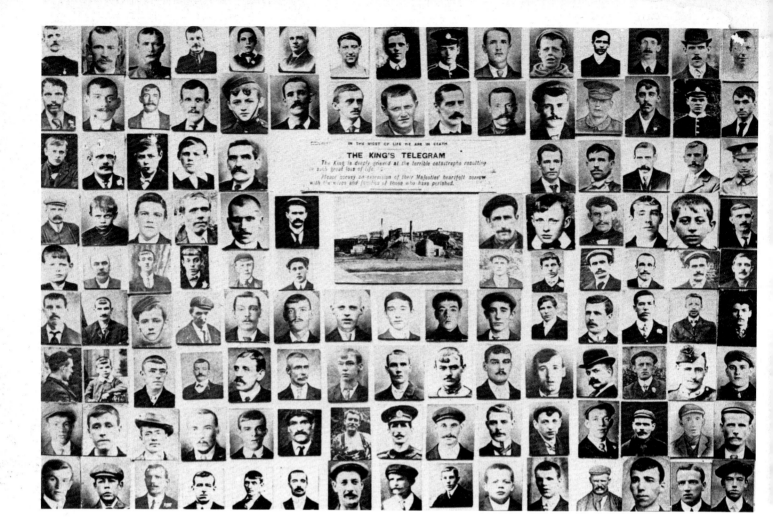

All Hope Abandoned

These photographs show how two Whitehaven photographers overcame the difficult problem of producing a visual record to mark the appalling explosion and fire at the Wellington Pit in 1910, which killed 136 men and boys.

In the first photograph John Leech brings together portraits of 124 of the dead, together with a telegram from the King expressing sympathy with their relatives, a view of the pit head, and the text *In the midst of life we are in death*. Some are middle-aged men in cloth cap and muffler, some just kids straight out of school. A few are in the uniform of the Army and the Boys' Brigade. Every one of them was killed in the Wellington Pit when it burned. The scale of the disaster is brought home by these rows of faces looking out at you – all dead and gone. Leech's photograph, unlike Gibson's, cannot have the accusation of ghoulishness made against it, but like Gibson's, it

brings home how many lives were lost much more directly than any casualty figure.

On the right is a photograph by James Bellman. Seven men stand at the pit head, six men looking directly at the camera, and one looking down at a wooden sleeper from the pit which is held by the others. On it is chalked a message which reads *all's well in this airway at 4 o'clock 35 men and boys. J. Moore.* This message was over four months old and had been left by one of the coal hewers who died. To understand the circumstances in which this photograph was taken in October 1910, you must know what happened after the explosion on 11 May.

The Wellington Pit extended four miles from the bottom of the shaft out under the sea. Rescue parties found that the pit was on fire over two miles from the shaft, 750 feet down. Smoke and fumes were everywhere. Beyond the wall of flame 136 men work-

Group of seven men
holding sleeper
James Bellman
1910

ing on the night shift were trapped. Only four men had managed to stagger clear. Early in the morning of Friday the thirteenth the decision was taken to brick up the colliery workings as all hope of rescue had been abandoned. The crowds at the pit head had waited in vain for news – the women of the mining community had waited all day and into the night.

Now the miners decided to take action to help the men and boys trapped below. Two thousand of them met to discuss what to do, and feelings ran high – they were bricking up whole families down there. The McAllisters were almost all entombed – father, three sons, three nephews and a son-in-law were all being written off as dead. The miners waiting above ground wanted to try to break through to their comrades, even if it meant leaving the raging fire cutting off their retreat to the shaft bottom. But the facts of the situation were against them. Once the fire had taken hold there was no hope of rescue for any of them. The pit was sealed and left to burn.

It was late September before rescue parties could re-enter Wellington Pit to recover the bodies. The trapped miners had tried to escape the smoke and the gas, but there was no way out. Some sat down together and died, others struck out in the hope of survival, with a scarf wrapped around their face. They chalked messages on the pit doors as they stumbled towards what they hoped was safety: *All well*, 6.30 – *A. McAllister*. Mr Moore the coal hewer left the

message held by the men in the photograph. He had been trying to work out the best way for those with him to escape by hanging pieces of newspaper on string from the roof to see which way the air was going. But death came to them all as the hours went by and no rescue came. One final message read: *William Opray John Lucas can get no further*.

Gradually the rescue parties pushed on into the devastated pit – eighteen weeks too late. By this time the miners could only be identified by the numbers on their lamps, or by their clogs.

In No. 6 North area the rescuers found a beam upon which had been chalked: *God is our refuge and help – a very present help*. And in the same area lay Mr McCluskey, who had made a bed for himself and his two sons out of brattice cloth – the canvas coated with tar and pitch used in mines to direct air currents. There they were found embracing each other, the younger son lying in the middle.

Now we can understand a little better the sombre faces of the men holding the message on the wooden sleeper. For all those men and boys to be killed was bad enough. To stand on the surface knowing that friends were dying and you could do nothing to help must have meant an agony of torment for the miners, who were only prevented by the police from forcing the gates of the pit to make what would have been a suicidal rescue attempt.

[47]

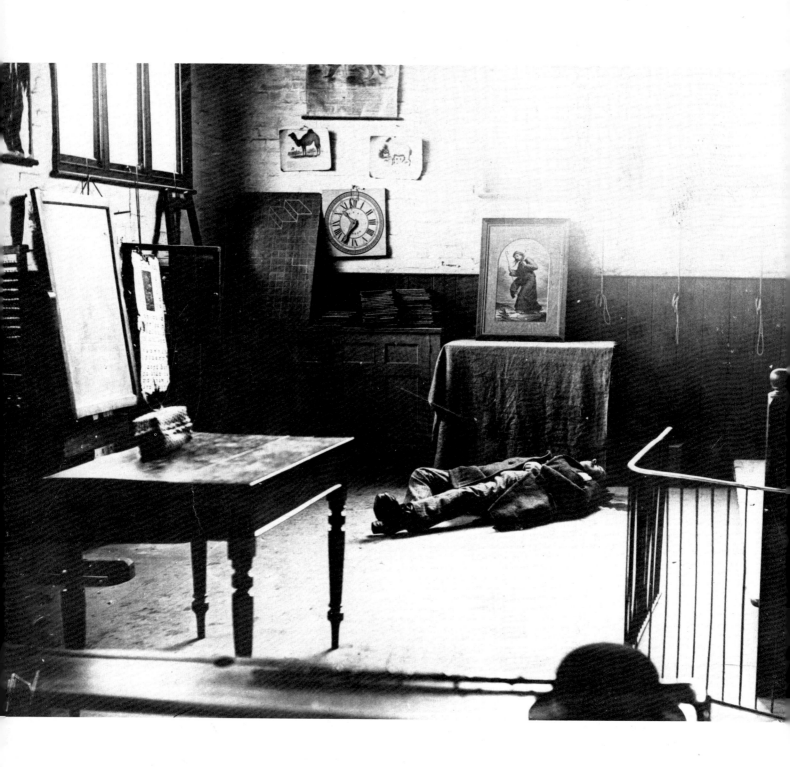

Bloody Murder

There is a phrase familiar to readers of detective fiction which describes this photograph precisely – *the scene of the crime*. There is the body, there is the blood. That is just how it was.

Perhaps because of the enormity of the crime the inanimate objects in the room seem to provide us with a symbolic commentary on this murder. Christ the Good Shepherd looks down on the body from the picture in the frame on the harmonium, which is draped with a cloth, making it look like a crude altar. Is this a sacrificial victim? The clock which is used to teach children to tell the time points, unchanging, to ten thirty-five, as if this has some vital significance. On the right, the metal rails suggest prison bars; behind, the fastenings for the window blinds hint more darkly of hangman's nooses and execution; and the sturdy wooden solidity of the schoolroom with its tiered seating facing the master's desk brings to mind the courtroom scene where the murderer will, perhaps, be brought to justice.

The process of relating the dramatic facts of the situation which led to this murder takes away some of the mystery and threat which hang heavy in that schoolroom, silent and still, with half-recognised shapes emerging from the deep shadows in its recesses. And yet at the same time the cold bare facts bring this room back to life and allow us to retrace the events of the day of the killing – Sunday the fifth of February 1899.

This scene of murder is the climax of a private local drama which had been going on for some time at Biddenden in Kent. Two years previously the daughter of the rector of Biddenden, Miss Bertha Peterson, had accused a local shoemaker, John Whibley, of indecent conduct with a little girl of eleven, named May Vane. Presumably because he taught in the Sunday school, she was able to set up some sort of inquiry and had interrogated him.

Bertha Peterson had then become matron at a home for inebriates near Reigate. From there she wrote letters 'showing curious religious delusions and a strong feeling about social evils such as mothers selling their daughters'. She was very much concerned with purity, and on reading W. T. Stead's pamphlet *The Maiden Tribute of Modern Babylon* – a piece of sensational investigative reporting in which he described how he bought a thirteen-year-old virgin for £5 in London in 1885 – she became determined 'that nothing of the sort therein described should take place in her father's parish'. She became more unbalanced, lost her job and returned to Biddenden, expressing a wish to make her peace with John Whibley. But she had 'heard a voice' telling her to kill him, and set out to do just that. She purchased a revolver at the Army and Navy Stores and practised shooting. She then arranged a meeting with John Whibley at the infants' school.

Miss Peterson had everything planned. She gave him an envelope containing two half sovereigns as a donation to charity, asked him to look at the picture of *The Good Shepherd* which she was presenting to the school, and, when he turned away, pulled out her gun and shot him in the back of the head, killing him instantly. The curate who was with them ran for help and another schoolmaster rushed in to see what was going on. He met Bertha Peterson at the door, gun in hand. She was perfectly calm and cool, handed him the gun and explained that she had to shoot him – 'I had to do it to protect little children'. As the astounded teacher confronted her holding the murder weapon and trying to pull himself together, she said: 'You don't seem to understand these revolvers. Will you let me have it back and I will show you how to unload the other five chambers?'

Bertha D'Spaen Haggerston Peterson went on trial at Maidstone Assizes charged with wilful murder. She remained composed throughout the proceedings, convinced that 'God told me to do it. God told me that I should be pardoned'. The court decided that she was insane. Her personal crusade in the cause of purity was over.

Now that you have read these facts the photograph can no longer be quite the same as before. Objects have become evidence – we know why the new picture of *The Good Shepherd* is placed so prominently on display, and we can guess at the chilling satisfaction that Bertha Peterson must have taken in choosing this particular picture. The last thing that John Whibley saw before he died was the scene of Christ saving one of his flock.

What we are looking at now is no longer a mystery but a murder, and this is the scene after the central character has left the stage. What remains is a matter for the police and for the undertakers.

The Scene of the Biddenden Murder, 5 February 1899
Hugh Penfold
1899

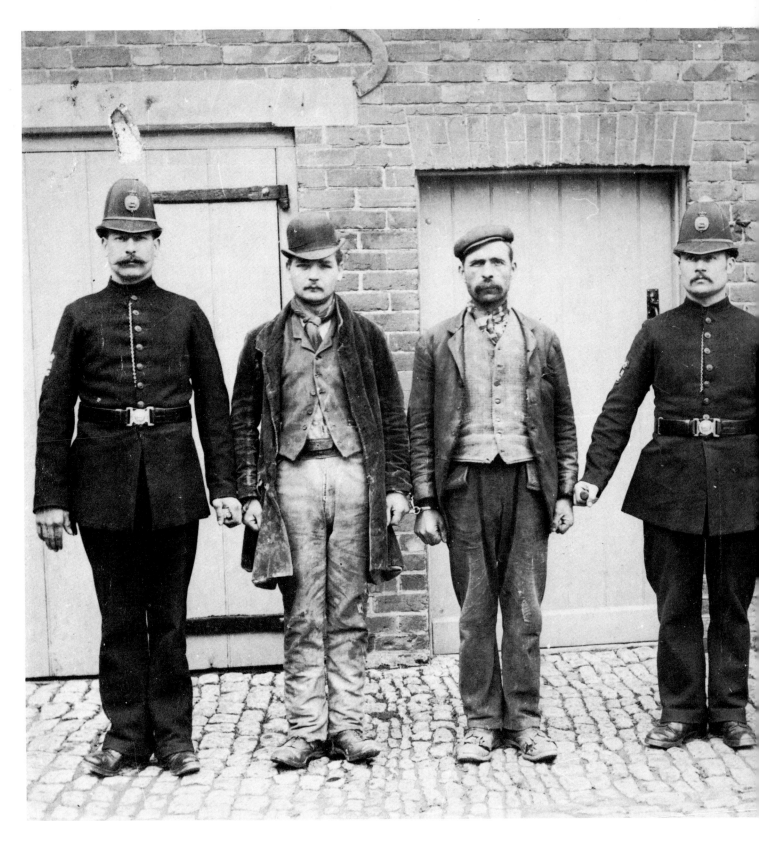

Law and Order

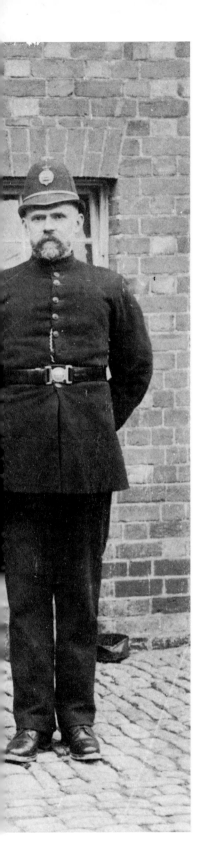

Here is a photograph of five men standing in a line, probably in a stable yard, looking directly at the camera. The police constables grasp hand-grips attached to handcuffs by which they hold the two men, who are obviously prisoners. The police sergeant, tall and smart in his uniform, stripes on sleeve, stands like the pillar of authority that he is, on the right.

The prisoners look disreputable and scruffy with their tattered clothes – fly button showing, trouser knees wearing through, and shoes falling to pieces. It is no surprise to learn that they were described officially as 'labourers, of no fixed abode'. In contrast, the police are a well turned out, upright band of men.

The reason why Tom Reveley, who took this photograph, presents the scene to us in this way is that the two men have been charged with murder – and the man they were accused of murdering was a colleague of the officers shown holding them under arrest.

On the night of Easter Monday 1899, two police constables were called to the Chequers Inn at Harwell in Berkshire to eject two men who were behaving in a disorderly manner and were refusing to leave: forty-six-year-old Joseph Slatter and Robert James, aged thirty-one. Constables Hewett and Charlton tackled the two men, who were eventually got outside. Presumably the two men were the worse for drink. The policemen were in plain clothes. Once outside, Slatter and James took off their coats and challenged the men who had thrown them out of the inn to fight one saying 'Now, Bob, give it them. Knife them and I'll back you'. In the fight that followed Police Constable Charlton, a married man with four young children, fell heavily and received a fractured skull from which he died the next day. The other policeman had his nose broken and both eyes blacked, yet knocked both men down with his truncheon so hard that it snapped, and eventually with the help of bystanders managed to handcuff Slatter. James was arrested soon afterwards. The charge against them was changed to manslaughter on the direction of the judge at their trial, who took note that they had already been convicted many times for various offences, and told them that 'but for certain technical difficulties they would have been tried for their lives, and the case was very nearly one of murder. Although the policemen were in plain clothes, it was abundantly clear that the prisoners knew who they were and committed a terrible assault upon them'. He sentenced them both to twenty years' penal servitude.

The unspoken message of this photograph is *we've got them*. The villains have been caught, we've got them under arrest, here they are for all to see. The photograph provides both documentary evidence and an assertion of the power of the forces of law and order.

Men accused of the Harwell Murder handcuffed to policemen Tom Reveley 1899

Making History

Awaiting the Royal Party
David Blount
1893

These two photographs were taken when the newly-married Duke and Duchess of York were staying in the north east of England at Wynyard, the residence of the Marquis of Londonderry. That day the royal couple had opened Ropner Park in Stockton, and had attended a civic luncheon at the Exchange Hall.

The first photograph, titled *Awaiting the Royal Party*, shows the photographers with their huge plate cameras set up on tripods to face a line of eight chairs. In the second the party has arrived and the photographers have taken off their coats and got down to work. This is titled *How Royalty is Photographed* and gives us a clue to why these photographs were taken.

It is obviously a set-piece affair. The photographs taken on that occasion by the various photographers ranked alongside each other were almost identical and gave no hint that each was anything but *the* official photograph – things have been carefully arranged so that there are no other cameras to be seen.

What is extraordinary is that David Blount should have set his camera back from the others to observe

the whole process of record-taking and history-making in which the photographers have become involved. This is an event staged for the cameras, just as today photo-sessions and press conferences are arranged. The main factor which brought them into being was the arrival of the camera.

Those today who seek power, fame or a platform for their views know that the way to get their message across is via the popular media of newspapers and television. Like the royal party at Wynyard (though for different reasons) they are prepared to put themselves on show to the public – nowadays under a battery of lights and in front of rows of still and television cameras. Seeing is believing, and with the coming of the camera the offhand reply to the question 'Well, how do you know?' has changed from 'Oh, I *read* it in the newspaper' to 'I *saw* it in the newspaper' or more likely 'I *saw* it on TV last night.

Anyone trying to 'make it' as a popular personality becomes involved in the struggle to present to the public a face which is instantly recognisable, and that

is achieved by getting it in the papers and on television. Anyone who has achieved fame is under strong pressure to appear before the cameras, to become even more famous, and be pursued even more relentlessly by photographers. Never underestimate the power of the camera *alone* to create 'personalities' or stars.

Through the camera seems to come success, and success is marked by the cameras always being around you. This process has been going on a long time. When Mark Twain visited England at the beginning of the century he accepted many invitations to sit for photographers – the snapshotting ancestors of today's *paparazzi* had not yet grasped their opportunity and broken with these formal politenesses. He sat for *hundreds* of photographers on this visit alone, and on one single day sat for photographers twenty-two times.

Photographs of the royal family had always been in huge demand and as you can see in the pictures taken at Wynyard, the organisers of the royal visit have arrangements very well in hand. The royal family had

no need of publicity, but *noblesse oblige*, and it made sense to get all the photographs over in one session. Blount's photograph of the staging of this photo-event shows the photographers soberly dressed and dutifully waiting for the royal party to present themselves. All except one photographer who seems so tickled by the idea of the photographers themselves being photographed that he plays up for the camera smiling broadly with his hat tipped jauntily back.

To say that Blount's photograph titled *How Royalty is Photographed* reveals the camera *making* history would be to go further than he intended. He set out to give us a fascinating glimpse behind the scenes at the show staged for professional photographers. But with the benefit of hindsight we can also see that he has given us a warning of things to come, an early caution that if photographers are prepared to take pictures of events staged especially for them, then eventually the camera can only be trusted to give us half-truths.

How Royalty is Photographed
David Blount
1893

Camera Fiends

These two photographs were both taken in 1881 and show the public and the private face of the actress Sarah Bernhardt. On the left is a formal studio portrait of her in stage costume. Above is an informal scene with a few friends on the beach, and despite its early date this photograph has the intimate and spontaneous feel of a snapshot. There is a fundamental difference in approach between the two which produces subtly contrasting results. Until the 1890s that type of static studio shot would have suited public taste – a photograph giving an idea of how the divine Sarah looked on stage. But by the early years of this century the public – and the editors who served them – were looking for photographs like that above. The public would still have been interested in her as a public figure, but they preferred to speculate on what she might be whispering to her friend. The public now wanted confidential revelations in visual form, not set speeches – people *being themselves*, not playing rôles.

Glimpses of the lives of the famous were popular with the readers of illustrated magazines which proliferated at the turn of the century, and they were encouraged to send in their own photographs to feature under headings such as *Taken Unawares: Snapshots of Celebrated People*. For the first few years the public put up with very amateurish efforts. In the past, photographers had clung blindly to the idea that photographs taken in 'beauty spots' must be beautiful; now they seemed to believe that photographs of important people must be important. A blurred shot of the comedian Dan Leno on the beach at Clacton found its way into print. So did another titled *A LIFE-LIKE SNAPSHOT* which showed Joseph Chamberlain opening the door of his carriage. As if to bolster up this otherwise unremarkable photograph the editor of *The Penny Pictorial Magazine*, in which it appeared, added *N.B. Notice the orchid in the Colonial Secretary's buttonhole*. The orchid could just be distinguished as a white smudge.[1]

Hannen Swaffer advised press photographers to

Sarah Bernhardt with five friends on the sea shore
Théodore Humblot
1881

Madame Sarah Bernhardt
W. & D. Downey
1881

[55]

King Edward and the
Royal shooting party
at Sandringham
Walter Edwards
1909

Mr Somerville
Tattershall conducting
an auction at the
Bloodstock Sales at
Newmarket
Horace Hall
1910

Man and woman
carrying a child in a
sling
William Gore
1909

M. Roger Sommer of
France on his biplane
at the Doncaster
Aviation, October
1909
Thomas Hanstock
1909

go for informal shots of human interest – 'Photograph people in motion – doing something':

When stalking a prominent man track him down in all legitimate ways, till you have him playing a part in some scene of human interest. Lord Milner is taken at a hospital simply standing, in company with a doctor and a nurse. But Lord Milner the same day goes on all fours and gives a little patient a back ride in one of the wards; and a snap of that would have had real value. The hospitals wanted publicity and there probably would have been no extraordinary Cerberus for an insistent camera to get past.[2]

The aim was to delight the reader by showing famous people off-guard – granting them privileged glimpses of the private life behind the public mask. This trend has continued into the nineteen-eighties and the market for candid shots of internationally famous personalities – of the Princess of Wales, of Jackie Onassis, and of pop stars for example – is now immense, and public interest undiminished.

More and more photographers found it worth their while pursuing members of the royal family for informal snapshots. They were no longer prepared to line up meekly to take some static, lifeless shot – as years before the local photographers had done at Wynyard. They didn't need tripods and the huge plate cameras which were by now outdated. Press photographers and ambitious amateurs no longer thought it necessary to ask someone's permission before taking photographs – they grabbed their

pictures and were away. Inevitably it was the royal family who were the first to discover how the drive to secure exclusive photographs for publication was going to erode their privacy and try their temper. In 1907 it was reported that: 'King Edward has been much annoyed for the past two days at Biarritz by the unpleasant pertinacity of the photographers who spring out from behind doors or rocks as his Majesty is passing.'[3]

It was at this period that the press photographer began to be treated as someone with special rights. Inspector Spencer, who was in charge of security arrangements to protect the King, used to let press photographers inside the barriers which held back the general public so that they could take better pictures. There were photographers who tried to get one jump ahead of their competitors and so brought down the wrath of other members of the profession who saw themselves losing the privileges they had gained if these 'camera fiends' continued to make a nuisance of themselves. Francis Fielding was a staff photographer with the Manchester *Daily Dispatch*, who felt strongly enough about the indignities being inflicted by photographers upon the royal family to write to the press warning that 'a "scoop" is all very well, but we have the future to consider'.[4] He was afraid that the King, who used to allow photographers to move forward at public ceremonies to get their pictures, would lose patience with their antics.

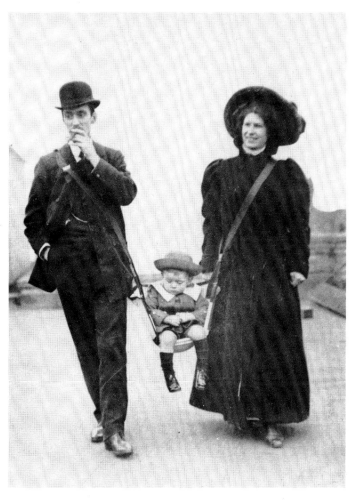

Responsible photographers who depended on the goodwill of the famous, and especially of the royal family, had good reason to be worried about the behaviour of irresponsible tearaways which threatened their livelihood. Everywhere the King went, photographers went. At Cowes Regatta they swarmed around the Royal yacht in launches, shutters clicking: 'Worse still, it appears that attempts were made to photograph the King and the Prince of Wales while bathing.'[5] Only occasionally did the King lose his temper – which he did when he saw a photographer with a camera trained on him as he left Sandringham church. 'Stop, *stop*', he shouted, putting up his hand, '*I do not approve of that*.'[6] Inspector Spencer, of the King's Special Police, did his duty, and the offending photographer was removed. The snapshot on the left was taken at Sandringham in 1909 by Walter Edwards, one of the partners in the Topical Press Agency – one of a number of agencies which were set up at this period to supply photographs to the illustrated press.

Above are two other examples of agency photographs, one by William Gore taken for The London Views Agency Photos Ltd, and another by Horace Hall for the Sport and General Illustrations Co. The photograph on the right of M. Sommer in his biplane was taken by Thomas Hanstock of York, a freelance photographer.

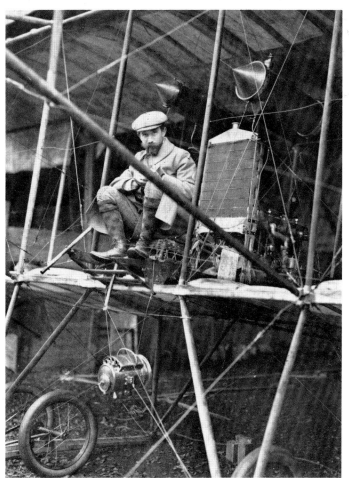

A Foot Ball Scrimmage
Robert Shaw
1884

Rugby Football
Practice. A flying
tackle
Horace Hall
1910

It took a revolution in camera design and an increase in film speeds before fast-moving sports action could be photographed. On Good Friday 1884 Robert Shaw of Broughton-in-Furness tried to capture something of the feel of a game of rugby football by persuading a local team to pose motionless for him – presumably the stand-off half removed his bowler hat when the game hotted up. Nearly thirty years later Horace Hall, using a hand camera with a fast shutter speed, was able to record a flying tackle at the split second it was made. This was taken in 1910 for the Sport and General Illustrations Agency, and again shows how photographers moved swiftly to take advantage of the new possibilities which technical improvements to their equipment offered them.

An Art of Great Singularity

In 1844 Fox Talbot, the man who probably has the best claim to be the true inventor of photography, asked the readers of his book *The Pencil of Nature* 'to excuse the imperfections necessarily incident to a first attempt to exhibit an Art of so great singularity, which employs processes entirely new, and having no analogy to any thing in use before.'[1] The book was the first to be illustrated by means of photography – actual calotype prints made from Fox Talbot's own paper negatives, and the readers were presented – most of them for the first time – with images which were of a completely new kind. It seemed that photography had appeared from out of the blue, and no-one knew quite what to make of it.

Nobody had any clear idea of what photographs should look like. There were no photographic traditions to work within, no academy of photography to lay down laws, no master photographers whose skills you could learn and whose style you could follow. The earliest users of the camera were trying to solve two problems at the same time – the chemical and optical problem of actually producing photographic prints successfully, and the more difficult problem of what to photograph and how. When George Eastman much later in the century offered photographers freedom from dabbling around in airless darkrooms with smelly chemicals, telling the public that with his new Kodak snapshot cameras 'You press the button, we do the rest', he was still leaving the most difficult problem to the person looking through the camera viewfinder. Anyone can press a button, anyone can take a photograph. Even in the days of the calotype, Fox Talbot had no difficulty in teaching his valet Nicholaas Henneman how to use a camera and how to make prints.

This is a fundamental point which is of crucial importance. *What decides the quality of a photograph was and still is the photographer's eye, not his camera.* To understand this is to understand a great deal about photography. All around you will see photographers paying homage – and a great deal of money – to the Great God Equipment. They wear their cameras around their necks like stylish and expensive jewellery – tokens of their faith in hi-tech to which they cling with possessive pride. But you can own the best camera in the world and still be a dreadful photographer. The ability to see and convey visual messages and ideas is worth any number of gadget-bags full of camera gear. Anybody can take a photograph, but not everybody can produce a good photograph.

The question which plagues so many photographers now, especially amateur photographers, was precisely that which the earliest photographers asked themselves. What was a 'good' photograph? – one that was in focus? – one that didn't fade? – one that showed something interesting? – one that paid due attention to the rules of composition? Photography had no such rules. If photographers had needed a set of rules on composition, subject matter or anything else, they would either have had to make them up or – as happened more usually – borrow them from painting. It was inevitable that the process of discovering the strengths and weaknesses of photography was a long one, but it was prolonged unduly by all the tub-thumping and heart-searching, all the condemnation and the self-justification which went on concerning the 'art of photography'.

When Fox Talbot described photography as 'an art of great singularity' he was using the word 'art' to carry its basic meaning – an *art* is a skill. Unfortunately most photographers over the years have understood *art* to refer to painting. It's quite understandable that a new and aspiring medium still unsure of its abilities should wish to gain confidence and respectability by mimicking the established fine art of painting.

But looking back over photography's brief history at all the rules and conventions which at one time or another were devised to hem it in, we might adapt Rousseau: *Photography was born free, and everywhere it is in chains.* Luckily most rank-and-file photographers sprang from such humble origins that they went their own way in blissful ignorance of any rules at all. It wasn't that they openly defied the established rules of the older visual arts – many commercial photographers simply didn't know the first thing about them. For those well-informed enough to harbour doubts, the photographers who earnestly listened to 'artists' (that is to say *painters)* at their local camera clubs – brought in to set them on the straight and narrow – it took many years to realise that what Fox Talbot had said was true. Photography *is* 'an art of great singularity'. And although painting and photography might superficially seem to have many features in common, they are and always have been fundamentally dissimilar. It was true that painters tackled some of the problems of representation which confronted photographers, but painterly traditions proved in the long run to be of little use to Fox Talbot or any of the millions of other camera-users who came after him.

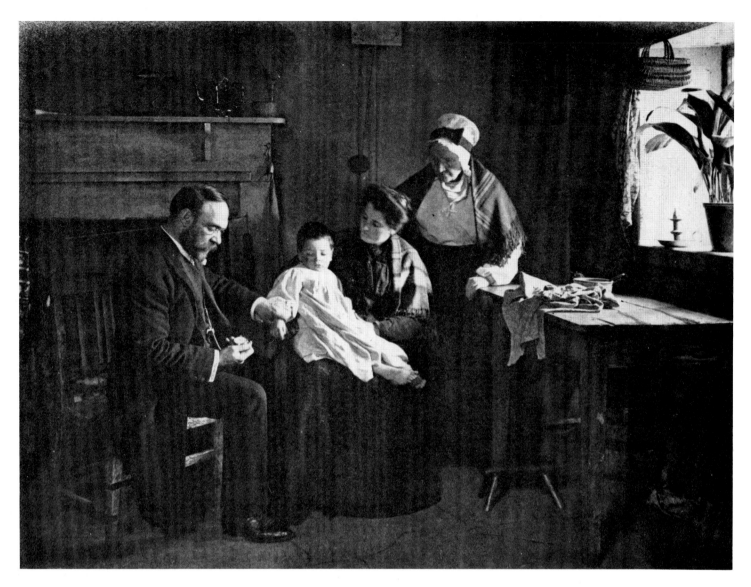

The Wee Invalid
John Hepburn
1905

*The House Physician
is interested*
Walter Thomas
1897

Here is a photograph taken in 1905 by John Hepburn which probably has its origins in *The Doctor* – a genre painting by Luke Fildes which was a smash hit at the Royal Academy exhibition of 1891. The painting was sentimental story-telling; this photograph, with its cloying title *The Wee Invalid* is third-rate amateur theatricals –the lighting is more dramatic than the actors.

Just how much like a painting this photograph looks can be seen if you compare it with Walter Thomas' photograph taken in 1897 entitled *The House Physician is interested*. Here we are not peering into the gloomy recesses of the real world wearing the dark glasses of accepted art. This straightforward photograph shows not a row of stereotyped characterisations – caring, experienced doctor, wee invalid, loving mother, anxious grandmamma – but a real child being nursed back to health at Guy's Hospital in London. The relationship between the doctor and his patient is I think more touching in this honest depiction of a hospital scene. The splendid cot with its brass knobs, the thermometer, bottle of medicine and record sheets – all these are objects in daily use, not assembled props. The little child who looks towards the camera from under drooping eyelids is clutching a doll for comfort; details such as this and the fact that the doctor is wearing a rather ill-fitting suit with the trousers riding up to reveal his polished black boots makes the impact of the scene greater rather than less. These are real human beings in a real hospital. There's no need for this photograph to borrow strength or respectability from painting, and its directness makes any thought of giving it a saccharine title such as *The Wee Invalid* quite absurd.

Photography shows a world constantly changing – a world in motion from which moments must be snatched out of a whirl of activity. Paintings have always tended to show a world full of order and quiet stability. Photography often presents us with scenes which are chaotic and perplexing.

Fishing boats at the
pier-head, Newlyn
John Preston
1908

The Lighthouse
Oil painting by
Stanhope Forbes
1893

The barber's shop in
Alston
Thomas Bramwell
1895

The barber's shop in
the Union Jack Club
Norman Collyer
1907

Look at this photograph above on the left, by John Preston, showing *Fishing boats at the Pier-head, Newlyn*. It seems as though the image is bursting outwards in a confusion of lines and an explosion of movement – the fishing boat sliced off as it moves out of the frame on the left. Boats form shapes not easily recognisable, rigging and mooring lines become the fabric of an entangled web. At the centre of this maelstrom of activity the fishermen in their oilskins on the deck of the *Diadem* look impassively towards the camera.

This is the world as seen by the naked eye – complicated, unharmonised. In contrast Stanhope Forbes' painting of *The Lighthouse* at the end of the same pier is poised and balanced. The painting is carefully organised and composed. Nothing is out of place and everything is in its place. Stanhope Forbes prided himself on his 'unflinching realism', but it is clear how far his vision of Newlyn was divorced from the disorderly reality of the scene recorded by the camera.

Anybody who thinks that he knows what photographs should look like is heading for a rude awakening. What if we decide that the camera is the champion of 'unflinching realism', showing us the real world as we suppose it must be? This would surely be a champion worth supporting. The photograph as a visual document produced by the unbiased eye of a machine – visions of the world without benefit of painterly clergy. *A hot line to the real thing.*

Here's a photograph which puts all that in question (top right). It was taken by Thomas Bramwell and

shows the barber's shop in Alston, a small market town in the north of England. Or rather that's what it *pretends* to show. What we're actually looking at is an elaborate tableau with figures placed in a set which has been carefully constructed to create the illusion of an everyday scene. This isn't real. This is fake, with walls of insubstantial paper pretending to be wood. But it's far too real to be dismissed as some story-telling period piece – there's no story there anyway, and no sentimental clichés. All the people play their parts un-selfconsciously and recreate in what is probably the photographer's studio the reality of life in the Alston barber's. It's a marvellously reconstructed scene. The posing is superbly done and the details are right, down to the posters, the grimy hand towel and the snippings of hair on the floor. Apart from the pristine state of the newly-laundered barber's aprons around the customers' necks, it could hardly have been done better.

But you need only look at a photograph taken of the interior of an actual barber's shop for the illusion to be shattered. Here, below, Norman Collyer has photographed the barber's shop at the Union Jack Club in London. The barber sits surrounded by *things* – inanimate objects packed into cupboards, covering shelves. The clutter of sponges and shaving mugs in the washbasin is as interesting as the barber, and the camera records them both with the same impartiality.

Which of the two photographs shows us what it was like to be in a barber's shop then? Which is more

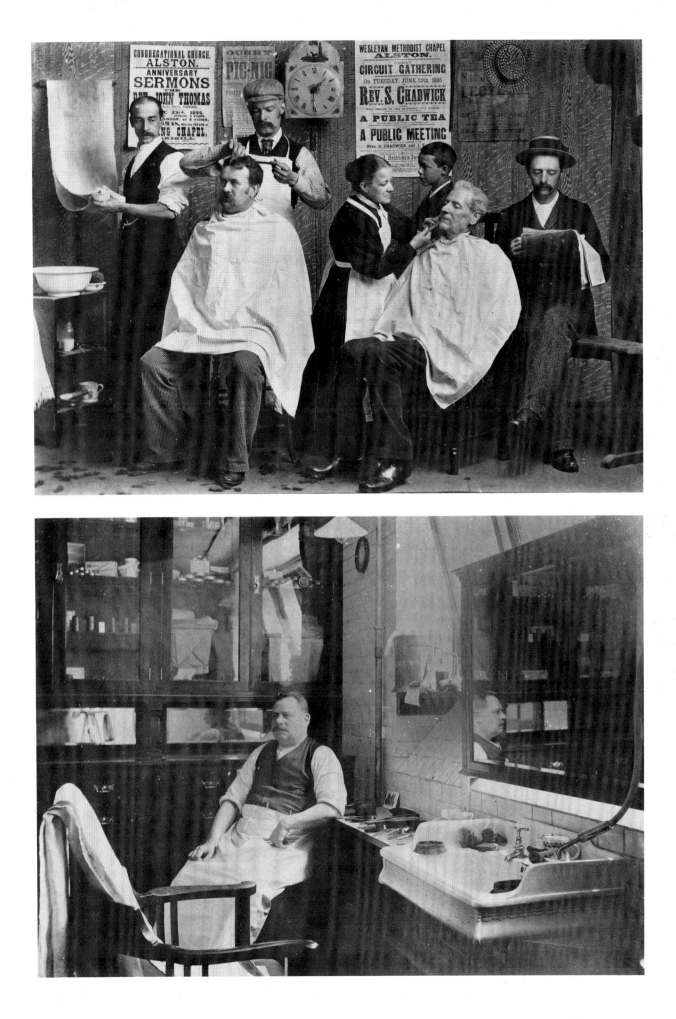

real? These two photographers, presented with similar problems, have had to come to terms with the practical difficulties which faced them, but have attacked the problem from entirely different directions. The choice is between a barber, his assistants and customers posing for the photographer, probably in his studio, and the barber in his actual work place, surrounded by the tools of his trade, sitting silently reflected by the mirrors in his empty shop. One photograph is centred on people, the other on objects. There is no easy answer to the question of which is more real. Realism in photography is something which is to be found in varying amounts and in different forms.

Photographers have had to solve many problems which would never have presented themselves to painters. Barbers' shops were non-subjects for a start – having your hair cut was an everyday experience beneath the contempt of painters. Even of those who would have considered realism as one of the cornerstones of their artistic credo.

Photography had no conventions laying down what was an what was not appropriate subject matter. Can you imagine a painting or even an illustration of this subject photographed by Harry Allen in 1894 – 'Taking a Raven's Nest from the Pembrokeshire Cliffs'? And how would a painter have tackled the scene above – The Prince of Wales about to go for a carriage ride with Lady Lilian Wemyss and the Earl of Dudley with his mother the Countess? Certainly not in the way the photographer Thomas Bennett has arranged the group here. Members of the house party stand back to give pride of place to Lady Lilian who stands at the centre of a complex construction of pillars, coach and coachman. Lady Lilian's husband Randolph Wemyss had walked out on her three years previously at about the time that she had gone on a continental jaunt with the Prince of Wales. Here she has been singled out as the centre of attention, and seems to stand on the sweeping line of the carriage – Venus arising at the huge Dudley mansion of Witley Court.

H.R.H. The Prince of Wales, the Earl and Countess of Dudley, and Lady Lilian Wemyss at Witley Court, 10 December 1892
Thomas Bennett 1892

Taking a Raven's Nest from the Pembrokeshire Cliffs
Harry Allen 1894

Evening —
a study of the
Matterhorn
Herbert Ponting
1907

Gradually photographers gained confidence and begin to explore the visual opportunities offered to them by the camera. Photography began to assert its independence, and photographers alert to the possibilities offered by the new medium produced work which displayed new confidence, new vigour and a new vision. We can see something of this crucial development in these photographs taken in the Alps.

Herbert Ponting took this photograph entitled *Evening – a study of the Matterhorn* in 1907, three

[66]

The Merjelen See at
'high water'
Henry Speyer
1902

years before he left with Captain Scott's expedition to the South Pole, on which he served as 'Camera Artist'. Ponting is not satisfied with recording the Matterhorn with its banner of cloud, dark buttresses of rock and with its glaciers and snowfields catching the last of the sunlight. He has found a position where the water in the mountain lake catches the light and forms not a real reflection – the ripples on the surface of the water make that too indistinct – but a balancing shape which acts like a reflection. Dark mountain against light sky, balanced by water reflecting light set against black rocks. To complete this *study* – a significant word – Ponting places a mountaineer on the left who appears in silhouette, breaking the skyline, and gives some idea of the vast scale of the mountains. Man's insignificance – Nature's magnificence.

Henry Speyer was also a mountaineer who had a great deal of experience both climbing and photographing in the Alps. His work was admired for 'the wonderful manner in which he is able to represent the transparency of great walls of ice, the awful grandeur of lofty snow-clad peaks, the shimmering whiteness of the snow-fields, and the glaciers, and seracs, and cornices.'[2] Alpine photography had as its subject-matter barren and inhospitable mountains, and it was comparatively difficult to incorporate those elements of picturesque sensibility which tended to blinker photographers who trod the lusher lowland pastures of Britain in the steps of painters. In addition Alpine photography was valuable as a scientific record. Appeals were made for photographers to take pictures of glaciers, showing their advance and retreat, also 'anything bearing upon the question of the share borne by ice in formation of lakes'. The writer of this appeal added: 'Such photographs should be taken far more for these purposes than as artistic views.'[3]

Speyer had the opportunity to take photographs which were both visually pleasing and scientifically informative. These three photographs were taken by him in Switzerland in 1902 on a large-format camera set on a tripod. It is as if he concentrates more and more intensely on the mountains and the ice which he sets his camera to record. In the first photograph, reproduced above, he shows *The Merjelen See at 'high water'* caught by shafts of sunlight which shine through a gap in the clouds hanging heavy over the mountains beyond. In the second, overleaf, he chooses to photograph towers of ice – séracs – from close to. They are thrust in towards the viewer and we lose any sense of scale as the largest of them rises up towards the peaks behind. In the third we are presented with a scene which is straightforward in its presentation but complex in its effect. This is an accurate record of glacier ice at the edge of a high mountain lake. It is also a very strong composition of Speyer's choosing, with the division made at the point where the water meets the ice cliff emphasising the pattern-making created out of cold facts.

Each of these photographs by Speyer takes us a step further away from the manner in which this subject might have been tackled by painters – in the unlikely event of them choosing glacial ice formations as subject matter. They are clear statements of facts which transcend mere record-making, photographs which owe nothing to painting – images displaying original methods of re-presenting the world, the unique creations of Fox Talbot's 'art of great singularity'.

▷
Séracs near the Great
Aletsch Glacier in the
nearly empty bed of
the Merjelen See
Henry Speyer
1902
▷▷
The Merjelen See,
partially empty,
showing the exposed
side of the Great
Aletsch Glacier
Henry Speyer
1902

[67]

The Light of the Future

Miss Dorothy Dene
Henry Van der Weyde
1886

in the use of artificial light in photography.

One of the biggest problems faced by British photographers was to get enough light into their studios to enable them to work. Virtually all exposures, and prints made from the resulting negatives, had to be made by available daylight. It was not easy to take effective portraits under dull grey London skies or on a short, foggy winter's day.

Having experimented with redesigning the glazing of studios, Van der Weyde tried to condense light entering a studio by constructing a massive lens – he claimed it was the largest in the world – measuring over six feet across. It was formed by two sheets of glass each three-quarters of an inch thick. One of these he made convex to a depth of eight inches and formed a plano-convex water lens by filling the gap with filtered water weighing 987 pounds – in all, about the weight of an out-of-condition cab horse. This was the contraption which fell on him. As he stepped underneath it to test the light 'there was a terrific explosion, a shower of glass and water, and I found myself on the floor drenched to the skin, and my right fore-arm pierced through between the bones with the point of a huge jagged splinter of glass, cutting the artery, and laying me up for six weeks; fortunately for me, I knew how to improvise a tourniquet.'[1]

He looked on this catastrophe philosophically as 'only a detail in the life of an inventor' and continued to think big. He ordered a Fresnel annular lens four feet across – as used in lighthouses – to collect and direct light. Through this he shone electric light from a Serrin lamp powered by a huge battery, and the first test sitter was a relative of his: 'He was placed so close to the apparatus that his face turned fiery red, and streamed with perspiration – I literally roasted him.' Once he had eliminated the worst of the heat, he knew that he had a workable system which would enable him to take studio photographs by artificial light.

No London photographer was prepared to exploit his invention and so in 1877 Van der Weyde himself set up a photographic studio in Regent Street, London – then the most prestigious address for a portrait photographer. His studio was lit not by daylight but by a Crossley gas engine driving a Siemens dynamo, which in turn fed an arc light in a five-foot reflector providing 4,000 candle-power illumination.

In 1876 Major Henry Van der Weyde of the U.S. Army, who had fought at Yorktown, Bull Run and Gettysburg, and had his horse shot from under him at the Battle of the Wilderness, was floored and nearly drowned by the explosion of his latest invention.

After the civil war he had come to England and become a portrait painter, exhibiting work at the Royal Academy. At the same time he tried to make his fortune through inventions and patents, and this activity was eventually to make the Major a pioneer

This was the first commercial photographic portrait studio to rely entirely on artificial light, and the technical advances which it embodied were to transform studio photography the world over. Exposure times dropped to only a few seconds. Photographs could be taken as easily at night as during the day, and in addition electric light greatly increased the photographer's speed of working. One night in 1877 Van der Weyde took thirty-four negatives between nine and eleven o'clock in the evening. New commercial possibilities were opened up. A lady called in at the studio and had her portrait taken on her way to the opera. She was provided with a proof print of her photograph whilst in her box at the theatre – the negative had been taken and the print made by electric light. Van der Weyde boasted that 'I never took, and shall never take, a photograph by daylight.'

When he exhibited prints at exhibitions he was pleased to receive press comment that in his work 'the shadows are so skilfully modified that they compare favourably with pictures produced by natural light.'[2] This had been his objective from the outset. But in the eighties, as these two examples show, he became interested in the effects which could be achieved by photographing in close up by artificial light. Miss Dorothy Dene directly confronts the camera and is photographed with the light coming from behind her; Miss Adelaide Detchon peeps coyly upwards from the shadow of her fan.

Light was now at the service of the photographer rather than the other way about. These bold poses would have been next to impossible in daylight and reflect the way in which artificial light both extended the range of photography and, by handing control of light to the photographer, gave the medium a new sense of freedom. Studio photography of all kinds – portrait, theatrical, fashion and advertising photography were all to benefit immensely from these advances. The very forms they were eventually to take were made possible by flexible sources of artificial light.

Unfortunately, although Van der Weyde had hitched his fortunes to the rising star of electric light – 'the light of the future' – and had been first on the scene, he had not the business skill to profit from his inventions and exploit the opportunities they offered. Of fifty-eight patents either taken out or applied for,

none of them proved financially successful for him. In 1901 The Star Ice Company Limited, which had been formed to work one of his patents involving the trade-marking of pure ice, went (appropriately) into liquidation and in the following year he went bankrupt. His photographic business – when he found time to turn his attention to it – had always paid. What had ruined him was, as he admitted, his 'want of business habits' and his 'weakness for inventing.'

Miss Adelaide Detchon
Henry Van der Weyde
1884

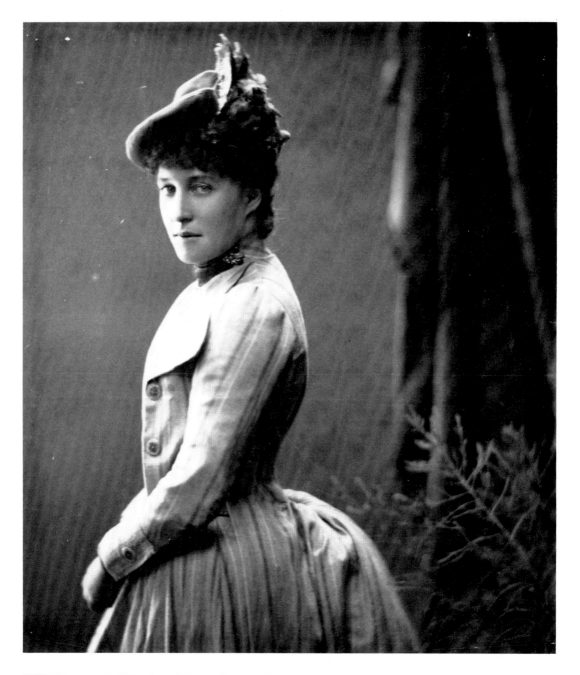

Mrs Langtry
Hayman Seleg
Mendelssohn
1888

Mrs Langtry in the
character of
'Cleopatra'
Henry Van der Weyde
1890

Miss Dorrie Keppell
Rita Martin
1910

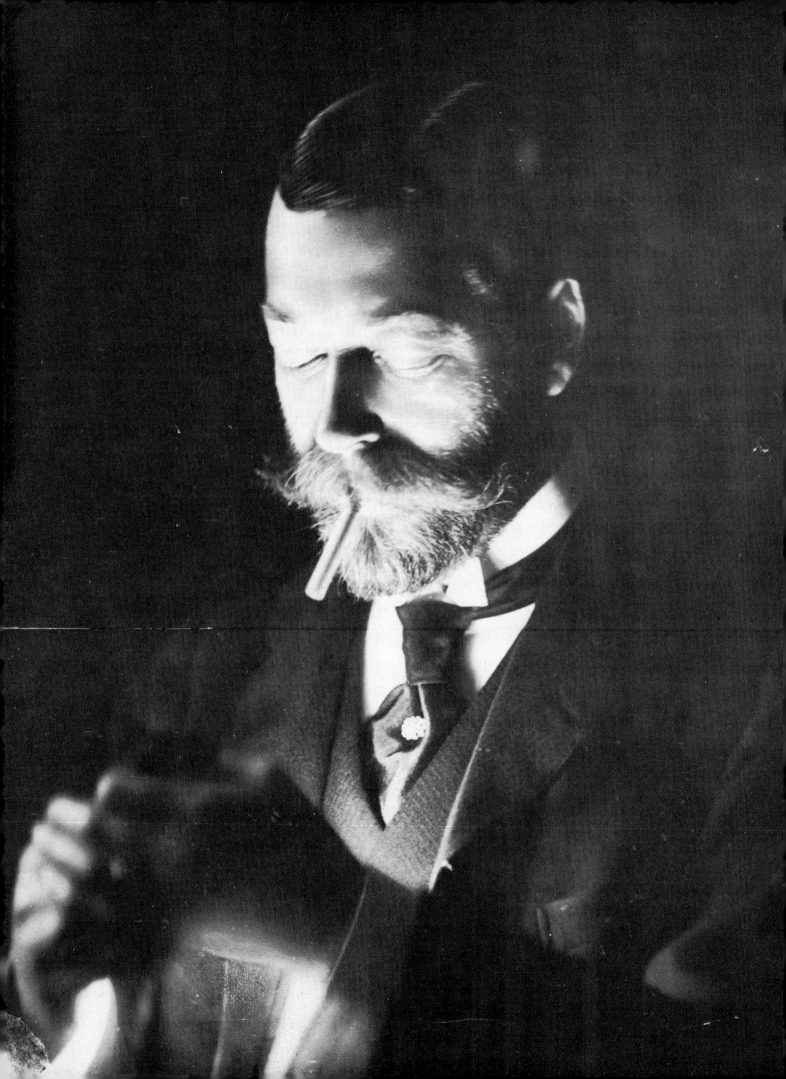

Pyromaniacs and Living Daylight

Artificial lighting also provided photographers with new opportunities outside the portrait studio. But they were rarely able to make use of electric lighting. Until the flashbulb was invented photographers had to cast light on their subjects by firing off magnesium flash powder. These hit-and-miss pyrotechnics could be very dangerous and the results often spectacular, and not always in the way that the photographer intended. One early press photographer tried to take a photograph from a balcony in St Paul's Churchyard of the crowds celebrating the arrival of the New Year:

As the hour approached he piled up a great heap of powder on a tray, and at this moment it began to rain – always a dangerous matter in outside flashlight work.
 The hour of midnight struck.
 Instantly there was a blinding flash, a terrific explosion, and the cries of frightened people. The flash had gone wrong! The balcony was badly damaged, windows were shattered, and the expert lay unconscious.[1]

He survived and spent several weeks in bed furious that although he'd let the New Year in with a bang, he'd failed to get his photograph. His fellow pressmen, who sometimes mixed gunpowder with their flash powder, went on their way like demented anarchists, grabbing flashlight shots and then running. Policemen rushed to the scene to investigate these terrifying explosions; public meetings had to be halted and halls evacuated until the rolling white smoke produced by some intrepid photographer had cleared and the audience could see the platform speakers again.

The photograph below was taken by John Burrow in a mine passageway at Easton Colliery in the Somerset coalfield. In mines where there was the danger of igniting gases underground a flashlight photograph could have caused a catastrophic explosion. Even in comparatively safe mines like this, where the pit lad sees his way by the light of a naked flame and not a safety lamp, there were difficulties with coal dust and with the smoke which followed the firing of magnesium flash. Burrow used to use both limelight burners and flashlights burning magnesium ribbon to take photographs like this showing the work of miners underground. This 'triggle chap' had the job of dragging a sledge carrying coal from the coal hewers working at the face along a low passageway to the point where the passage widened and the coal could be transferred to trams. Taking photographs like this was difficult – the work had to be done in very cramped conditions. Blasting was going on as usual in the mine; there was dust in the air and water dripping from the roof. Burrow succeeded in overcoming all these obstacles and allows us to see by artificial light what life is like down a pit.[2] Not only that; by the way the photograph has been arranged and lit we get an idea of how much physical effort this lad's job involved as he dragged his way through the pitch blackness.

Pit lad called a 'Carter' or 'Triggle chap' drawing coal from little vein coal face to tram, Easton Colliery
John Burrow
1906

The Prince of Wales lighting a cigarette
Robert Johnson
1903

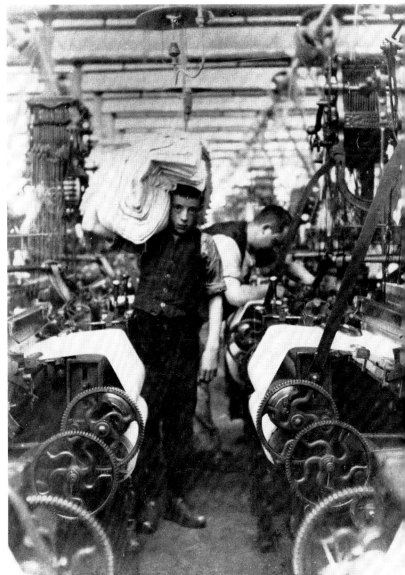

Warehouse boy
bringing weaver up
and
Weaver taking ends
up and tenter taking
piece up
John Richardson
1906

A maid ironing
John McMichael
1899

In the mid-nineteenth century photographers had spent much time and effort – like Van der Weyde in his earlier days – in trying to control the light in their studios by means of specially angled windows, and blinds. The development of electric lighting gave them the total control they wished for. Other technical developments were opening up new opportunities for photographers. Plates and films were getting faster, and cameras were getting smaller and easier to carry. Photographs could now be taken under most lighting conditions, indoors or out. On the left is a photograph by John McMichael of a maid ironing which would have been carefully posed, but taken by available daylight. This is what gives the photograph its delicacy of lighting – look at the crockery on the shelves in the background – and a freshness of vision which makes it seem as though you have just turned the corner and seen her there, as the sunlight streams in through the window and is reflected up onto her face.

Given equipment which didn't bring major disruption into every situation in which it had to be set up, photographers could set out to photograph almost anything they chose and know that at worst they were only going to have to ask their subjects to hold still briefly. The photographs above were taken in the weaving shed of a mill, probably in the photographer's home town of Nelson in Lancashire. You can see the weaver setting his looms and getting the lad to take away a finished piece of cloth. There's a fish-tailed gas burner lighting them from above but otherwise they're taken by available light. Here's another glimpse of working life – an area of everyday experience which went almost unrecorded.

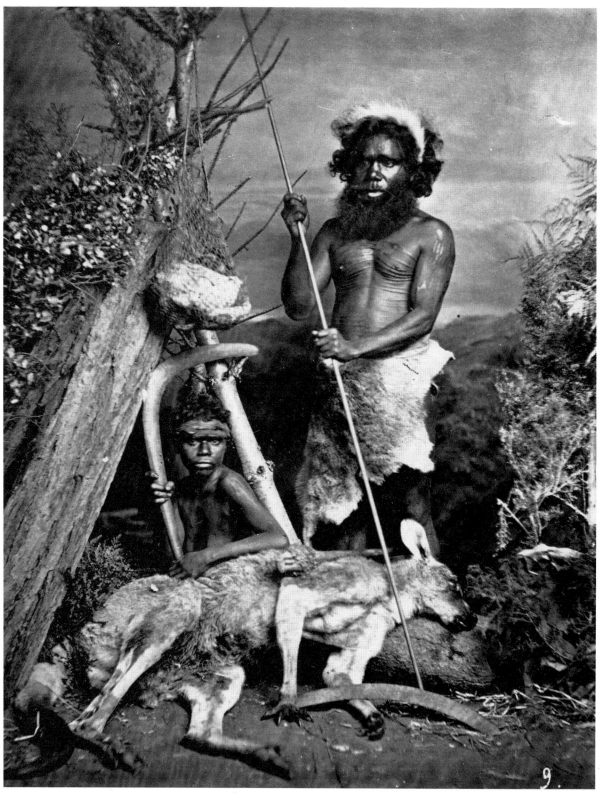

Australian aboriginal
John Lindt
c.1872

The technical developments which freed photographers from the constraints and restrictions of the studio also made a considerable impact in other specialist areas of photography. Anthropologists were using photography to record native life, but their efforts were often far from realistic. Everard im Thurn, who had photographed extensively in Guiana, addressed the Anthropological Institute on the subject and criticised the way in which many photographs taken gave no real idea of what native life was like:

Just as the purely physiological photographs of the

anthropometrists are merely pictures of lifeless bodies, so the ordinary photographs of uncharacteristically miserable natives . . . seem comparable to the photographs which one occasionally sees of badly stuffed and distorted birds and animals.[3]

He placed great emphasis on gaining the confidence of 'uncivilised folk': by putting them at their ease you could hope to get fairly representative photographs.

Some of the early anthropological photographers had tried to restage 'typical' native life in studio mock-ups. John Lindt photographed these Australian

[78]

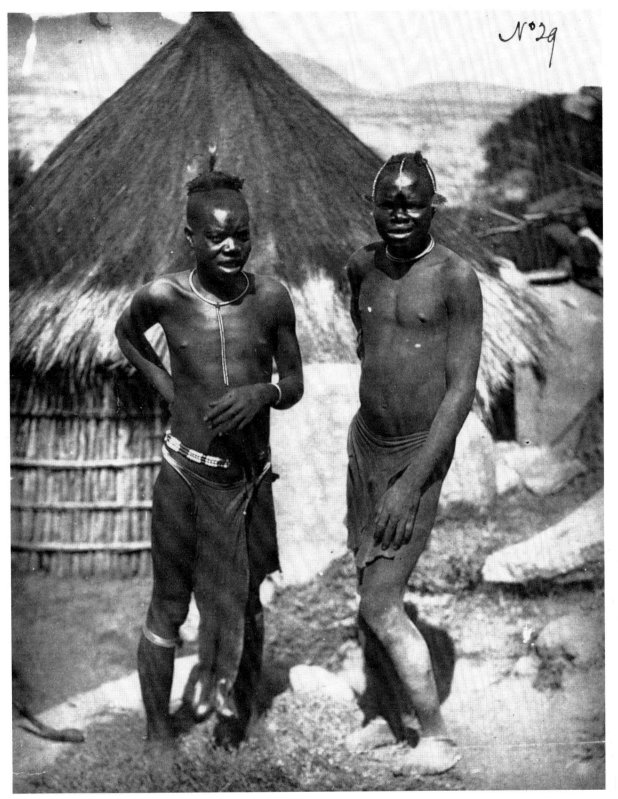

Aborigines (above, left) in his studio in the early 1870s, and has obviously posed the figures carefully and constructed the scene until it looks right to his Western eye (he was a German immigrant to Australia). I've no doubt that every prop is authentic – even down to the dead kangaroo. But in this photograph we can see what Everard im Thurn meant – their bodies *are* lifeless. These aborigines have been brought into the studio to re-enact their outdoor life – here are im Thurn's 'uncharacteristically miserable natives'.

In contrast, the photograph on the right taken twenty years later in Mashonaland is full of life and gives a much better idea of what it was like to travel and to meet people with a completely different culture and way of life. William Fry must have asked them if he could take their photograph, but he has not asked them to act out the sort of snippet of native life which these days might be used to rouse the interest of tourists. This is *their* land and *their* village. The photographer is taking them on their home territory and not transplanted to the artificial environment of the studio.

Two Mashonas,
Mashonaland
William Fry
1891

[79]

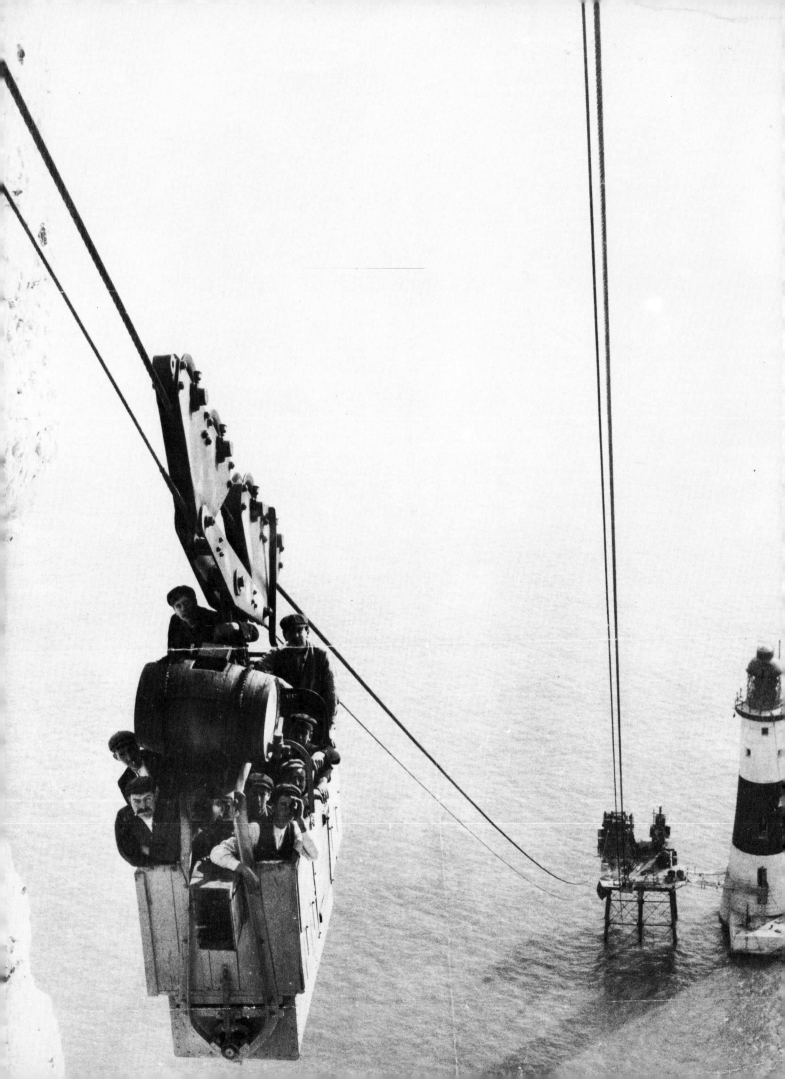

Points of View

Most photographs present us with views of the world which seem to tally with what we can see with our eyes. Many photographs are taken at eye-level and show 'normal' views of familiar objects – here, right, the Eddystone Lighthouse photographed in 1863 by William May as if from a boat approaching the rock.

Herbert Briggs' shot taken at Beachy Head forty years later is a more complicated photograph from a more unusual point of view. The effect of perspective, emphasised by the converging lines running down to the work platform, makes the lighthouse appear smaller than the workmen packed into the cable car suspended close to the cliff face, far above the sea.

All this would have been visible to anyone watching from the top of the cliff. What the photographer has done is to isolate the elements of the scene he wishes to record and, by waiting for the right moment, to emphasise the precariousness of the ride the men are taking so nonchalantly. Because the top of the cable car run is out of sight it seems as if they are suspended miraculously in space, like voyagers marooned but within sight of land.

'A new angle' can change the whole balance and meaning of a photograph. Unusual photographs often result from unusual situations. The photographer selects a point of view which is non-standard, and by showing only part of a familiar object from an unfamiliar angle he can create 'new' shapes which confuse because they are atypical and not easily recognised.

George Carle's photograph of RMS *Adriatic* in dry dock, over the page, shows a gleaming monster rearing up like a metallic, man-made thunderhead. The rudder has been photographed end-on and has almost disappeared from view. The tiny figure of the man climbing the ladder ascends into light which seems to transform the shape of the stern – flattening it off, or even turning it inwards.

Photographs can use new angles in photography to try to breathe new life into old and jaded subjects. But these acts of desperation are much less interesting than photographs which function as revelations, showing the world anew, the world as we never remembered seeing it.

Men descending in the car on the aerial railway at Beachy Head; Herbert Briggs; 1903
The Eddystone Lighthouse; William May; 1863

The nose of Dr Barton's airship photographed from inside; Charles Beckmann; 1903 ▷
Looking up a chimney shaft at Lots Road Power Station, Chelsea; John Sullivan; 1904

Stern view of R.M.S. *Adriatic* in dry dock; George Carle; 1907 ▷▷

Mixed Motives

Holidays
Robert Slingsby
1885

Photographs offer instant visual access to the past. Many books have been published to provide reflections of lost time and satisfy the public's appetite for nostalgia – the dream of a golden past. Almost any photograph will do; just make sure that it prints reasonably well and give it a caption. These two photographs might well find a place in such a book under the heading 'At the Seaside', with captions reading *A Victorian family on an outing to the beach* and *A bathing woman*. Neither caption is untrue, but they're both completely misleading.

The first thing to notice about people who set out to pilfer the visual past by misappropriating photo-

graphs is that they very rarely mention the name of the photographer. Factual captions can be quite informative, but you can learn almost as much by finding out *who* took a photograph and, following on from that, *why* they took it.

The first photograph is titled *Holidays* and was taken by Robert Slingsby, who was a professional photographer in Lincoln. He had no intention of producing a photograph which would record for posterity what a Victorian family looked like on the beach. Slingsby was in his heyday 'a frequent, prominent, and successful exhibitor at the principal photographic exhibitions'.[1] Prizes were awarded at these

exhibitions in the form of medals which brought not only personal satisfaction but also financial benefits. Almost any commercial portrait photographer worth his salt had a set of facsimiles of medals he'd won with which to embellish the back of his photograph-mounts. This medal-gathering was a peculiar mania of the time in which the photographers were joined by the brewers of bottled beer and the makers of patent sauces.

Robert Slingsby called his photograph *Holidays* – this is a *study*, an evocation of a lazy summer day on a family vacation. The photograph is full of evidence of careful consideration. Great care has been taken in deciding where the figures should be placed and what they should be doing. The composition has been very carefully worked out, making the best possible use of the sunlight, and the background has been thrown out of focus, leaving the family grouped around the boat standing out sharply. Although this photograph was taken only a few years before Kodak and other hand cameras arrived on the market, it is quite differ-ent from any casual snapshot. It is static and studied, and was taken on a very large plate camera producing negatives eleven inches by nine. This is a photograph taken by a professional, not an amateur; a photograph to show how skilled the photographer is both technic-ally and 'artistically'.

The second photograph was taken by William Marsh and shows *Mary Wheatland the Bognor Bath-ing Woman* – you can see her name on the ribbon of her straw hat. The key to this photograph, taken al-most twenty years after the first, is the boom in the sale of postcards which took place at the beginning of the century. Professional sold postcards to make extra money during the tourist season. This was taken in 1903, and in the same year an article by 'A Profess-ional' appeared urging photographers to wake up to the opportunities of doing business in 'this new and growing line' of postcards:

The best subjects for regular sale are the stock views of the town, the principal business thoroughfares, public buildings, and chief residential roads. The latter especially are growing in importance as the post-card cult spreads, for people who have met at the holiday resorts and wish to exchange greetings through the post like to have a view of their own road, if such happens to present a good appearance. . . . Local 'characters' of the streets, if well known and at all picturesque, are sound subjects, and easily secured with a hand camera.[2]

So that's why we have this photograph of Mary Wheatland. She's a little bit of Bognor – a local sight, a memorable figure with her freshly-tied bow, her medals (for lifesaving?) and her striped bathing cos-tume. Another one for the album.

Both of these photographs were taken for a specific purpose. Their form was dictated by their function. Visual meanings can be elusive, and the only way to ensure that what you think you see matches what the photographer intended to convey is to pinpoint meaning using the latitude and longitude which help locate a photograph – *motive* and *context*.

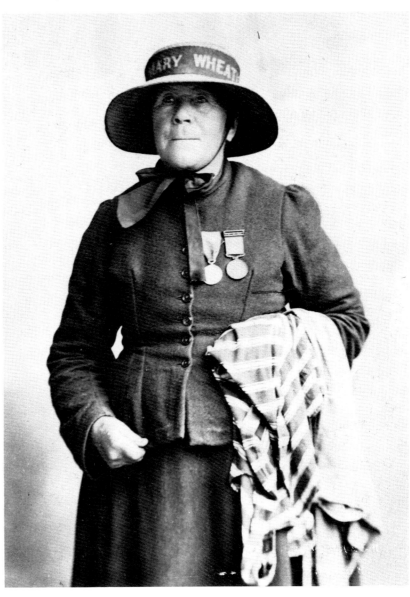

Mary Wheatland the
Bognor Bathing
woman
William Marsh
1903

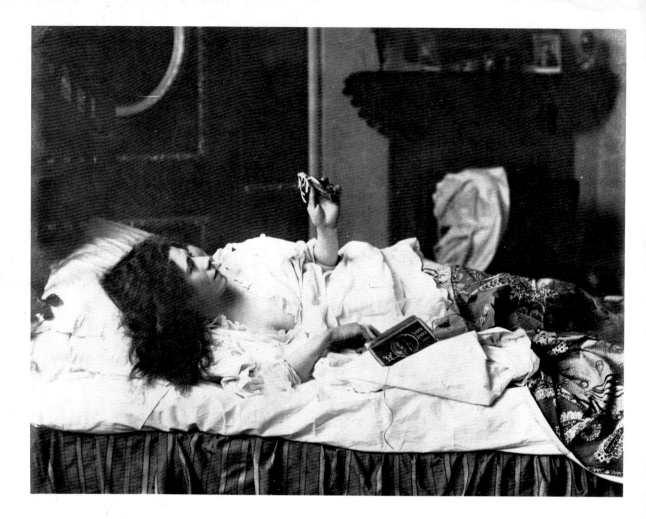

Conflicting Views

If a photographer approaches a subject directly you'd think there would be no problem in understanding what it is he's trying to show. But we're all so used to standardised ways of tackling subjects that any photograph which departs from stereotyped methods of presentation tends to obscure and confuse.

War is hell, according to General Sherman – so what are troops doing in this corner of paradise? They're Boer snipers posed as if ready to fire across the Tugela River at British troops. Take away the guns and the men would seem to be enjoying some tourist beauty spot. But they're in deadly earnest – people get shot in idyllic locations such as this. Guns turn fields into battlefields, rocks into 'cover' for troops, and the landscape into territory to be fought over. It might seem more grimly appropriate for a soldier to be shot while he's knee-deep in mud, stuck in a shell hole, but in war Death casts a long shadow, even into the most idyllic and peaceful places. There are no heroics here, just crack shots trying to pick off

their enemy. *A Matter of Outposts* is the title Reginald Sheppard gave his photograph – deliberately neutral and low key. Because it doesn't conform to our idea of what war *should* look like this photograph may at first seem confusing. But if you keep looking it becomes a much more disturbing picture of what war involves. These Boer farmers are playing the rôle of soldiers. The beautiful Tugela river is the front line. War makes monsters of us all. Here are gunmen in paradise.

The photograph above also dates from the time of the Boer War, and also presents difficulties in understanding its meaning. The woman has opened a parcel which has arrived from her husband who is away at the front, and is looking at a miniature of her husband, exclaiming *Ah!! My husband, he's not an absent-minded beggar*.

This is a reference to a poem by Rudyard Kipling which was very well known at the time. *The Absent-Minded Beggar* was written to raise money to help

A MATTER OF OUTPOSTS; BOER SNIPERS EXCHANGING SHOTS WITH BRITISH OUTPOSTS
BELOW TUGELA FALLS

soldiers' wives and children. Kipling didn't need telling that it was a vulgar piece of verse which had no right to be described as poetry, but it did the job he intended it to. It appeared in the *Daily Mail* and Kipling appealed directly to the British public to do more than stay at home 'killing Kruger with your mouth', and to give financial support to the absent-minded beggar in khaki ordered South:

There are girls he married secret, asking no permission to,
 For he knew he wouldn't get it if he did.
There is gas and coals and vittles, and the house-rent falling due,
 And it's more than rather likely there's a kid.
There are girls he walked with casual. They'll be sorry now he's gone,
 For an absent-minded beggar they will find him,
But it ain't the time for sermons with the winter coming on.
 We must help the girl that Tommy's left behind him!
Cook's son – Duke's son – son of a belted Earl –
 Son of a Lambeth publican – it's all the same today!
Each of 'em doing his country's work (and who's to look after the girl?)
Pass the hat for your credit's sake, and pay – pay – pay!¹

Kipling told how: 'Sir Arthur Sullivan wedded the words to a tune guaranteed to pull teeth out of barrel-organs. Anybody could do what they chose with the result, recite, sing, intone or reprint, etc., on condition that they turned in all fees and profits to the main account – "The Absent-minded Beggar Fund" – which closed at about a quarter of a million.'²

John Henry intended to show in his photograph 'the home that Tommy's left behind him' – and the girl that Tommy left behind him, in this case his own wife Louise posing for the camera.

To lie in a warm bed with clean sheets next to the soft body of the woman you love – this very unusual and personal image must have encapsulated many a soldier's dream of home. The woman in the photograph is beautiful, but she's not transformed by any mistaken attempts to glamorize her. It's an erotic photograph of a very special and personal kind. She is not the temptress looking you in the eye and giving you the come-on. She's the loving wife, looking at a picture of her husband, and waiting for him – for her lover – to come back from the war.

Some of the wives and lovers of the absent-minded beggars in the Inniskilling Fusiliers and the Connaught Rangers would have to wait in vain. As General Sir Redvers Buller pushed on to relieve Ladysmith, they came under fire in the battle for the Tugela Heights. The ground near the Colenso Falls, which we can see in the first photograph, was cleared of Boers by artillery and by the fire of the Scots Fusiliers from the opposite bank. Then the Inniskillings and the Rangers went in, hugging the bank of the river for cover and moving in single file. As they moved slowly along just above the Falls on the afternoon of 23 February 1900 they were picked off by Boer snipers. Several men fell and lay there with their feet embedded in the mud of the river-bank and with their heads in the river. The rest of the brigade had to step over their bodies as they advanced.³

Those absent-minded beggars never returned.

All on Fire with Great Ideas

In 1867 one of the first critics to tackle the daunting subject of 'photographic aesthetics', writing under the *nom de plume* of 'Aliquis', made an attack on the 'art photographers' of the time – people like H. P. Robinson — who were seeking public acclaim by combining different negatives to produce photographic pastiches of current trends in popular academic painting. 'Such attempts at composite photographs cannot be too severely condemned,' he thundered: 'They are not works of art in any sense of the term'.

Behind this article and behind the struggles of these photographers, who were convinced that they were ugly ducklings and dreamed of becoming swans, lay the whole question of what photography's role should be, and what subjects were suitable for the camera. As far as 'Aliquis' was concerned, allegorical photographs should not be attempted, and he once more tried to drub into his readers two maxims – two stars to steer by in the darkroom:

1 *Photography has no scope for direct embodiment of ideas.*
2 *Photography deals only with the actual.*

Photographers who did not take these maxims to heart were suffering from 'misapprehension of the peculiarities of the new art being so uncompromisingly restrictive of all idealism.' To turn aside from the real world and to try and reconstruct a world of the imagination in the photographer's studio was, to him, sheer madness:

How is the aspiring poetic genius, all on fire with great ideas, to spiritualise by photography a woman of indifferent features in gauze wings and a night gown? By sticking a tin nimbus round her head, perhaps! We can imagine the sore travail of such an one, burning to excel in 'the poetry of art, sir.' See him tearing away at his model like a stoker at his engine fire, wasting no end of chemicals and plates in fruitless efforts to get a proper expression. 'Don't hold that hammer so like a feather, now, will you? Grin – look more askance – keep your chin in – take care, you'll be squashing that ere wing against the sky if you don't mind – keep your elbow clear of the moon. Darn it! if she don't look as sweet as a she *bear* goin' to eat one! You'll never do for a *h*angel, you won't!'

This wasn't photography's true role: 'One cannot contemplate the idea of a man devoting himself seriously to such work without a feeling of profound pity, mingled, I must confess, with a strong sense of the ludicrous.' And he concluded by restating his firmly-held conviction: 'Remember that photography is a noble instrument for recording realities – things as they are.'[1]

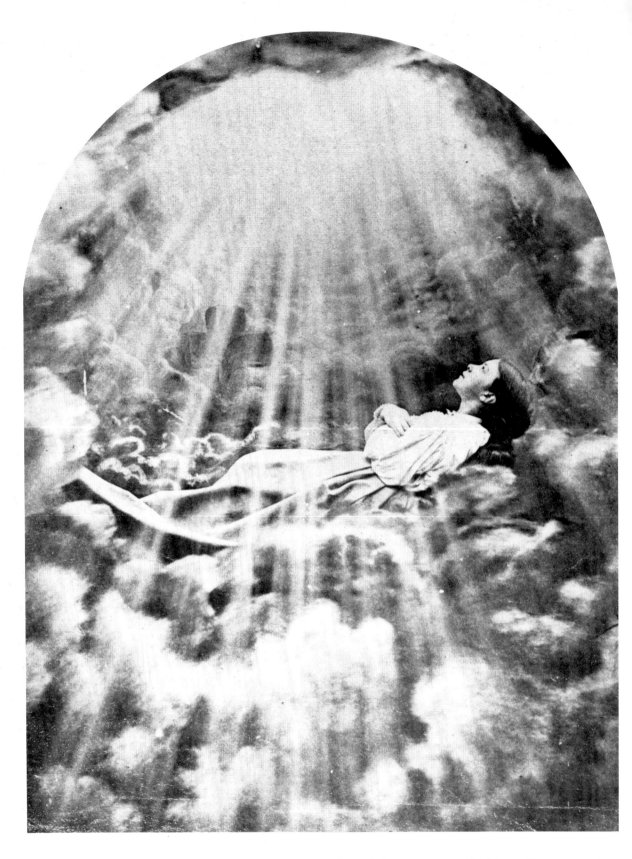

Realms of Light
Charles Tune
1872

But there were photographers who were not prepared to restrict themselves to the making of records of the real world and, 'all on fire with great ideas', struck out on their own into the unknown. Here is a photograph entitled *Realms of Light* produced by Charles Tune a few years after that article, in 1872. The figure, with arms folded across her breast as a sign of chasteness or as if laid out like a corpse in a shroud, opens her eyes and gazes heavenwards. Light streams down in a glorious sunburst, and a cross can be seen in the swirling mists of infinity beyond. Here is a photograph of a soul ascending into heaven; and – given the extraordinary nature of its subject – it's a photograph which works surprisingly well.

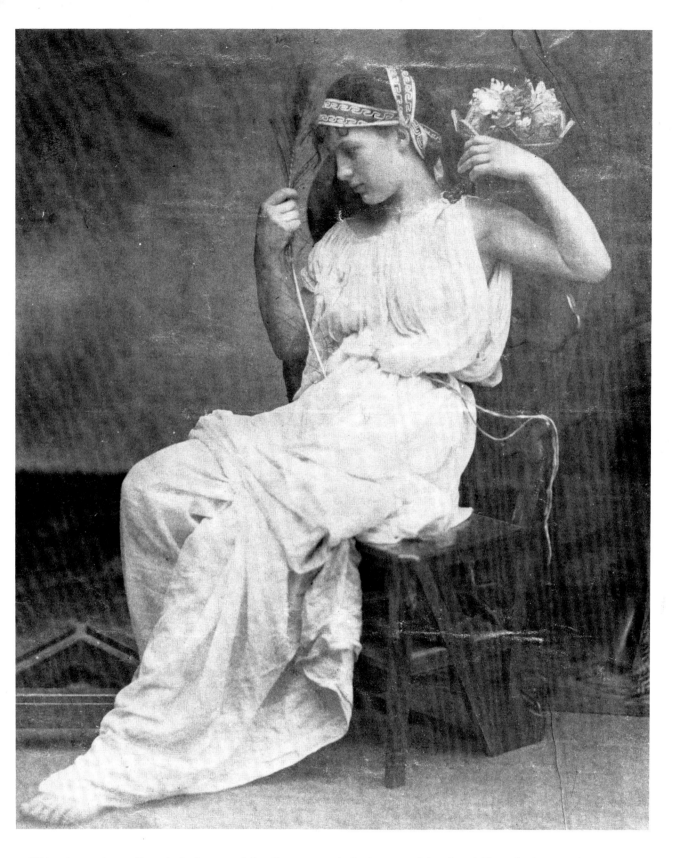

This picture is an allegorical photograph by Oscar Gustaf Rejlander from the same year, which is titled *Flora contemplating Vanity*. The girl holds a peacock's feather in her right hand and a basket of flowers in her left. She is barefoot, and her dress and the ribbons around her head are intended to read as 'classical'. Rejlander had studied painting and had been particularly interested in the ability of photography to record accurately the folds of drapery. He probably regarded it primarily as a study for painters; this figure has, incidentally, echoes in the work of painters such as Alma-Tadema who pursued a classical ideal, although I think that the photograph is interesting in its own right.

Flora contemplating Vanity
Oscar Gustaf Rejlander
1872

Penelope mourning the departure of Ulysses
Emilio Zambra
1896

Science presenting Humanity with the Power of Flight
William Zelger
1910

The photograph above is by Emilio Zambra of the London firm Negretti & Zambra, makers of cameras and photographic equipment. They held the monopoly for photography at the Crystal Palace at Sydenham, and Zambra took various studies – usually of girls – in the ready-made settings which the Crystal Palace provided, for example the Alhambra Court, and the Pompeian House, where this was taken. It is titled *Penelope mourning the departure of Ulysses* and was taken in 1896. Such an ambitious subject, played out by Victorian models dressed up as Greek maidens in a corner – even though it's an *appropriate* corner – of the Crystal Palace might reasonably be expected to fail miserably. This does not, which says a great deal for Zambra's skill in posing his models and his striking use of lighting. Penelope is collapsed into a graceful heap of drapery, with the sunlight dappling her clothes and her neck and arms. The face and the arm of her companion coming forward to comfort her stands out against the dark background in profile.

But not everyone had the sensitivity and the wisdom to understate, which Rejlander and Zambra shared. There were photographers such as William Zelger who boldly went where no photographer had been before. To understand fully the photograph on the right, which dates from 1910, you must read how Zelger described it when he registered it as copyright:

Photograph, *the Earth*, a female figure representing Humanity chained to same; A Second female figure representing Science presents humanity with the Power of Flight in the shape of an Aeroplane. (Symbolic)

The poor girl representing *Science*, suspended half-naked from the studio roof, manages a brave smile as she hands her remarkable biplane – a Wright Flyer – to *Humanity*, who is showing a lot of leg and is manacled to the ground.

Zelger's photograph remains earthbound, like one of those amazing early flying machines which took some aspiring aeronaut years to construct, but which failed when it came to the test. Although its theme is *The Power of Flight*, his photograph is incapable of taking to the air. Like many photographers who abandoned the real world and took to allegory, Zelger could not distinguish between the sublime and the ridiculous.

Sign Language

Holman Hunt and
Ruskin at Coniston
Frederick Hollyer
1894

John Ruskin
Frederick Hollyer
1894

One of the most sensitive portrait photographers of the late Victorian period was Frederick Hollyer. In September 1894 he travelled to the Lake District to photograph John Ruskin at his home, Brantwood near Coniston. These two portraits were taken during this visit and present us with very different images of Ruskin. One shows a prophet, the other an old man. One presents us with the public image, the other with the private reality. One functions as a symbol, the other as a likeness.

In the photograph on the right we have the image which the world expected to see. Ruskin is seen as the venerable sage – frail and white-bearded but still formidable – gazing out at the beauties of Nature from the shadows of his book-lined library. He appears here as a far-sighted prophet, a symbol of timeless wisdom.

But by now he was old and living under the shadow of bouts of madness. He could hardly write and said little more than yes and no. A friend who had visited him the previous year wrote that: 'The days of con-flict, of Lear-like storm and suffering, are over, and the poor old wizard is no longer on the rack but in the armchair.'[1]

Hollyer's other photograph shows Ruskin as a shrunken old man, lost inside his overcoat, sitting next to the painter William Holman Hunt. No words are spoken as he lays his hand on Ruskin's arm and looks into the eyes of his old friend. It is a most touching and eloquent gesture, and a most moving photograph. Some years earlier Holman Hunt had written to Ruskin: 'I always wish to remember you as my first soul's friend',[2] and this photograph conveys the genuine warmth and affection of the friendship between the two men.

Hollyer has the skill and the sensitivity to produce these two quite dissimilar portraits which offer penetrating insights into the decline of a once-great man. It is debatable which of the two – the symbol of the wise man or the image of the old invalid – presents us with a more truthful and accurate portrait of Ruskin.

[94]

S.S. *Lusitania* and
New Brighton Tower
George Searjeant and
Joseph Mumford
1907

Photographers realised that they had a wide variety of devices available to them to convey meaning and that the message carried by the photograph could be modified by the manner in which it was communicated.

The basic message of these two photographs is the same – 'this is a very big and powerful ship,' but the means by which they convey this message are quite different. The *Lusitania* and her sister ship the *Mauretania* were built for the Cunard Company with financial assistance from the British government. Designed for the Liverpool–New York transatlantic crossing, they could each carry over two thousand passengers, one thousand of them (the first and second class) in luxurious accommodation. They were the biggest ships in the world, each with a gross tonnage of 32,500 tons, and were described as 'floating palaces', with spacious cabins and lavish facilities. The huge power from their marine turbines – engines which embodied the most advanced technology of the day – thrust them through the water at an average speed of almost twenty-five knots. One unusual detail was that these transatlantic liners were fitted out ready to be mounted with twelve six-inch guns.

These ships were built to be impressive and to dominate. They were British champions, designed to win a race in which the honour of the nation was at stake. The prize to be won was the blue riband, and it was expected that one of these great liners would win back for Liverpool the proud position she had held as the port of the fastest Atlantic liners.

The adversary in this commercial cold war which developed on the North Atlantic was Germany, and it was with the growing naval power of Germany in mind that the British government 'decided that it would be expedient in the national interest to possess, in view of certain recognized requirements of naval war, some few ships, at any rate of great speed and lasting qualities at sea.' In 1907 the *Lusitania* took the blue riband for the fastest Atlantic crossing from the German ship *Kaiser Wilhem II*. This international rivalry was to reach its conclusion when the cold war hotted up to become the First World War, and one of the Kaiser's U-boats sent the *Lusitania* to the bottom of the Atlantic.

So it was patriotism that inspired the crowds at Liverpool – numbered in tens of thousands – to burst into singing with great spirit 'Britons never, never shall say die' as the *Lusitania* slipped out of the Mersey on her maiden voyage.

Newspapermen tried to give their readers some idea of the size of these great ships. The *Lusitania* was

785 feet long and 88 feet in breadth: 'Various comparisons might be made to give an idea of her magnitude, but perhaps it will be sufficient to say that in regard to width and height she would more than fill up Northumberland-Avenue, and would occupy most of the terrace of the Houses of Parliament.'[3]

The two local photographers at New Brighton at the mouth of the Mersey, George Searjeant and Joseph Mumford, decided that a local landmark was required as a readily appreciated yardstick by which to measure the ship, and chose the New Brighton Tower. It has been cut out from another print and stuck onto the photograph of the *Lusitania* steaming along at speed. Unfortunately, for those not familiar with the New Brighton Tower the juxtaposition, though easily enough understood, becomes bizarre, and the tower with the buildings at its base, divorced from its setting and set on its side, resembles some magnificently improbable rocket.

The photograph of the *Mauretania* by William Coats Jnr shows it leaving the Tyne, guided by tug-boats, after completing its sea trials. There was enormous public interest in seeing this great ship set out, and once again huge crowds lined the banks, and vessels sounded their steam whistles as she passed.

In contrast to the comparison between the *Lusitania*

and the tower, William Coats' photograph of the *Mauretania* employs older and more traditional devices and symbols. The dull October weather obscures details of Tyneside, and the liner looms up dark and imposing above the attendant tugs guiding its progress. The rowing boat with the figures silhouetted against the glinting water hints at man's puny strength against the might of this enormous, invincible symbol of power, adding its billowing smoke to the lowering sky.

As magazines and newspapers became less writing-orientated, less type-bound, journalists experimented with ways in which pictures could be made to communicate in conjunction with words. They tried to provide simplified visual aids which could convey complex meanings. Some of these visualisations were comic – in fact rather more of them than were intended to be so. One attempt to provide graphic evidence of The White Man's Burden in an article titled *Your Share of the Empire* featured a portly John Bull shouldering the globe, with the caption: 'Each individual John Bull is an Atlas who carries $184\frac{3}{4}$ acres of Empire on his back.' Readers were told that each one of them possessed 16 lbs of an 'ironclad' – their share of the British Navy.[4]

S.S. *Mauretania* leaving the Tyne on 22 October 1907
William Coats Jnr 1907

[97]

Admiral Lord Charles
Beresford standing on
the Quarter deck of
H.M.S. *Caesar*
Thomas Sims
1909

The 'Whipping Post'
in Wormwood Scrubs
Prison
William Grove
1895

It was difficult for photography to tackle this kind of task – photography was too earth-bound, too prosaic, too straightforward. The New Brighton sky rocket comparison never really got off the ground, and it was risky for a photographer to set out deliberately to incorporate symbols into his work – it was unlikely that they would appear subtly unobtrusive. This photograph by Thomas Sims sets Admiral Lord Charles Beresford next to a bulldog – the symbol of Britain's steadfastness and tenacity. In this case the overt symbolism avoids any sense of the ridiculous, but it is an exception.

A photograph almost always gains by understatement rather than overstatement. The most unnerving scenes of carnage and terror are those which remain locked inside the imagination. The photograph of the 'Whipping Post' in Wormwood Scrubs Prison is terrifying precisely because there is not a man hanging bleeding on that cross-frame. We have to work out how the arms and legs are strapped down, wonder what appalling practical purpose the worn padding at hip-level serves, and gaze with curious but apprehensive dread at the neat rows of cat o'nine tails and birches. It is brutal because it is so functional. This is a device which has been carefully designed and constructed for the sole purpose of giving great pain. The stark patterns which these repulsive objects make only serve to heighten the horror.

A description of the process of flogging fleshes out our dreadful imaginings:

The man who wields the cat shakes out its nine thongs, raises it aloft with both hands, and deals the criminal the first blow across the shoulders. A red streak appears on the white skin. Again the thongs are shaken out, again the hands rise, again the whips are brought down with full force, and the streak on the skin grows redder and broader. A turnkey gives out the number as each stroke falls; and the silence is broken only by his voice, by the descent of each successive blow, and by the cries or groans of the sufferer.[5]

In 1895, the year in which the photograph was taken, prisoners were given as many as thirty strokes. As recently as 1889 boys were flogged for selling newspapers on Edinburgh station without permission.

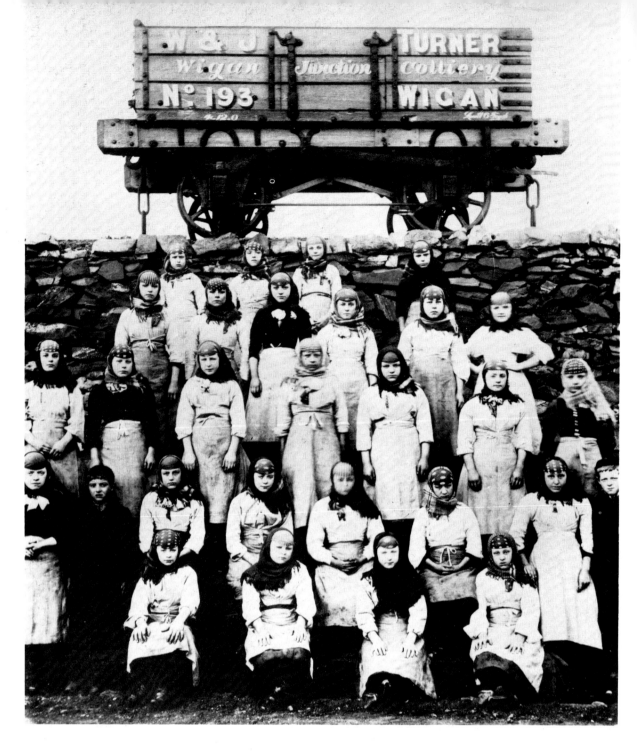

Pit brow girls just
before starting their
work
Thomas Taylor
1893

Other photographs seem to incorporate symbolism almost inadvertently. These pit brow girls photographed near Wigan in 1893 by Thomas Taylor are posed beneath a rough wall supporting a railway embankment. They wear work-clothes like uniforms and apart from one or two individual gestures – the hands on the hip for example – seem to have been overawed into submission. All these children have their part to play in the great enterprise of coal-getting and profit making. Above them the coal wagon announces who these little workers belong to – *W. & J. Turner, Wigan Junction Colliery, Wigan*. The photograph gives workers and wagon equal status – both are useful in their different ways, both have a job to do. The wagon emblazoned with its owners'

names presses down upon them.

Perhaps the company asked the photographer to include the wagon simply as a ready-to-hand 'label' to identify their property. It is unlikely that this arrangement was constructed in order to make a social comment or a political point. But then the fact that wagon No. 193 crushes the individuality out of the nameless pit-brow girls and boys is all the more effective for being unintentional.

It's impossible to look at photographs like these without a modern awareness of problems which may never have crossed the mind of the photographers, but which convey themselves strongly through their work. This photograph taken in 1903 by William Thomas of Durban seems to embody an Edwardian

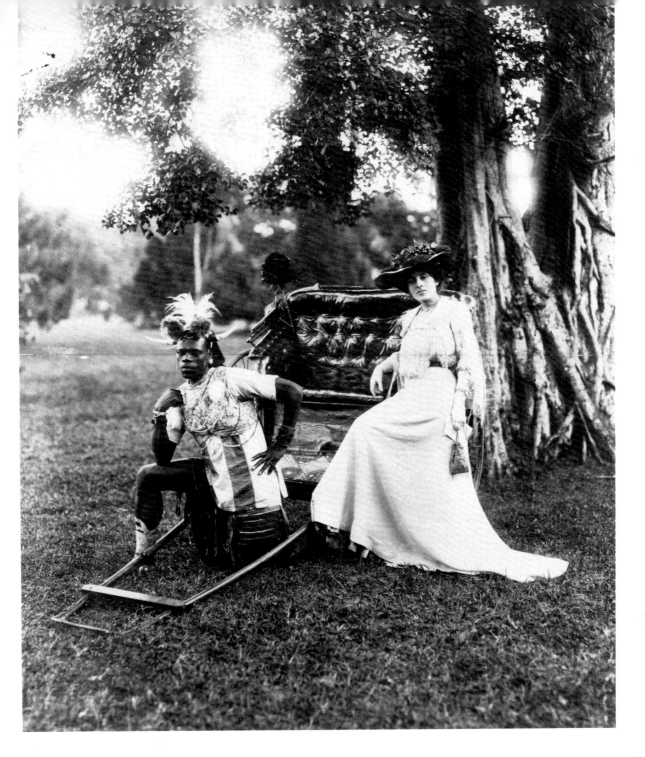

affirmation of apartheid. Reclining elegantly against her rickshaw, Mrs Lewis Waller looks with assurance towards the camera. She is wearing a fashionable hat and dress and displays the languor and sang-froid of a true lady – a frail representative of European civiliz-ation in this alien land. We can't be sure of the colour of her dress, but it appears white – a virginal pure white to match her white skin. Between the shafts of the rickshaw her black 'Kaffir boy' – the draught animal to pull her jogging along – kneels in sub-mission. He is strong and handsome, but he has been tricked out in some tourist version of warrior's dress, leaving him 'decently' clothed. The delicate horns of his head-dress seem almost a mockery of his virility.

She is the representative of the ruling white race. His people have lost the colonial war; he is enslaved.

These two figures posed in the shade of a tree seem to carry so many symbolic meanings in their inter-relationship that this photograph is mesmeric. Per-haps she was well-known in her day. It no longer matters. The meanings of 1903 have faded away. Per-haps this was meant as no more than a record of a pleasure trip around Durban. It no longer matters.

The lady's lips seem about to break into a gracious smile. She is relaxed and confident. The negro boy looks and waits, unsmiling. They do not communicate. They have nothing to say to each other.

Mrs Lewis Waller
with a Kaffir boy
William Thomas
1903

[101]

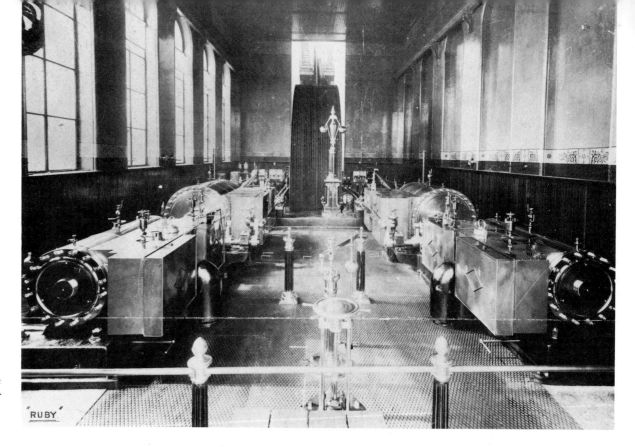

The Engine and
Engine House of the
'Ruby' Mill Co. Ltd.
of Oldham
Walter Schofield
1893

Curiouser and Curiouser

Photography's power to recall the past is based to a large extent on its ability to re-present the world as it really is, or was. But the more photographers peered at the world through the lenses of their cameras, the stranger it seemed to become. Seeing through a camera lens is like looking at the world while you're wearing blinkers – all you can see is what's straight in front of you. If you're looking at a scene photographed by someone else, you haven't even the chance to turn to one side or the other to see what sort of context their photograph fits into. You have to try and make sense of the bit of the world you see in the reproduction in front of you.

In the photograph above by Walter Schofield, many of the pointers which would give us a clue to its meaning are missing. This scene is presented to us quite out of context and with almost no sense of scale. The lighting seems unnatural and the camera lens is distorting shapes at the far left and right. The enigmatic name *Ruby* at the bottom left does not help us.

These gleaming machines, watched over by the towering automaton at the far end of the chamber seem to be the land-bound creations of some Captain Nemo come ashore from his *Nautilus*. This is high technology which is inscrutable and as impressive as any shining rocket that NASA has come up with on

the launch-pad at Cape Canaveral. The fact that it looks new and yet is hopelessly outdated is worrying; it appears to be some sci-fi backdrop to a *Flash Gordon* episode – the powerhouse of Emperor Ming. The only way to stop the 'reality' from escaping is to search for evidence which will bring these fantasies down to earth – the kettles of oil for lubrication, and the gas brackets and decorative frieze on the wall. This is the powerhouse not of an alien space-cruiser, but of a Lancashire mill, though knowing that does not stop the photograph displaying quite alarming characteristics. This is the real world looking remarkably unfamiliar.

Walter Schofield, who was brought in to photograph this engine-house, would have had no wish to do anything but record the scene as well as he could. He wasn't in the business of producing visual conundrums. But other circumstances gave rise to photographs which were puzzling and enigmatic. The photograph on the right is titled *As I looked at Wilson's fire I did feel Waxy. I never had such a close shave.* It seems as if the figure has turned her head to look with mild interest at some event of which we are not aware. At the same time she appears as a macabre apparition, only half human – her breast soaked in what might be blood. Around her are random objects by means of which we try to make

sense of this troubling scene – just as we did when faced with the man murdered in the schoolroom. Can the notice about Ladies' Combings provide us with information about this disquieting, pre-Surrealist mannequin?

The facts of the situation are fairly straightforward. This is a wax model in the window of a shop in Brentwood. There was a huge fire at the Great Eastern Stores owned by Wilson & Co. which was so furious and so hot that it set fire to shops and houses fifty yards away. The heat began to melt the wax, which saturated the bodice of the dress and made the figure lean forward, pressing up against the window. Samuel Reynolds, who took the photograph, was able to sense the strangeness of this extraordinary sight and to record it by means of the camera. In order to rationalize what he has done, and to pass it off harmlessly with a laugh, he has given it a comic caption. But even knowing about the fire and realising that what we're looking at is a damaged shop window display does not take away the power of this surreal image.

As I looked at Wilson's fire I did feel Waxy. I never had such a close shave
Samuel Reynolds
1909

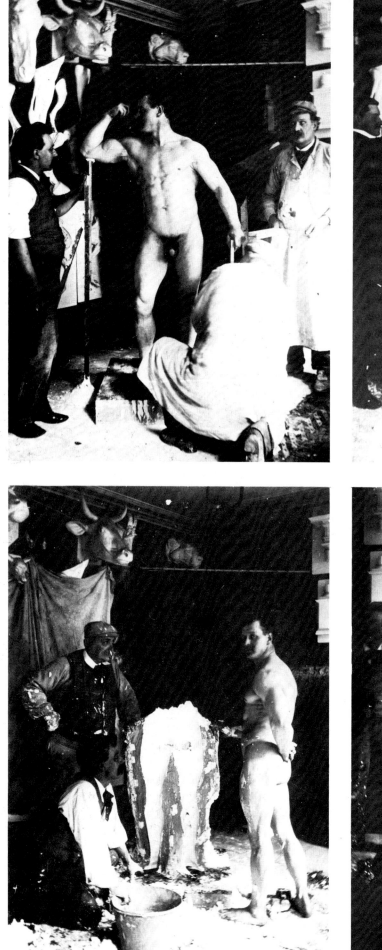
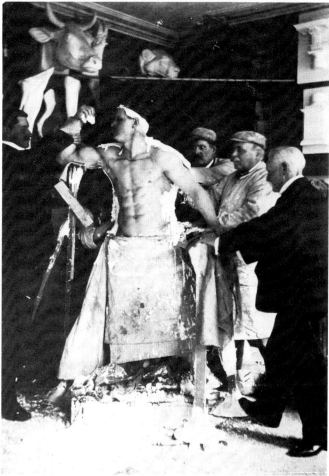
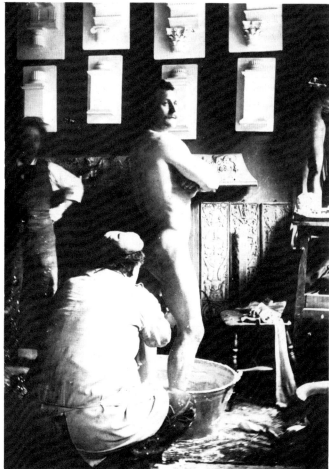

2

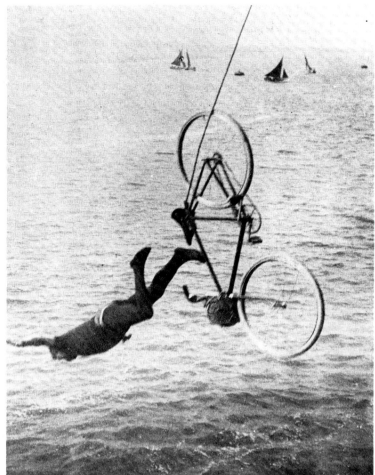

In this series of photographs we see a naked man upon whom it appears that something unspeakable is about to be inflicted by shifty-eyed, white-coated attendants. Like overgrown natives of Lilliput they try to hold their muscular Gulliver down and then, exhausted, worship the very imprint of his buttocks and legs, as some other bovine god looks down from above. This powerful deity is finally placated, and is ritually anointed by his votaries.

In fact this is the strong-man Eugen Sandow – 'The Marvel of Anatomists, Sculptors and Artists in the Nude' – who is being cast in plaster to enable a statue to be made of his finely-developed body. These photographs were taken for a body-building organisation – the Sandows Grip Dumbell Co. – probably as publicity material for his Schools of Physical Culture, his Dumb-bells and his Chest Expanders. You too could have a body like his if you followed his system of Physical Culture by Post. But even then it would be unlikely that you would be able to match Sandow's stage act at the London Pavilion which usually ended as he supported a bridge on his chest, over which two people drove a horse and chariot, making a total weight of about 3,200 pounds.

◁ Sandow being placed in position for casting;
having a cast taken of his back;
with a cast taken from the back of his legs;
being washed down to remove the particles of plaster
Arthur Weston 1901

Sometimes, however, I conclude my performance by lifting with one hand at arm's length a platform upon which rests an ordinary piano, with a man seated playing upon it. Having lifted it, I march off the stage with the lot, the musician playing a lively tune as we go.[1]

Sandow himself had composed a rousing *Marche de Athlètes* for just such a moment at this.

Some photographs are strange because of their bizarre subject matter, some are made strange by the surreal possibilities which the photographer decides to exploit, others have strangeness thrust upon them because they have been wrenched out of context. Because we know that what we are looking at in a photograph actually existed, photographs which reveal a world run mad are more troubling than any fanciful painting.

The following photographs have all some perfectly good reason for looking as they do – Barnum & Bailey, for example, wanted a record of their star attractions. But they still present us with a phantasmagoria of nightmares-made-real, and need no comment from me.

Professor Powsey's Cycle Dive off Southport Pier
John Rawlinson
1908

George Moss of Leicester, Hair Specialist
Henry Hitchcock
1907

▷
Mr F. Anson
— 'The Iron Mask'
Joseph Giles
1908

▷▷
Annie Jones, the Bearded Lady
James Hunt
1899

Billy Wells, the Hard-Headed Man
James Hunt
1899

Jojo, the Human Skye-Terrier
James Hunt
1899

Perry Albright, the Human Living Skeleton
1899

[105]

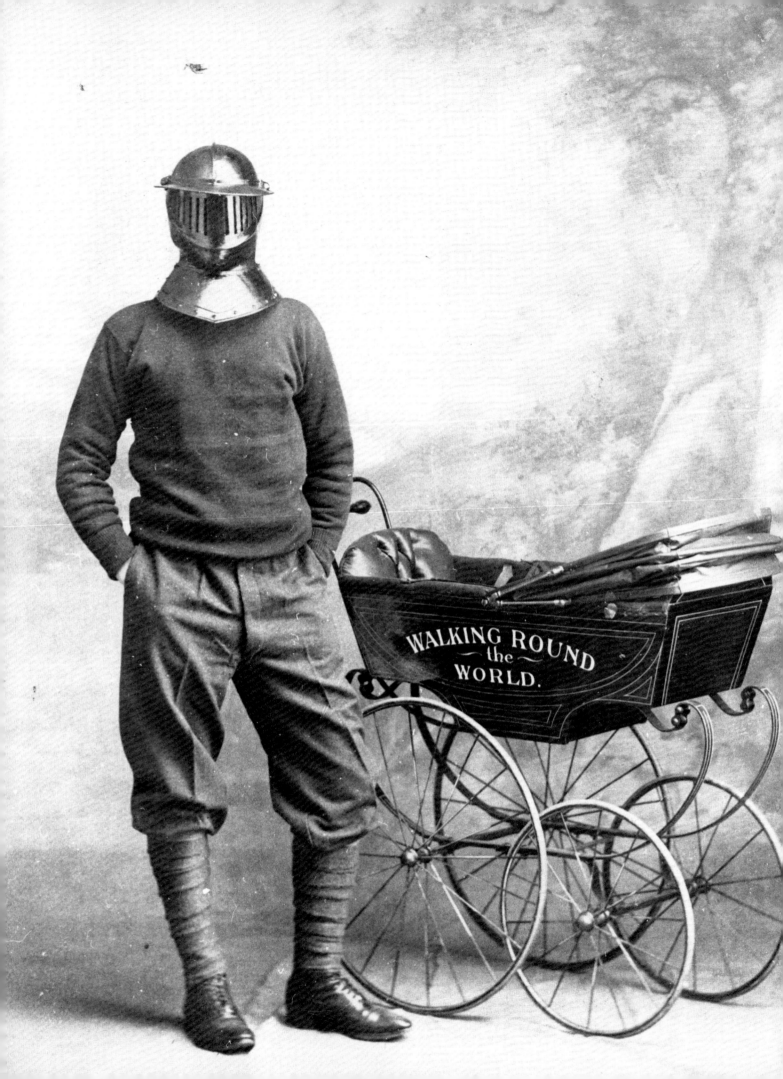

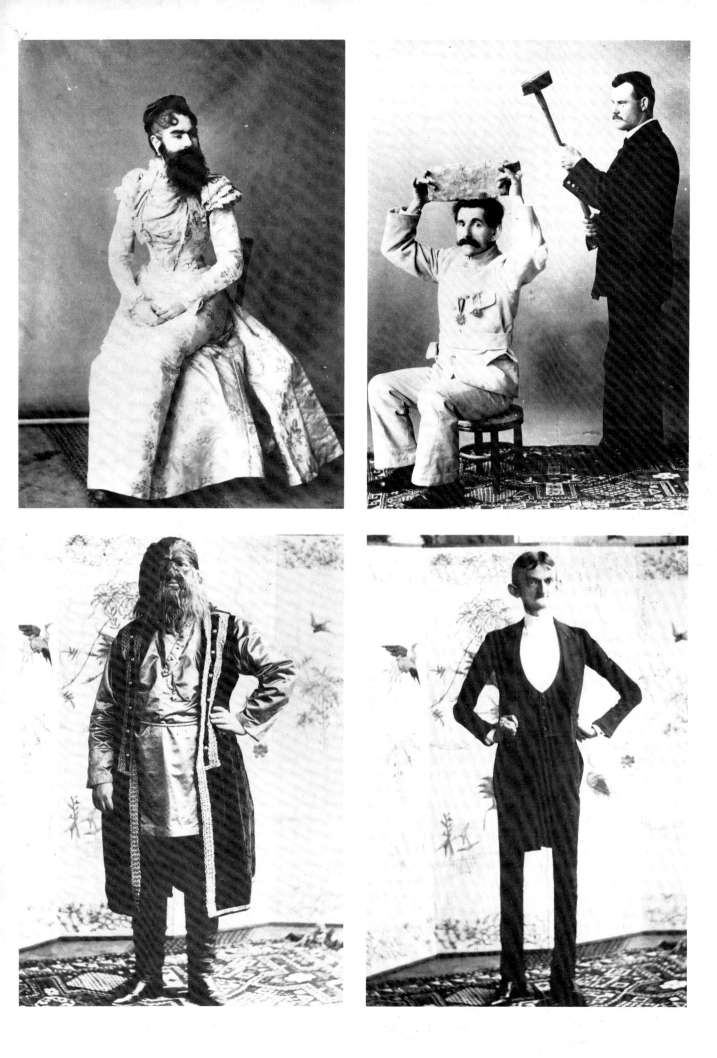

Blowing Bubbles

In 1885 the painter John Everett Millais went to see his friend Rupert Potter – the father of Beatrix Potter – who was a keen amateur photographer. He wanted a specially-posed photograph of his grandson Willie for a painting he was working on:

I just want you to photograph that little boy of Effie's I've got him you know, he's (cocking up his chin at the ceiling), he's like this, with a bowl and soap suds and all that, a pipe, it's called *A Child's World*, he's looking up, and there's a beautiful soap bubble; I can't paint you know, not a bit! I want just to compare it, I get this little thing (the photo of the picture) and I hold it in my hand and compare it with the life, and I can see where the drawing's wrong.[1]

The completed painting appeared two years later as the presentation plate published as part of the Christmas number of *The Illustrated London News*. Its title had been changed from *A Child's World* to *Bubbles*, and it was already on its way to becoming one of the most famous advertising images. Messrs A. and F. Pears had purchased the painting in the previous year and, by adding a bar of Pears' soap, they had produced an eye-catching advertisement. This photograph is a tribute to the popularity of *Bubbles* twenty years later – Millais' painting has been meticulously recreated for the camera.

The story goes that Millais objected to his painting being hijacked from the sacred domain of Art and thrust into the market-place. *Bubbles* might be a pot-boiler, but to see soap suds emerge from the pot was to bring the artist's name into disrepute. However the facts seem to be different. The Chairman of Pears, T. J. Barratt, was the man who made the decision to purchase *Bubbles*. He recognised that the best way to promote his product was to mount an aggressive but attractive advertising campaign on a huge scale, and was looking for an image to help bring his product to the attention of as many potential purchasers as possible. The qualities which made *Bubbles* appealing to visitors to the art galleries where it was exhibited were the same characteristics which enabled the painting to function efficiently as an advertisement. It was an image which could be taken in at a glance, was very easy to understand, and appealed to popular sentiment. Barratt showed Millais their version of the painting which now included a bar of Pears' soap, and he exclaimed 'That's magnificent!', agreeing with Barratt that advertising could bring pictures like this to a vast public. Barratt went ahead and spent the then immense sum of £30,000 on an advertising campaign for Pears' soap based upon *Bubbles*.[2]

Advertising began by drawing upon the talents of the typographer and of the wood-block engraver to produce visual appeal. The birth of 'commercial art' and of the advertising agency lay ahead in the first two decades of the twentieth century. *Bubbles* came at a moment when businessmen were looking around to expand the visual vocabulary and the appeal of advertising. But the future in advertising belonged to photography and not to painting, and it was photography which was to flourish thanks to the vast amounts of money which would be poured into advertising in the twentieth century. Only a few years after Barratt bought Millais' *Bubbles*, no-one would have thought of reproducing a painting in an advertisement unless they wanted to add a touch of class. A drawing or a staged photograph was better for their purposes and more direct. Once photographs could be reproduced easily by fast-running printing machines, the world was to see an explosion of advertising imagery based upon the power of photography.

Modern advertising has transformed the business of selling goods and has also provided us with what amounts to a completely new visual culture which you can consider either as mainstream in our society or as secondary in importance to more established visual arts. The choice of alternatives depends on whether you think the so-called 'fine arts' can withstand the onslaught of ideas and the sheer visual impact flowing from advertisements – which I doubt – and whether you regard advertising in general as pollution of both eye and brain – which would seem to indicate an inability to see and to understand how modern cultural forms are shaping up. People who thought Millais had been involved in some kind of act of betrayal would not be able to begin to cope with the hi-flying, mind-zapping, fingersnappin' world of modern advertising imagery. *Bubbles* was just the beginning.

Once technical problems of reproduction were out of the way, the reason that photography was able to move in fast to serve the interests of commerce was that it had already developed styles and techniques which could do the job required. Some early photographers had been happy to invite comparisons with painting by putting together pictures which told a story – photographs which were similar in content to the narrative paintings which won popular acclaim at Royal Academy exhibitions. They worked at the top end of the market, exhibiting their work, getting it reviewed just like paintings, and in the case of the 'art photographers' Rejlander and Robinson, having their photographs bought by Queen Victoria for inclusion in the Royal Collection.

Blowing Bubbles
Mary and Amy Austin
1906

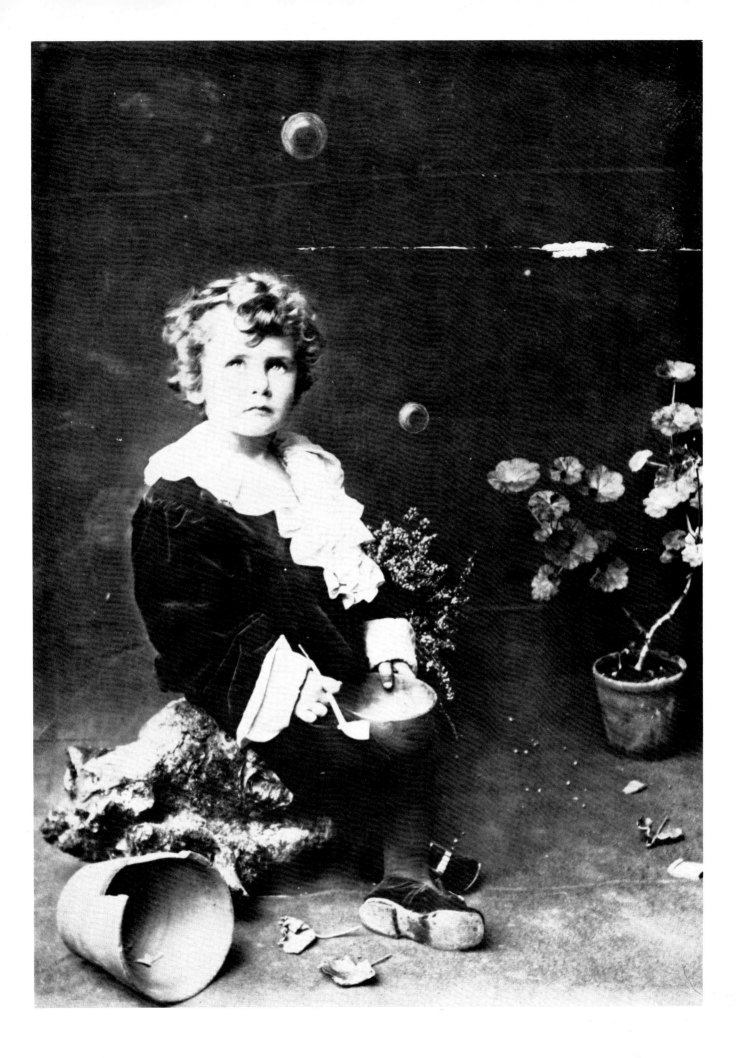

Who threw that stone?
Michael Burr
1865

A domestic upheaval
Michael Burr
1875

A Tailor's Shop
Michael Burr
1875

From the lantern slide
sequence
A peep behind the scenes
James Bamforth
1888

The financial base of the photographic business rested on the support of much less wealthy patrons with much more modest demands. Michael Burr was a Birmingham man who made a fortune by selling cheap card-mounted photographic prints with narrative scenes. This is a *carte-de-visite* titled *Who threw that stone?* The whole scene has been specially constructed in the studio. The actors have been selected, dressed and drilled in the parts they have to play, and the stuffed dog has been placed in position. The speed of photographic emulsions of the time meant that there was no possibility of making instantaneous ex-

posures – hence the stuffed dog. Very little is known about Burr except that he began his career as a 'painter on glass' and when he died in 1912, aged 86, could be called on his death certificate a 'landed proprietor'. This was how he made his money, by setting up photographs which very often showed comic scenes. This example (top left, next page) has lost its title; the man in the trousers with the loud check pattern has overturned the breakfast table and knocked the happy home about. His wife is in tears, the servant looks at the scene in shocked disapproval. Supply your own caption.

Burr not only got together people who were pre-
pared to act out rôles, he assembled props and con-
structed special sets. Here a door is open and a light
hangs from above. In another the interior of a tailor's
shop has been constructed and we look through from
one 'room' to another. Again the caption has been
lost, but would probably have referred to the custom-
er's ill-fitting clothes. These sets are more inventive
than those used by the earliest makers of movies
working several decades later. It is not surprising that
other photographers such as James Bamforth of
Holmfirth who also produced popular narrative images
should have found it so easy to move into film-
making. Bamforth constructed sets and posed figures
for sequences of photographic lantern slides: here is
one taken from the series *A peep behind the scenes*
taken in 1888. By 1897 Bamforths were producing
short narrative films.[3]

This whole field provided a very lively and profit-
able market for photographers which changed at a
rapid pace and offered what seemed unlimited opport-
unities. In 1886 Messrs Pears had bought *Bubbles*.
Only eleven years later in 1897 their rivals in the
business of soap manufacturing – Lever Brothers –
were moving fast producing the very first advertising
films. They bought equipment from the pioneer
cinematographers, the Lumière Brothers, and drew
crowds in London streets by projecting onto hoard-
ings.[4]

In the field of still photography narrative forms gradually became more refined. Burr's photographs are the ancestors of the thirty-second narratives we see in television advertising. Magazine advertisements were to demand more sophisticated and complex forms of scene-setting. The photograph on the right is titled *Refreshing Moments* and was taken by the amateur J. B. B. Wellington in 1911. It belongs to the movement in art photography which by the turn of the century had become known as pictorialism. This was a photograph taken to hang on the walls of a gallery. A gentleman sits on the verandah of a hotel and orders a drink from a pretty French maid. It's a lazy, hazy day. He smokes and reads the paper. The photograph is precisely balanced and very strongly composed, with the doorway framing the scene, the vertical stripes of the awning, and the serpentine S-shape of the carefully positioned arms. It's no wonder that another pictorial photographer – Baron Gayne de Meyer – was able to exploit the commercial possibilities of this elegant style and become *Vogue* magazine's very influential principal photographer. To appreciate how this 'art style' could be harnessed for commercial purposes, and to see how it provides another link between nineteenth-century narrative techniques and modern advertising, you only have to take away the title *Refreshing Moments* and replace it with a slogan such as *Make Mine a Martini*. This photograph contains many of the elements we now expect to find in modern advertising. It is serene, perfect, self-enclosed, desirable, real and yet from another world. It offers promise and hints at satisfaction – a subtle and powerful Edwardian dream-image.

An article written at the turn of the century urged photographers to develop the potential of photography as an advertising medium, and to exploit its ability 'to easily express a telling scene' such as this. Take the example of a man who is thinking of buying a bicycle and dreams of leaving the crowded streets of the city behind him for the sweet, fresh air of the country: 'He has a vague, pleasant picture in his mind's eye, compounded of hedges sprayed with dog roses, or honeysuckle, single-arched, greystone bridges, spanning clear, running streams, cool country inns, home-brewed, and so on.' If that man received several brochures from manufacturers giving technical details of their bicycles, wouldn't he be most likely to choose the one which brought his dream to life in the form of a photograph showing a 'telling scene' – 'the bicycle leaning against the wall of the village inn, with a rider in the act of discussing the glass of ale which the landlord, jug in hand, had just poured out.' The writer obviously knew a good deal about what would later be called consumer motivation. To make use of such a photograph in a bicycle brochure was: 'A small matter, admittedly; but if any one will take the trouble to review his life, and analyse course and cause of action, it will possibly surprise him to find how small and insignificant in themselves the deciding factors have ever been.'[5]

Sometimes the 'telling scene' could be too subtle and more thrusting approaches had to be devised to carry the message home. 'Advertisement photography is akin to the "popular journalism" which has created it', another writer observed. 'Both are a produce of the same modern habit of crowding too much into the day. The busy man who must now have news served up in quickly-digestible paragraphs, requires also to be considered in the same way by the merchant who desires to convey information of his wares. Advertisement photography is, in short, the journalist's gift of being "readable" in photographs.'[6] And a London advertising agent told photographers: 'A simple and direct idea that tells its own story right away is what I want.'[7]

Refreshing Moments
J. B. B. Wellington
1911

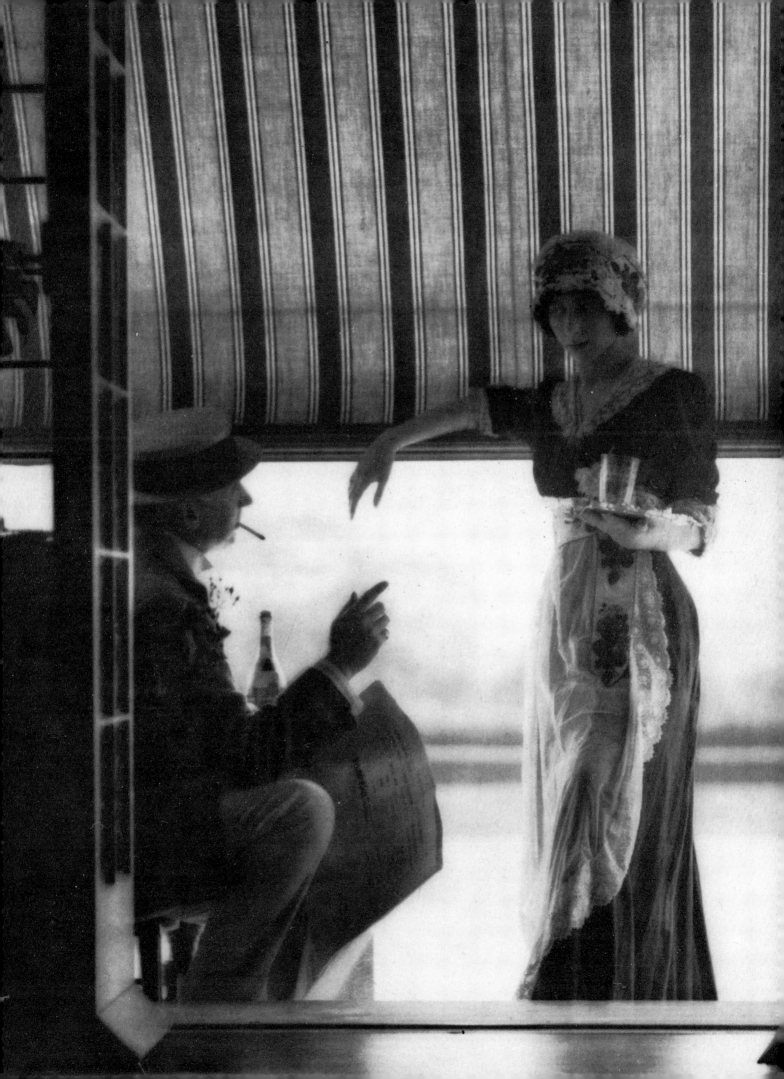

One way to make certain that the message was put over swiftly was to make use of stereotypes, and photographers were already geared up to produce them. Michael Burr could sum up the story of a man's life in two photographs. In *Outward Bound* a poor Irish peasant prepares to set sail for America in the hope of making his fortune. In *Homeward Bound* he prepares to return to Dublin, a changed and more prosperous man. In the world of stereotypes mothers are loving, fathers are brave, children are appealing – so are dogs and cats – and girls are lovely as a summer's day. To deviate from this norm, however unfair or distorting the stereotype might be, would be to complicate matters, and to stop the message reaching its target. This is as true today as it was then.

Outward Bound; Michael Burr; 1867
Homeward Bound; Michael Burr; 1867

My Mammy; Walter Winter; 1888
Untitled; Robert Faulkner; 1876
Hurry back Daddie; George Simmons; 1900
Fine New Herrings; George Davison; 1895

Who's next?; William Bratherton; 1904 ▷
In Colby Glen; George Cowen; 1906

The Evening Prayer; Seymour Lacey; 1905 ▷
Why not be friends?; Ralph Robinson; 1895

The effect of pasting a Radical election poster on a tree — before and after
Thomas Roberts 1892

The effect of the election on a red hot Radical
George Jobson 1895

The best in the market; William Bond; 1910

Gradually photographers became aware of the wide variety of techniques they could use to promote ideas or to sell products. Thomas Roberts was so incensed by the Radical candidate in his constituency in the General Election of 1892 that he produced the pair of 'before' and 'after' photographs seen on the left as an expression of his exasperation with the man whose election posters blighted the landscape. Sometimes it was more effective to tell a story in a series of posed photographs rather than in one single image. On the left is another comment on an election result, except in this case the Radical candidate lost.

Photomontage was a technique which was identified early on by photographers as offering extensive possibilities in the field of advertising. Photomontage is still exploited by the modern advertising industry for its ability to startle and to arrest the eye. When this photograph was taken by William Bond its impact would have been more arresting, and therefore more effective, than it appears to our eyes which are now familiar with the complex visual trickery used by advertisers to grab our attention. It was given the title *the best in the market*, and the towering bottle of Whitbread's London Stout stands there like a gleaming monument to the product. The people in the marketplace gaze up in awe.

Photographs could be taken from different sources and combined into one image, united by a caption. Here the message is conveyed both verbally and visually – *Singer's Sewing Machines are so simple that the youngest can understand them. So easy that the oldest can work them.* This skilled photomontage was put together by John Napier in 1896. Remembering the idea put forward at the time that advertisement photography owed a lot to popular journalism, it's interesting to see how this example shows the way in which advertisements were gradually moving forward to create a marriage between words and photographs very similar to that which Hannen Swaffer was seeking to achieve in the pages of the *Daily Mirror* at about the same time. Photographers had begun to specialise in advertising photography at the same time that others began to specialise in news photography. And because the public now saw photographs being used extensively in the editorial pages of the popular press, they expected to see this up-to-date medium used in advertisements as well. Rather than put forward photographs which *might* prove useful to advertisers, photographers began to work closely with advertising agents who could commission work directly. Things were changing with great speed. It was no use trying to go back to the older style of advertising using bold and varied typography: 'Skilfully-arranged lettering is no longer sufficient for the purpose, there must be a picture.'[8]

Both in the rapidly-expanding field of advertising and in the newspapers, which were beginning to understand how to develop photojournalism, verbal and visual messages were becoming fused.

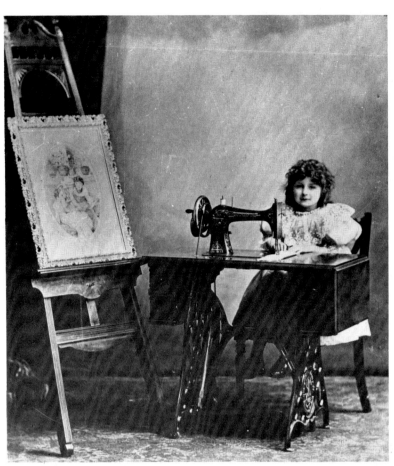

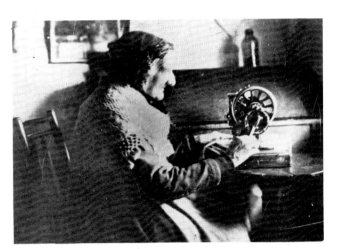

Singer's Sewing Machines

Are so simple that the youngest can understand them.

So easy that the oldest can work them.

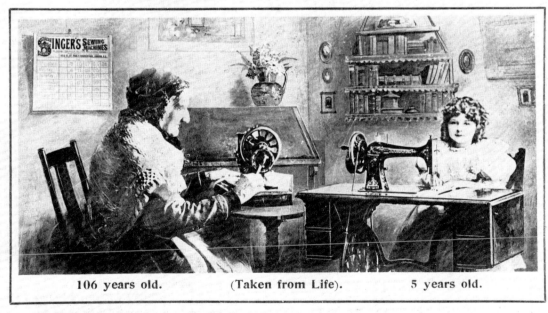

Rosamond Bullworthy,
aged 5, using a
Singer sewing machine
John Napier
1896

Mrs Griffin, aged 106,
using a Singer sewing
machine
Joseph Matthews
1896

Composite photograph
used to advertise
Singer's Sewing
Machines
John Napier
1896

106 years old. (Taken from Life). 5 years old.

Such easy terms that anybody can purchase one.

Very good discount for Cash, and

As much as **20/-** allowed for an old machine in part exchange.

London Stereoscopic Co., Photomezzotype.

Pretty Dolls

and Elegant Dummies

In 1912 Miss Ivy Close appeared in a cinematographic film entitled *Dream Paintings* in which she was seen in several 'charming poses' including a re-creation of '*Bubbles*, the celebrated Pears' Soap advertisement'. It's clear that by this time the offspring of Millais' painting had set out on a career of its own.

Ivy Close was a woman who would have been described at the time as a 'professional beauty' – now we'd describe her as a *beauty queen*. Until the turn of the century 'beauty contests' of any kind were regarded with considerable distaste. An 'International Beauty Contest' was held in Paris in 1899, and British press comment was hostile:

'It would seem that no English competed, and one cannot be sorry for it, for it would be degrading. There was once a beauty show in this country, but then it was confined entirely to barmaids, and we are pleased to say the show was but a limited one, and that it was not repeated. So far as we are concerned, we should like female beauty shows to be confined to the other side of the Channel, whether they be international or otherwise.'[1]

Not all photographers would have agreed, because photographs of beautiful women had always sold in large quantities, and photographs of reigning beauty queens would have been even more profitable.

Thirty years earlier there had been objections to *carte-de-visite* portraits of show girls being displayed in the windows of photographic print sellers. These show girls, claimed the objectors, were little better than courtesans, and the 'morbid curiosity' which led people to buy photographs of the reigning beauties of the day was 'a sign of the gross degradation of society':

It sickens us to see the coarse, idiotic, sensual features of these goddesses promoted from the scullery to reign over the Casino, impudently smirking and leering side by side with the pure gentle faces of those whom all Englishmen justly love and honour. Is it come to this, that we wish publicly to confess our shame? to declare to all the world that we have so degraded fame to the level of notoriety that a great philosopher, a venerable bishop, or a well-beloved princess, is put on a par with the last 'lady of the ballet' who has perpetrated the most popular feat of clumsy indecency at one of our theatres, or the favourite pet of the hour, whose pockets are filled with the money and the love letters of our gay youth? Shame on all respectable tradesmen who thus turn their shops into an advertising mart for unblushing profligacy.[2]

These 'pretty dolls', these 'elegant dummies', these 'alluring damsels in silken hose, the nattiest of boots, and with no trunks to speak of' are notable only for their immodesty and their 'reckless assurance':

Photography, it is said, can never lie or misrepresent; but it can and does when it gives the collective term of 'favourite actresses' to this crowd of brazen, impudent, shameless creatures who attitudinise on velvet couches, elevate one leg on a property stile, throw a shapely limb over the arm of a chair, or sit on the edge of a table to be photographed in their stage dresses. These Cupids and Pages, who simper and leer from the polished surface of prepared paper, are nonentities rather than actresses.[3]

Faced with 'this overflow of half-nude figures' who were described as actresses, the writer could only ask *Who on earth are they?* Articles appeared with titles such as 'Alleged Immorality of Photographers' with pointed advice that they should 'distinguish themselves from swarms of semi-pimps who pander to coarse and vitiated tastes'.[4]

What has changed in the hundred years since those articles were written? Why do they now seem so prudish and over-cautious? Gradual steps forward have been taken towards female emancipation, and at the same time widespread changes have taken place in society's self-censorship. It is no longer felt to be lewd or immoral for picture newspapers to carry prominent photographs of attractive young women with bare breasts in tempting poses. What once had to be smuggled in from Paris and other resorts of immorality is now available over the counter at the corner shop.

Photographs allow you to stare at beautiful women who appear alluring but are unapproachable, untouchable. Always waiting dreamily, they have each launched a thousand fantasies. Photographers did not worry that the beauty they saw through their camera lens was only skin deep; they weren't concerned that by putting women on display they might be humiliating or degrading them. These idealised visions of beauty, these escapist reveries, were big business for photographers, and gradually they began to weave the web of enchantment which they could wrap around the women who posed for them. The nebulous half-truth which lies beneath the imagery they were teasing into being was – *glamour*.

Who is glamorous and who isn't? The Victorians would have preferred to wonder instead who was admirable or famous or praiseworthy, and they made a clear distinction between fame and notoriety. Various princesses and wives of earls and viscounts might be attractive as well as famous-by-marriage. But that was part of their function – to become jewels in the crown of the aristocracy – and to buy portraits of them was to purchase photographs of people of considerable social standing. Good actresses might achieve fame on the stage and find that large numbers of the public

Five 'Gaiety' fairies in
the burlesque *Ariel*
Samuel Walker
1883

[120]

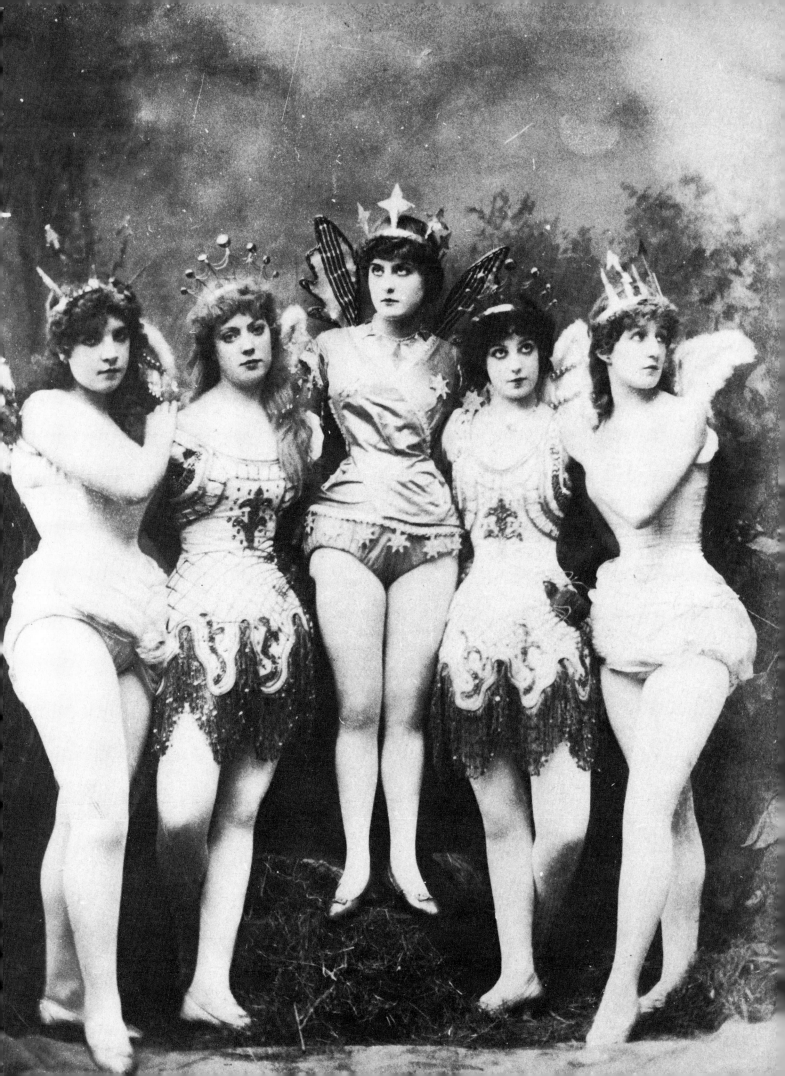

knew them from *carte* portraits, just as today we seem to 'know' television personalities who appear regularly. Glamour is divorced from any consideration of worthiness or of talent and is often to be found when the women on display in photographs are 'professional beauties' and little else. Glamour lies at the heart of the process used extensively by the modern mass media in which attention is diverted from people who could be described as famous because they are praiseworthy, towards those who have gained the dubious distinction of becoming famous through being *a personality*. They owe much of their prominence to the camera – to the still, the movie, and the television camera. They take care to make use of whatever photogenic qualities they can muster, because of the crucial importance of their image in the photograph or on the screen.

One of the first photographers to exploit the possibility of using the camera to create glamorous images of women for promotional purposes was Elwin Neame. From the age of twelve he studied at the Bristol School of Art but before he was out of his teens he had become a professional photographer and had moved to London. There he found that there was a flourishing market for photographs of what were described as 'show girls'. Several weekly papers depended on these photographs of pretty girls to keep up their circulations. A contemporary summed it up: 'The idolatry of the actress is a craze which thrives on what it feeds upon, hence the omnipotence of the pictured show girl.'5 *Show-girlitis* gripped the public.

Neame photographed show girls and actresses for the illustrated papers for a year and then became involved in the first national Beauty Competition, organised by the *Daily Mirror* in 1908. The editor Alexander Kenealy had experience working on a Hearst newspaper in America and his flair for popular journalism was an ideal complement to Hannen Swaffer's skills as a picture editor. It was decided that the *Mirror* would set out to find 'the most beautiful woman in the world'. Neame was employed to photograph the most promising girls who entered, and the winner was Ivy Close. Here was what amounted to a Miss World, and a million reproductions of her portrait in the form of postcards and photogravures were sold in Britain alone, and at least another million abroad, apart from press coverage. Why did so many people buy photographs of Ivy Close? Who was she? She was 'the most beautiful woman in the world', according to the *Mirror*. She was beautiful and to be envied in her rise from the ranks of ordinary womanhood. The mantle of glamour descended upon her. She was now a personality, and became famous.

Elwin Neame didn't lose much time in marrying her, and she became one of his principal models. He was rapidly carving out a career for himself as a photographer specialising in photographs of women – pretty girls to appear on the front cover of magazines, on calendars, on advertising showcards, and in the illustrated press. And in doing so he was opening up new and very profitable areas for photographers. His dream women are tantalising and bewitching, catching the eye without distracting attention from the product they are advertising. Bit by bit commercial photographers like Neame and their clients were learning how best to use photographs in advertising. A contemporary commented that 'a fuller and more pictorial subject' than these 'might engross a buyer's attention too deeply. Mr Neame's faces and hazy draperies attract, partly by what they do not offer, and, having attracted, they do not hold too exclusively. What could a manufacturer want more?'6 In advertising photography to be lightweight and frivolous could be an asset.

Working with a large plate camera in his studio, he set out to create his romantic visions of women, and the trade-mark of his photographs was the diaphanous drapery in which they were wrapped. 'Neame's working outfit', it was said, 'consists mainly of an armful of chiffon and a mouthful of pins.'7 He claimed to be making 15,000 negatives a year, and when approached for examples by clients would send anything up to *two hundred* on approval.

He was not upset at being described as 'a cheerful young faker'. Some of his photographs were made up from a dozen or fifteen negatives and he retouched his work extensively – look how he has given his model a more flattering waistline in *November*. He said that he didn't care a hoot for Art for Art's Sake and worked all the time bearing in mind how his photographs would reproduce: 'His big glossy silver-prints are always a joy to process men, and it is to their aims and needs that he gives his closest study.'

The girls whom he photographed appeared as 'the damsels of a gauzy Utopia', and the products of Neame's studio displayed, it was claimed, 'the trinity of grace, feminine attractiveness, and good photography'. With his sure grasp of photographic technique, his accurate assessment of public taste linked with his ability to judge what his clients would buy, his understanding of how photography could serve advertising profitably, and his capacity for both hard work and self-promotion, Elwin Neame was a prototype of the twentieth-century 'star' photographer. He even had a beautiful model/wife. Neame was the David Bailey of Edwardian England.

November
Elwin Neame
1911

Decorative photograph of a girl; Elwin Neame; 1909

Constance Stanhope; J. A. Smythe; 1886

Getting the Message Across

'Success in advertising is often achieved by the aid of photography when nothing else would answer. The amount of business in this direction which is open to photographers of brains is unlimited.' That's from an article written in 1912 encouraging photographers to move into advertising. Even at this late date advertising was being presented only as a 'profitable side channel' which could be exploited by professional photographers – 'and one in which there is great scope for ingenuity and originality as well as artistic ability'.[1]

It was only gradually that businessmen and their advertising agents began to realise that photography offered them almost unlimited powers to bring their product into public view, to promote and to sell their products, and in many cases to make a fortune. Here was the ideal method of getting the message across. You didn't need to read, you didn't even need to think. Photographs communicated directly and swiftly with a visual impact against which there was no defence. The image held you mesmerised and the slogan delivered the knock-out punch. Who cared whether this was art or not – *it worked*. The road towards the future seemed paved with gold and off along it skipped Advertising and Photography hand in hand – as if made for each other, inseparable.

Western culture is most vividly and accurately mirrored by its advertising imagery. More than any more traditional form of art it reveals the values and aspirations of the society in which we live. No-one has ever seen anything like it before. At no other period in history has any society had to cope with such a mass of sophisticated and complex visual messages – on billboards, in newspapers, in brochures,

on the sides of vans and buses, on packaging, on the front covers of row after row of magazines in newsagents, in the street, at work, at home. We're still too blind, too visually illiterate to understand what's happening, and there is no going back. Our whole culture has switched over onto mass-produced images which are the creations of some of our best brains and most talented and innovative visual designers. Advertising is exciting, amoral, potentially dangerous, uncritical and packed with ideas. The enjoyable graphics, the sizzling visuals slide around the defences of the mind.

Now all this has happened very recently. We have not always gone around with advertising jingles echoing around our heads, with our eyes dazzled by visions of plenty, and with our hands reaching into our pockets ready to buy happiness. If you go back to the end of the last century and look at a *Trades Directory* listing firms in London you find that there weren't then what we would now call Advertising Agencies – that is firms specialising in creative graphics and using photography extensively as their main method of communication. There was Walter Hill & Co. over towards the City who described themselves as 'general advertising contractors, publishers, bill posters & experts; contractors for railway stations, railway carriages, protected street stations, omnibuses, tramcars & every description of advertisement in all parts of the world.'[2] These people – and other firms like them – organised the huge business of booking advertising space and actually posting the printed advertisements on hoardings. Other firms offered to insert your advertisements 'in all newspapers & periodicals throughout the world'. Willing & Co. Ltd of

Gray's Inn Road boasted that they were 'the largest advertising contractors in the world'. Advertising was seen to be very profitable both for the contractors and their clients.

To trace the origins of the flood of advertising imagery using photographs you have to look under *Photographic Publishers*. Let's take a closer look at one entry in particular:

Poulton & Son, Taunton Road, Lee, London SE

This was a business run by Sam and Alfred Poulton who commissioned work from photographers. It was from small firms like this that one strand of modern advertising came – the devising of photographic images which appealed to popular taste, work which was amusing but which took the message home. Above is an example of a sequence of three prints which George Higgs photographed for them in 1884. This kind of comic story-telling could either be sold simply as comic photographs or adapted for use in advertising. The Poultons were probably watching developments in America where things were moving fast, and where sequences of facial expressions linked to captions were used on advertising trade cards. For example a set from 1882: 1. *I'm a Daddy!* (smiling proudly) 2. *The Nurse says there are two!* (wide-eyed in amazement) 3. *Five!* (in bed looking sick with a bandage around his head).[3]

In 1884 Poultons commissioned William Carroll to photograph a boy smiling holding a pipe and a tin of tobacco. This was given the title *Anticipation*, followed by the boy smoking the pipe – *Realization* – and finally having put down the pipe and looking sick – *Consummation*. Maybe you could trace back some of

their ideas to paintings which told stories but most of what they were doing and the way that they were doing it was quite new. That is not to say that it was totally original. The people working in advertising, then as now, were happy to borrow ideas from almost any source if it suited their purposes. Poultons' ideas sprang out of easily-assimilated lightweight popular culture. It's doubtful that even the most popular and mercenary Academy painter would have got away with exhibiting paintings of the subjects photographed for the Poultons such as *The Engaged Solo*, *The Married Duet*, *The Parental Trio*. This was the territory of the *Punch* cartoon, of the racy music hall comedians, and of the cheap china ornament you bought for your sweetheart – *he promised to buy me a fairing to please me*.[4]

A COMEDY IN THREE ACTS

1. *She said she couldn't resist me*

2. *Now she sues for breach of promise*

3 *Oh horror, damages £5,000*

George Higgs 1884

The sequence which was to become one of the most famous advertising images was commissioned by Alfred Poulton from William Carroll in April 1889. In May the copyright was assigned to J. S. Fry & Sons of Bristol, the cocoa and chocolate manufacturers – Poulton had found a client. In 1890 Fry's ran the advertisement in the national press – the example on the right is from the *Illustrated London News* – and by this time the photographs had gained captions. *Desperation, Pacification, Expectation, Acclamation* and *Realization* "*It's Fry's*" told the 'Story of Fry's Chocolate' more directly and more persuasively than words ever could. Fry's discovered that they had put together a very successful advertising campaign and called their chocolate *Fry's Five Boys*, using simplified versions of Carroll's photographs on the wrappers. The Five Boys went forth and multiplied into thousands of advertising images, including enamel signs which used to be seen at railway stations and outside corner shops. The *Fry's "Five Girls"* formed part of a continuing campaign to keep the public interested and to keep the product at the forefront of their attention. If you remembered seeing the Five Boys,

you knew which bar of chocolate to ask for. Once the product had registered in the public's mind thanks to punchy visual presentation, it was comparatively easy to jog the consumer's memory with further advertising. Until recently you could still buy a bar of *Fry's Five Boys* chocolate – Carroll's sequence of photographs provided an enduring image which promoted sales for nearly eighty years.

Fry's recognised the power of photography to get their message across, and figures have survived giving details of another of their advertising campaigns launched in the spring of 1912. This was based on a photograph of a little boy at a garden gate, dressed in white, with his hand tucked into his smock pocket. It was used on Fry's chocolate wrappers. 4,000,000 copies were printed to help sell the chocolate over a ten-month period, the photograph featured in advertising films, 20,000 sets of playing cards were manufactured with the child mascot's photograph on the back of each, and to immortalise the photograph and the campaign, a life-size cast of the image was made in bronze.[5]

STORY OF FRY'S CHOCOLATE

DESPERATION. PACIFICATION. EXPECTATION. ACCLAMATION. REALIZATION.
"IT'S FRY'S"

FRY'S PURE CONCENTRATED COCOA

Makes a delicious beverage for Breakfast or Supper, and, owing to its nutritious and sustaining properties, will be found eminently suited for those who require a light yet strengthening beverage.

Half a teaspoonful is sufficient to make a Cup of most delicious Cocoa.

TO SECURE THIS ARTICLE ASK FOR "FRY'S PURE CONCENTRATED COCOA."

Gold Medal, Paris, 1889. Forty-Three Prize Medals awarded to the Makers.

J. S. FRY & SONS, BRISTOL, LONDON, AND SYDNEY, N.S.W.

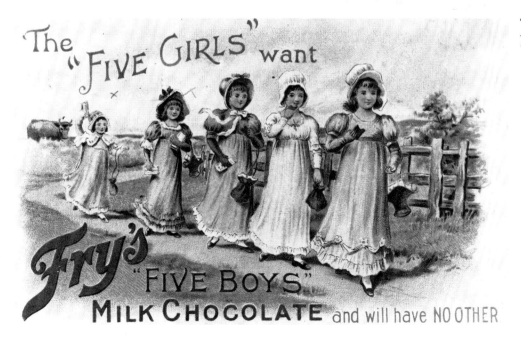

The "FIVE GIRLS" want

Fry's "FIVE BOYS" MILK CHOCOLATE and will have NO OTHER

Miss Evie Greene on
the telephone
Herbert Coston
1908

Not all advertising photography was as straight-forward as *Fry's Five Boys* and it is no longer always possible to discover the precise purpose for which they were intended. Still, we can see in them how commercial photographs designed to display products were rapidly becoming more elaborately contrived and more sophisticated. Here are two photographs which are in fact unrelated but come from about the same point in the swift rise of advertising photography. The first shows Miss Evie Greene – who was probably an actress because *modelling* had not yet developed as a career for attractive girls. It was taken in 1908 by Herbert Coston, working for Dover Street

Studios and Adart Ltd of London. The name *Adart* conveys something of the slick professionalism of the media machine which was to grow from agencies such as this.

The girl appears to be listening attentively to her bedside telephone with just as much self-assurance as later heroines (and heroes) in Hollywood movies who would indicate their direct link with a world of action and influence by using bedside phones – *keeping in touch*, even in bed. She wears an expensive lacey nightdress and her slightly tousled hair suggests that maybe she's just been awakened by the phone. Brocaded bed-hangings with silken tassels are swept back

[130]

to the gleaming brass bed-head – and significantly it's a *double* bed.

The fact that she has the telephone at her elbow endows her with power and status – no matter that this status symbol now looks to us like a wildly baroque pencil sharpener. If you had one of these new wonder-machines you could be like her. There is a blurring of distinction between the desirable objects shown here – the girl waiting half-smiling, and the telephone. Here is raw material for fantasy and desire. Even without knowing what precise purpose this photograph served, its visual message comes across loud and clear.

The second photograph shows a maid speaking into a house telephone. Above her is an electric indicator board to show the servants whereabouts in the house their services are required. This was taken in 1912 by William Campbell for The Sterling Telephone & Electric Co. Ltd of London. Again the photographer has chosen a pretty girl to listen attentively to the instructions being given by phone. Like the product, she too is attractive, and her eager face indicates the speed and readiness with which she will answer your call by this most efficient and up-to-date of gadgets.

A maid using the telephone
William Campbell
1912

Symington's Soups are so easily prepared – I find them delicious! They always give satisfaction: Yours truly, Ellen Terry =

Ellen Terry endorsing
Symington's Soups
Arthur Banfield
1910

It is the apparent straightforwardness of these photographs, with what seems their guileless innocence in presenting a world of costly materials, shiny surfaces, mechanical gadgets, enviable objects – a world which is inhabited by people sure of and happy with their place in life – that makes them so powerful. Advertising photographs are Trojan horses full of hidden ideas and influences. As they so often employ pretty girls to carry home their messages, perhaps the best adjective can use to describe them is *seductive*. But it could be argued that advertising photography has always been a tease – always the come-on, and nothing more than the empty promise of satisfaction.

Considering that advertising photography did not develop as a specialist branch of photography until the turn of the century, it's surprising how early on you can see characteristics which are typical of modern advertising. Above is a photograph taken for Symington's Soups by Arthur Banfield, the manager of Foulsham and Banfield, another company which was now specialising in producing advertisements using photography. Here Ellen Terry, the actress, is endorsing Symington's Soup – endorsement by prominent personalities was a standard technique even then – and

the photograph is backed up by a statement in her own handwriting – *Symington's Soups are so easily prepared – I find them delicious! They always give satisfaction: Yours truly, Ellen Terry.*

'Yours truly' is the commercial lie at the heart of the matter. Did she volunteer this supposed snippet of a letter with its complimentary message to Symington's Soups? No, it would have been composed for her; she only provided the handwriting. Would Ellen Terry have been in the habit of preparing Symington's or anyone else's soup? It seems unlikely – it would surely be cook's job to fill the shining silver tureen we can see on the table. Is she really eating soup? Of course not. In this carefully staged piece of play-acting there is no soup, but instead two interlinked stars – Ellen Terry and the Symington's Soup packet, which has been carefully retouched to add to its visual impact.

The staging is impeccable, and the overall presentation carefully thought out. The background is obscured both to concentrate attention on the soup-eating tableau and to provide a suitable ground for the handwriting – white on black for maximum impact. It does not show Ellen Terry *in a restaurant* or *at home* – that might prove distracting. As in many modern

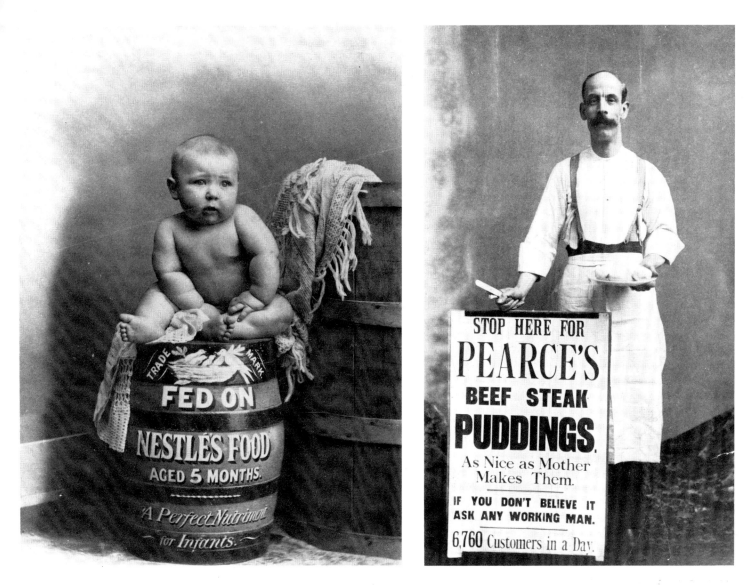

examples of commercial imagery using photographs, the physical and social settings are deliberately left vague and unspecified. The photograph concentrates on the essential business of showing her pretending to enjoy a particular brand of soup. There is enough high-quality cutlery and glassware on the linen tablecloth to hint at restrained opulence; Ellen Terry is impeccably groomed and fashionably dressed. The implication is that Symington's Soup is what all the *best* people turn to for nourishment.

Irrelevant details are eliminated. Everything is made to play its part. The chair adds to the overall pattern – a dark arm over a light dress – without being of an elaborate design which could possibly distract the eye. The vase of flowers balances Ellen Terry and takes the eye up to the beginning of the endorsement. All this is taken in almost in one glance. The artifice is not immediately evident. What is in fact artfully aggressive promotion of a product reads at first – deceptively – as a *natural, tasteful* and *truthful* statement of fact.

It is interesting to see how words are made to work in conjunction with advertising photographs. Here are two early examples. The first is by the Regent Street portrait photographer who called himself *Walery*, who has gone to the trouble of having a barrel specially painted to emphasise that this hefty baby, displayed like a prize animal at a show, has achieved its bulk by consuming the 'perfect nutriment' upon which it sits. In the second, Joseph Pearce stands holding a plate of beef steak pudding and potatoes behind a placard announcing his speciality. The first slogan has now proved its powers of endurance in advertising for a century or more – *As Nice as Mother Makes Them* applies a touchstone of quality which has a special meaning for each and every mother's son and daughter. The second slogan indicates that you can really get your teeth into Mr Pearce's food – it's real down-to-earth, belly-filling grub for working men. Mr Pearce knew what he was about. Ask *any* working man implies that *every* working man knows how good his food is. How he fed 6,760 customers a day I don't know, but 6,760 beef steak experts can't be wrong and he's ready with plate and knife and fork in hand to make you yet another satisfied customer. Ellen Terry's Symington's Soup is presented as a tasty appetiser for the affluent. Beef pudding was for the workers.

Joseph Pearce and his Beef Steak Puddings
Joseph Pearce
1891

Infant seated on a barrel
Walery
(Stanislas Julian, Count Ostrorog),
1890

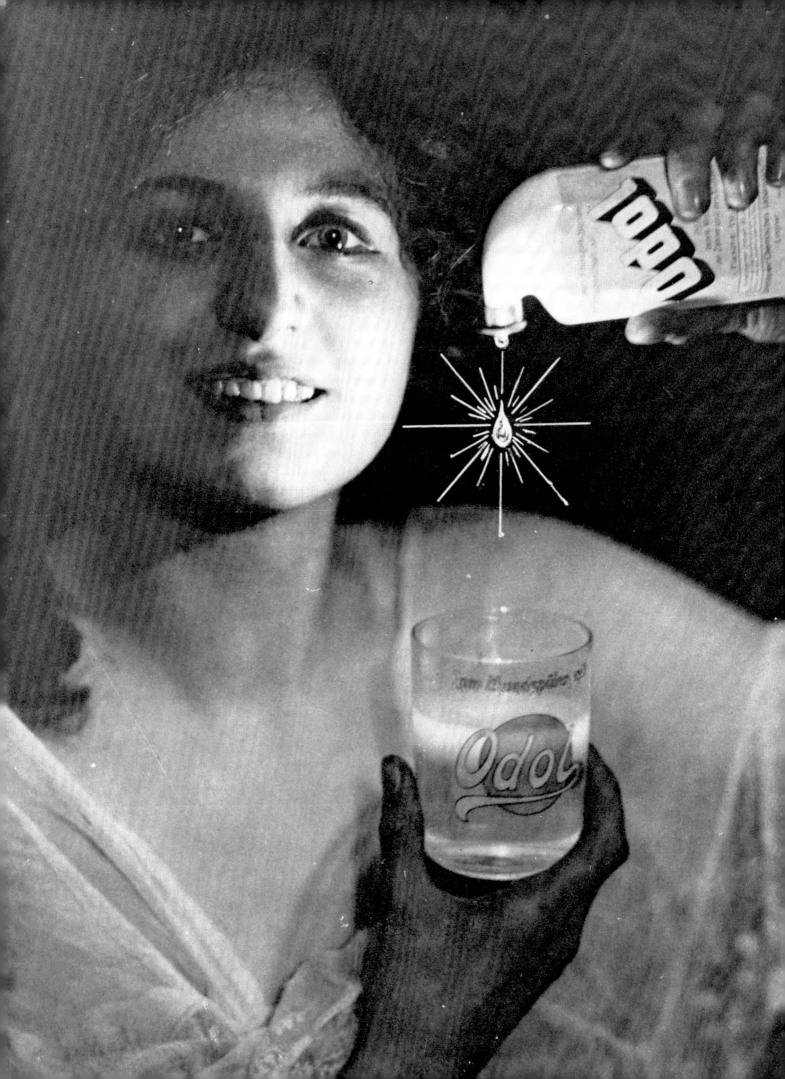

Other advertisements did away with any need for words. This *Odol* advertisement produced by Cavendish Morton in 1908 shows a very sophisticated use of a brilliantly simple visual device. Unfortunately the *Odol* management did not give their full backing to this ultra-modern approach and continued to issue word-based advertisements. Let me quote one in full from a newspaper of 1910, and as you read it ask yourself which is more effective in promoting the product – the advertisement containing 365 words, or the single image:

ODOL

Grave Warnings are uttered almost every day in the newspapers with regard to the wretched state of the teeth in old and young. It seems strange that in the face of these continual but timely reminders people should persist in treating lightly a subject of such importance. Not that we wish to suggest that the modern man neglects to clean his teeth at all – on the contrary, we find that it is habitual with most people – but the question is, in what way is the cleansing process performed?

There are legions of preparations, mostly tooth-powders and tooth-pastes, sold at reasonably low prices, and for all these it is claimed that they clean the teeth. But this so-called cleansing of the teeth, this scrubbing with powders and pastes, is precisely where so much harm is done, for the effect is but superficial, they lack entirely the essential quality of combating decay in the teeth. Now, the obvious way to prevent decay is to remove the particles of food which, after eating, remain between the teeth (invariably where the tooth-brush will not reach them), and owing to the destructive character of the bacteria attracted by these remnants of food, the processes of decomposition are very rapid in their action, and if not guarded against inevitably destroy the teeth. It is therefore clear that a thorough and effective cleansing can only be done by means of a *liquid* antiseptic dentifrice and mouthwash. Odol is the preparation to use, for a few drops in a tumbler of water form an emulsion which will most throughly cleanse and purify the oral cavity, destroying all injurious bacteria lurking therein. Odol penetrates the interstices between the teeth and impregnates the mucous membrane of the mouth, exercising its antiseptic and refreshing powers not only during the brief period of using but *for hours afterwards.*

We propose to continue to set forth in a series of announcements the many remarkable qualities of Odol, and we are convinced that where once it is tried Odol will be always used, so welcome will be the delightful feeling of freshness and cleanliness in the teeth and mouths that are cleansed with Odol.
ODOL CHEMICAL WORKS
LONDON, S.E., May, 1910.[6]

It grinds to a halt like an official announcement.

In contrast, Cavendish Morton, in creating a purely visual advertisement for *Odol*, shows us a magic potion dispensed by a good fairy. The drop of *Odol* – transfixed in mid-air between *Odol* bottle and *Odol* tumbler (and in fact drawn upon the negative) – irradiates the scene with its concentrated power. Inside this precious twinkling diamond with the pure, cleansing form of a snowflake are locked up all the mysterious powers of Science, rendered safe and bottled in a handily-sized dispenser.

Here the photographer plays the rôle of the magician, creating the required illusion by means of carefully controlled and directed lighting. Aladdin could summon forth a powerful genie from his lamp. Is this attractive girl with her wispy negligée plunging bosomwards the genie of the *Odol* bottle? What are the unspoken questions asked of this luscious phantom, and what are her unspoken replies?

Q. *Can I* (asks a woman) *be lovely and healthy like you, with beautiful teeth?*
A. *Yes* (she promises with friendly reassurance). *Buy* Odol.
Q. *Can I* (asks a man) *hope to attract a lovely and healthy woman like you, with beautiful teeth?*
A. *Yes* (she whispers) *Buy* Odol.

The eyes of this good fairy shine by its benevolent light. Her complexion blooms, her firm and regular teeth glisten. Her health and beauty are assured. She has put her trust in the product.

Notes

Introductory Quotations

Thomas Fuller: see *A Dictionary of The Proverbs in England in the Sixteenth and Seventeenth Centuries. A Collection of the Proverbs Found in English Literature and the Dictionaries of the Period*, by Morris Palmer Tilley (Ann Arbor, 1950), p. 536.

William Wordsworth: this sonnet, written in 1846, was one of the last poems he wrote and was first published in 1850, the year of his death. *The Illustrated London News* – the pioneer of illustrated newspapers – was first issued on 14 May 1842.

Elizabeth, Lady Eastlake: from her article 'Photography', *The Quarterly Review*, Vol. 101, No. 202 (April 1857), p. 465.

Charles Baudelaire: from his Salon review of 1859, quoted by Aaron Scharf in *Art and Photography* (London, 1968), p. 110.

Alfred Stieglitz: from an article entitled 'Pictorial Photography' published in *Scribner's Magazine*, 1899.

George Bernard Shaw: from a review headed 'The Exhibitions – 1', *The Amateur Photographer*, 11 October 1901, p.282.

Walter Lippmann: *Public Opinion* (New York, 1922), p. 92.

Franz Roh: from 'mechanism and expression, the essence and value of photography', *photo-eye*, (Stuttgart, 1929; facsimile edition, London, 1974), p. 3 and from 'The literary dispute about photography. Theses and antitheses to the theme "Mechanism and expression" ' (1930), translated and reprinted in *Germany, The New Photography 1927-33*, edited by David Mellor (London, 1978), p. 41.

Walter Benjamin: 'The Work of Art in the Age of Mechanical Reproduction', reprinted in *Illuminations* (Fontana edition, London, 1973), p. 229.

Marshall McLuhan: *Counterblast* (London, 1970); the book is not paginated.

The View from the Darkroom

1 John Leighton, F.S.A., writing in the *Standard*. Quoted in *The British Journal of Photography*, 26 January 1894, p. 52.

2 See *Hansard* for 28 February 1862, (Vol. CLXV), p. 845, and for 20 March 1862, (Vol. CLXV), pp. 1890-91.

3 Frederick Pollock, Lord Chief Baron, *The Photographic Journal*, 15 May 1861 p. 173.

4 Frank Sutcliffe reported under the heading 'Reminiscences of Valentine Blanchard' (and reprinted from his 'Photography Notes' in *The Yorkshire Weekly Post*), *The British Journal of Photography*, 29 September 1911, p. 752.

5 The Editor (William Gamble), 'Commercial and Press Photography', *Penrose's Pictorial Annual, The Process Year Book* for 1903-4, p. 111.

6 O. G. Rejlander (who spelled his middle name *Gustaf* on his copyright registration forms), letter to the eds, *The British Journal of Photography* 17 November 1865, p. 589.

7 Old Pro., 'In My Time', *The British Journal of Photography*, 27 January 1911, p. 65.

8 William Downey, 'Forty Years a Royal Photographer', *The British Journal of Photography*, 29 November 1907, p. 902.

9 *Annals of My Glass House* was written in 1874 and is published as an appendix to Helmut Gernsheim's *Julia Margaret Cameron, her life and work* (London, 1975), p. 183.

10 'A Reminiscence of Mrs Cameron' by A Lady Amateur, *The Photographic News*, 1 January 1886, p. 3.

11 William Downey, loc. cit.

12 H. P. Robinson, 'Digressions. No. XV – 150,000 Celebrities', *The British Journal of Photography*, 5 March 1897, p. 149.

13 Clement K. Shorter, 'Illustrated Journalism: Its Past and Its Future', *The Contemporary Review*, Vol. LXXV (April 1899), p. 491.

14 F. J. Mortimer, The Presidential Address given at The Photographic Convention of the United Kingdom, *The British Journal of Photography*, 11 July 1913, p. 530.

15 Fred O. Penberthy, reported under the heading 'Press Photography', *The British Journal of Photography*, 10 December 1909, p. 952.

16 F. J. Mortimer, op. cit., p. 529.

'One picture is worth a thousand words'

1 Elizabeth, Lady Eastlake, 'Photography' in *The Quarterly Review*, Vol. 101, No. 202 (April 1857), p. 465.

2 See *Stevenson's Book of Proverbs, Maxims and Familiar Phrases* (London, 1949), p. 2611, which gives credit to Fred R. Barnard for coining the phrase. He first used it in a slightly different form – 'One look is worth a thousand words' – in *Printers' Ink*, 8 December 1921, p. 96 and later changed it to 'One picture is worth a thousand words' in *Printers' Ink*, 10 March 1927, p. 114. He was reported to have called it a Chinese proverb 'so that people would take it seriously'.

3 See *The Times* (London) issues dated 3, 12, 13, 17, 19, 23, 24 and 26 April 1889. And also *The Donegal Independent and Sligo, Leitrim and Fermanagh Advertiser* (Ballyshannon) issues dated 20 and 27 April and 4 May 1889.

4 *The Donegal Independent*, 20 April 1889.

5 For the background to the lock-out, see R. Page Arnot, *South Wales Miners, Glowyr de Cymru, A History of the South Wales Miners' Federation (1898-1914)* (London, 1967).

6 *The Pontypridd & Rhondda Valleys Weekly Post*, 12 July 1906.

7 Clement Shorter, 'Illustrated Journalism: Its Past and Its Future', *The Contemporary Review*, Vol. LXXV, April 1899, p. 492.

8 For the story of the rise of *The Daily Mirror*, see Hugh Cudlipp, *Publish and be damned! The astonishing story of the Daily Mirror* (London, 1953) and also Allen Hutt, *The Changing Newspaper, Typographic trends in Britain and America 1622-1972*, (London, 1973).

9 James Jarché *People I have Shot*, (London, 1934), p. 217.

10 *The Daily Mirror*, 19 November 1910 For the details and quotations following, see also issues of *The Daily Mirror* for 21-25, 28 and 29 November 1910. Also *The Daily Sketch* for 19 November 1910.

11 H. N. Brailsford and Dr J. Murray, *The Treatment of the Women's Deputations by the Metropolitan Police* (London, 1911), quoted by Andrew Rosen in *Rise Up, Women! The Militant Campaign of the Women's Social and Political Union 1903-1914*, (London and Boston, 1974), p. 140.

12 E. Sylvia Pankhurst, *The Suffragette Movement, An Intimate Account of Persons and Ideals*, (London, 1931), pp. 342-3.

13 For Swaffer's involvement with the cause of the suffragettes, see Tom Driberg, 'Swaff', *The Life and Times of Hannen Swaffer* (London, 1974), pp. 57-9.

14 Quoted by Driberg, op. cit., pp. 64-5

Get Pictures!

1 This photograph was used without the photographer's permission by the election agent of the Conservative candidate at Romford. 40,000 copies were printed and distributed in election leaflets, and Carlton Roberts brought a successful lawsuit to gain damages for the unauthorised use of this photograph which he had registered as copyright. See 'Howlett v. Roberts' in *The British Journal of Photography*, 17 May 1901, p. 313.

2 For details of how the news of the relief of Mafeking reached London, and of the celebrations which followed see *The Times* for 19 May and 21 May 1900. *The Times'* correspondent's report titled 'The Last Day of the Siege of Mafeking', with the dateline *Mafeking, May 13th*, was eventually published in the issue dated 19 June 1900.

3 J. A. Reid, 'Photographers and the Illustrated Press', *The British Journal of Photography*, 20 April 1900, p. 247.

4 J. Rees, 'Journalistic Photography', *The British Journal of Photography*, 5 May 1899, p. 280.

5 Major J. Fortune Nott, 'Photography and Illustrated Journalism', *The British Journal of Photography*, 26 June 1891, p. 407.

6 See 'The Press Photographers' Market – What Editors Want' (no author given), *The British Journal of Photography*, 22 November 1912, p. 896.

7 Hannen Swaffer, 'The "Mirror" Art Editor on Press Photography', *The British Journal of Photography*, 9 October 1908, p. 774.

8 See 'Half-Tone Engraving on a Railway Flier' (no author given), *The British Journal of Photography*, 12 August 1904, p.712.

9 W. M. Duckworth, 'The Strenuous Life', *The British Journal of Photography*, 20 December 1907, p. 962.

Votes for Women

1 Annie Kenney, *Memories of a Militant* (London, 1924), pp. 35-6.
2 Evelyn Sharp, *Unfinished Adventure, Selected Reminiscences from an Englishwoman's Life* (London, 1933), p. 138.
3 Bernard Grant, *To the Four Corners, The Memoirs of a News Photographer*, (London, 1933), pp. 247-8.
4 Evelyn Sharp, *Rebel Women*, (London, 1910), pp. 54-5. The relationship between mother and daughter is in part autobiographical.

A Rocket to the Rescue

The Times carried an account of the rescue the following day, 12 November 1891, and in the issue of 20 November the ship is included in a long list headed 'Maritime Losses and Casualties'. The story of the wreck of the *Benvenue* is given in the issue of 13 November.

For reviews of this photograph when it was exhibited see *The British Journal of Photography*, 30 September 1892, pp. 629 and 635; also the issue for 7 October p. 649.

The Wreck of the Mohegan

1 The details of the wreck and the accounts of the survivors are taken from the news reports carried by *The Times*, issues for 15 and 17-21 October 1898, and the reports of the proceedings of the Wreck Inquiry into the loss of the *Mohegan* in the issues for 11, 12, 14, 25 and 28 November 1898.
2 Mr L. E. Pyke, Q.C. speaking at the Wreck Inquiry, quoted in *The Times*, 26 November 1898.
3 Quoted in *The British Journal of Photography*, 25 November 1892, p. 756.
4 From a report in *The Royal Cornwall Gazette*, 20 October 1898.
5 Editorial comment in *The British Journal of Photography*, 25 November 1892, p. 756.

All Hope Abandoned

Details of the disaster are taken from reports in *The Times*, issues dated 13, 14 and 16 May, 30 September, 1 and 5 October, 23 November and 3 December 1910.

Bloody Murder

Details of the murder and of the trial which followed are to be found in *The Times*, 6, 7 and 22 February, and 13 July 1899.
The photograph was unusual enough for Hugh Penfold to send it to *The British Journal of Photography*, which

commented: 'The photograph tells its own tale, and has quite a grim fascination for one'. (24 February 1899, p. 114).

Law and Order

Details of the incident and of the trial which followed are to be found in *The Times*, 6 and 13 April, and 19 June 1899.

Making History

Details of the royal visit to Wynyard are given in *The Times*, 5 October 1893.
Mark Twain was in London in 1907. see *The British Journal of Photography*, 12 July 1907, p. 528.

Camera Fiends

1 See *The Penny Pictorial Magazine*, Vol. 4, No. 43 (31 March 1900), p. 175, and Vol. V, No. 62 (11 August 1900), p. 423.
2 Hannen Swaffer, reported in 'The "Mirror" Art Editor on Press Photography', *The British Journal of Photography*, 9 October 1908, pp. 774-5.
3 Paragraph headed 'The King and Photographers', *The British Journal of Photography*, 29 March 1907, p. 243.
4 Letter from Francis Fielding headed 'Methods of Press Photography', *The British Journal of Photography*, 1 January 1909, pp. 14-15.
5 Editorial comment, headed 'The Camera Fiend', *The British Journal of Photography*, 11 August 1911. The King mentioned here is the newly-crowned George V, suffering just as much as his father before him.
6 This incident was widely reported in the national press and took place on Christmas Day 1908. It was in reaction to this that Francis Fielding wrote his letter of protest, and in it he quotes from the press coverage.

An Art of Great Singularity

1 W. H. Fox Talbot, 'Introductory Remarks' (no pagination), *The Pencil of Nature* (London, 1844; facsimile reprint New York, 1969).
2 From a report of a lantern lecture given by Henry Speyer at the Royal Photographic Society in 1900, entitled 'Round about the Matterhorn and the Aletsch Glacier'. See 'An Alpine Evening', *The British Journal of Photography*, 5 January 1900, p. 14.
3 Marshall Hall in a letter to the editor, *The British Journal of Photography*, 26 May 1893, p. 335.

The Light of the Future

This title is taken from a paragraph of editorial comment in *The British Journal of Photography* in 1901, headed 'Artificial Lighting' (1 November 1901, p. 690).

1 Henry Van der Weyde, 'Electric Lighting in Photography' (reprinted from the *Camera Club Journal*), *The British Journal of Photography*, 8 April 1892, p. 232.
The details of Van der Weyde's career have been taken from this article and from the following sources:
The British Journal of Photography:
'Van der Weyde's New Method of Lighting Studios', 30 July 1875, p. 372.
'The Van der Weyde System of Lighting Studios', 20 August 1875, pp. 398-400.
'Recently Patented Inventions. No. VII. Van der Weyde's System of Lighting', 7 April 1876, pp. 159-60.
'New Method of Lighting the Sitter', 2 February 1877, pp. 50-51.
'Nocturnal Photography', 14 December 1877, pp. 590-91.
Commercial & Legal Intelligence [for details of his business dealings and bankruptcy] 7 March 1902, pp. 195-6; 21 March 1902, p. 236; 20 July 1906, p. 577; 17 August 1906, p. 657.
See also 'The Van der Weyde Electric Studio in Regent Street', in *The Photographic Studios of Europe*, by H. Baden Pritchard, (London, 1882), pp. 72-6; and Van der Weyde's lecture entitled 'Photography by the Electric Light', published in the *Journal of the Society of Arts*, 24 February 1882, pp. 370-71.
2 From a review of the annual exhibition of the Photographic Society of Great Britain (which was later to become the Royal Photographic Society) in the *Morning Advertiser*, reprinted in *The British Journal of Photography*, 24 October 1879, p. 508.

Pyromaniacs and Living Daylight

1 Bernard Grant, *To the Four Corners, The Memoirs of a News Photographer* (London, 1933), p. 251. See also 'Commercial and Press Photography', by the Editor, *Penrose Annual, The Process Year Book*, 1903-4, p. 112 and Paul Martin, *Victorian Snapshots*, (London, 1939), pp. 40-41.
2 See J. C. Burrow and W. Thomas, *'Mongst Mines and Miners*, (London, 1893), pp. 6-9, where Burrow describes how he took photographs below ground.
See also Herbert W. Hughes, 'Photography in Coal Mines', *The Photographic Journal*, 25 November 1893, pp. 93-101.
3 E. F. im Thurn, 'Anthropological Uses of the Camera', *The Journal of the Anthropological Institute of Great Britain and Ireland*, Vol. XXII (1893), p. 186. For further details of Sir Everard im Thurn see *Observers of Man, Photographs from the Royal Anthropological Institute* (catalogue of exhibition at the Photographers' Gallery, London, 1980), and for details of J. W. Lindt see Jack Cato, *The Story of the Camera in Australia* (second edition, Institute of Australian Photography, 1977).

Points of View
(No Notes)

Mixed Motives

1 See the brief obituary in *The British Journal of Photography*, 23 August 1895, p. 540.
2 'Picture Post-Cards' by "A Professional", first published in *The Bromide Monthly* and reprinted in *The British Journal of Photography*, 2 October 1903, p. 793.

Conflicting Views

1 *Rudyard Kipling's Verse, Inclusive Edition, 1885-1932*, (London, 1933), pp. 451-2.
2 Rudyard Kipling, *Something of Myself, For My Friends Known and Unknown* (London, 1951 edition), p. 150.
3 See *The Times History of the War in South Africa* [1899-1902], edited by L. S. Amery, Vol. III, 1899-1900 (London, 1905), p. 524.

All on Fire with Great Ideas

1 'Aliquis', 'Occasional Papers on Photographic Æsthetics, No. V, Deductive. – Allegorical and Composite Photography', *The British Journal of Photography*, 3 May 1867, p. 207.

Sign Language

1 Edith Cooper, quoted by Joan Evans in *John Ruskin* (London, 1954), p. 407
2 See *'Your Good Influence on Me': The Correspondence of John Ruskin and William Holman Hunt*, by George P. Landow, (The John Rylands University Library of Manchester, 1977) p. 43.
3 *The Times*, 30 July 1907. For other details concerning the *Lusitania* and the *Mauretania*, see *The Times* for 9, 16 and 18 September, and for 12 and 25 October 1907.
4 See 'Your Share of the Empire. You Did Not Know You Were So Wealthy', by Percival Naylor in *The Penny Pictorial Magazine*, Vol. 3, No. 34 (27 January 1900), pp. 379-83.

5 Luke Owen Pike, *A History of Crime in England*, Vol. II (London, 1876), p. 576. Statistics on corporal punishment for 1895 were given in *The Times* for 12 October 1895. The case of the boys who were flogged in Edinburgh was brought up in the House of Commons and reported in *The Times* for 12 April 1889.

Curiouser and Curiouser

1 Eugen Sandow, *Strength and How To Obtain It* (revised edition, London, c.1901), p. 147.

Blowing Bubbles

1 Noted by Beatrix Potter in her Journal for 15 November 1885. See Mary Bennett, *Millais* (the catalogue of the exhibition at the Royal Academy, London, 1967), p. 59.
2 See the very interesting details given by Malcolm Warner in *Great Victorian Pictures, their paths to fame*, (Arts Council exhibition catalogue, London, 1978), p. 60.
3 See G. J. Mellor, *Picture Pioneers, The Story of the Northern Cinema 1896-1971* (Newcastle, 1971).
4 See Cecil M. Hepworth, *Came the Dawn, Memories of a Film Pioneer*, (London, 1951), and George Eglin's article, 'Mr Lever, The Film Pioneer', in the *Liverpool Echo*, 7 March 1957.
5 J. Rees, 'Photography as an Advertising Medium', *The British Journal of Photography*, Supplement, 4 February 1898, p. 14.
6 No author given, 'Photographs for Advertising Purposes', *The British Journal of Photography*, 4 January 1907, p. 6.
7 From a letter to the editor of *The British Journal of Photography* from Charles W. Walker of McCaw, Stevenson and Orr Ltd, Advertising Contractors, printed in the issue for 2 November 1906, p. 878.
8 No author given, 'Photographic Advertising', *The British Journal of Photography*, 1 January 1904, p. 4.

Pretty Dolls and Elegant Dummies

1 Paragraph headed 'An International Beauty Contest', *The British Journal of Photography*, 30 June 1899, p. 404.

2 'Photographic Nuisances', *The British Journal of Photography* (reprinted from *Tomahawk*), 11 December 1868, p. 597.
3 'The Degradation of Photography', *The British Journal of Photography*, (reprinted from the *Morning Advertiser*), 19 May 1871, p. 235.
4 'Alleged Immorality of Photographers, *The British Journal of Photography*, (reprinting and commenting on a leading article from the *Daily News*) 1 January 1869, p. 5.
5 Charles E. Dawson, 'Beauty and the Camera, With Special Reference to the Work of Elwin Neame', *Penrose's Pictorial Annual, The Process Year Book*, Vol. 15, 1909-10, p. 57.
6 No author given, 'The Work of S. Elwin Neame in Decorative Photography', *The British Journal of Photography*, 27 March 1908, p. 239.
7 This and all the subsequent details and quotations are from Charles Dawson's article, loc. cit., pp. 57-60, and the article on Neame in *The British Journal of Photography*, loc. cit., pp. 239-41.

Getting the Message Across

1 J. W. Beaufort, 'Poster Work for Photographers', *The British Journal of Photography*, 14 June 1912, pp. 456-7.
2 The details are taken from *The Post Office London Trades Directory for 1891* (London, published by Kelly & Co.).
3 See John M. Kaduck, *Advertising Trade Cards*, (Des Moines, Iowa, 1976), p. 35. The full set consisted of six cards.
4 For examples of narrative themes in fairings, see W. S. Bristowe, *Victorian China Fairings* (London; second edition, 1971).
5 See 'The Money-Getting Power of a Photograph', *The British Journal of Photography*, 20 December 1912, p. 972.
Published in *The Times*, 31 May 1910, p. 6.

Reference to Photographs

The photographs are – except for those few indicated below – those registered at Stationers' Hall as explained, and now in the care of the Public Record Office. The following references are to the class of papers identified as COPY 1, which should precede the number for identification.

I have not been able to give a full numerical reference in every case as the process of foliation had not been completed at the time of my research.

Index